SOUVENIRS FROM
HIGH PLACES

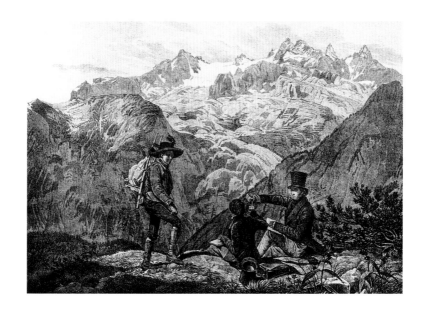

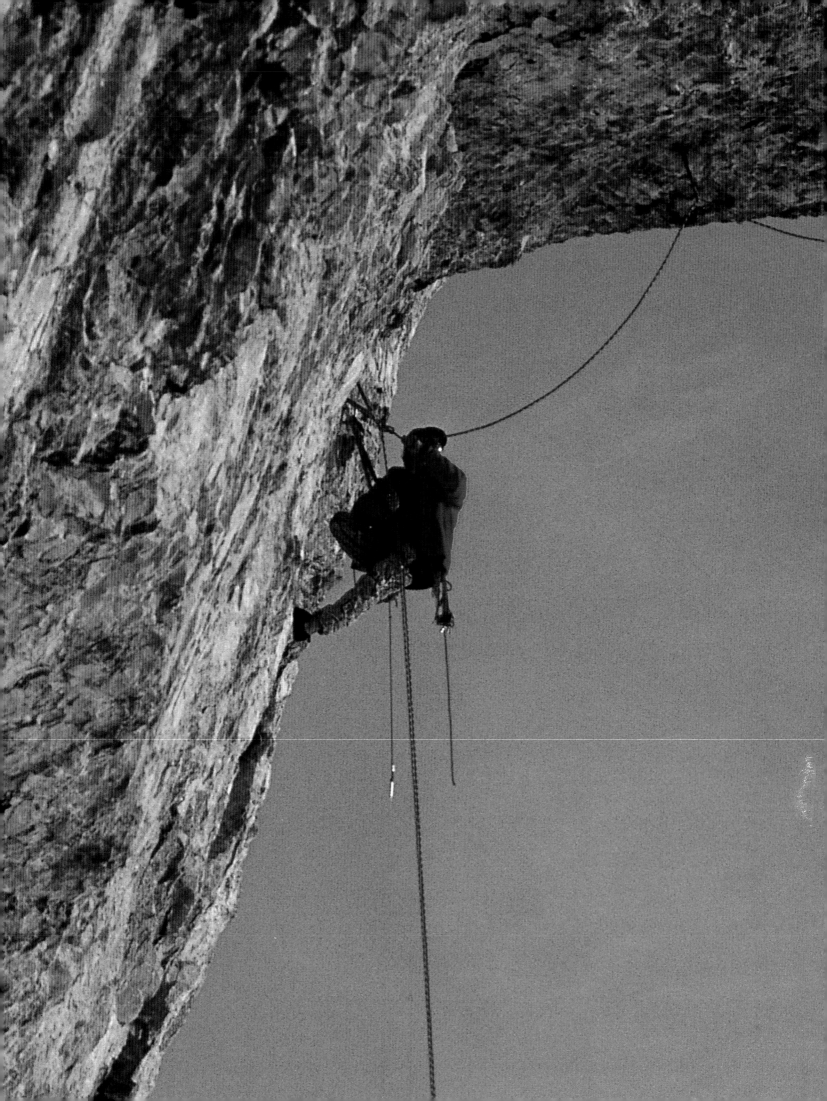

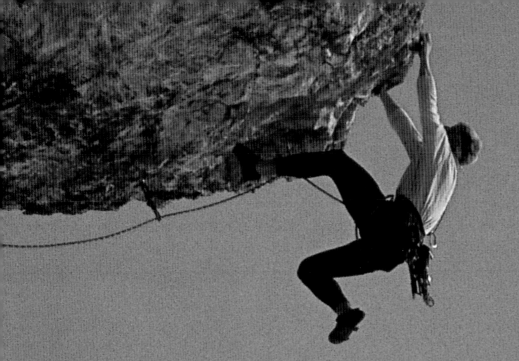

SOUVENIRS FROM HIGH PLACES

JOE BENSEN

THE
MOUNTAINEERS

This book is dedicated, with love and respect, to Julia Bensen,
a paragon of intelligence, sensibility, and patience.

Souvenirs from High Places

Published in North America by

The Mountaineers
1001 SW Klickitat Way, Suite 201
Seattle, WA 98134

First published in 1998 by Mitchell Beazley,
an imprint of Reed Consumer Books Limited
Michelin House, 81 Fulham Road, London SW3 6RB

ISBN 0-89886-598-0 (North America)

Library of Congress Cataloging-in-Publication Data
A catalog record for this book is available at the Library of Congress

Executive Editor **Samantha Ward-Dutton**
Executive Art Editor **Emma Boys**
Editor **Jane Royston**
Senior Art Editor **Paul Drayson**
Production **Rachel Lynch**

Set in Bembo and Trajan
Produced by Toppan Printing Co (HK) Ltd
Printed and bound in China

HALF-TITLE PAGE *Der Dachstein von Blassen bei Hallstatt* (anonymous, 1825).

TITLE PAGE Heinz Müller working on his project, "Extasy" (Robert Bösch).

CONTENTS The Duke of the Abruzzi and guides on Chogolisa Glacier, Karakoram (Vittorio Sella, 1909).

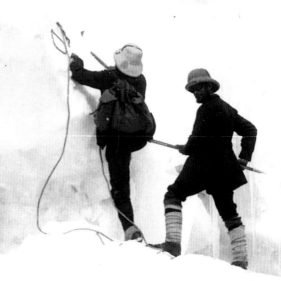

CONTENTS

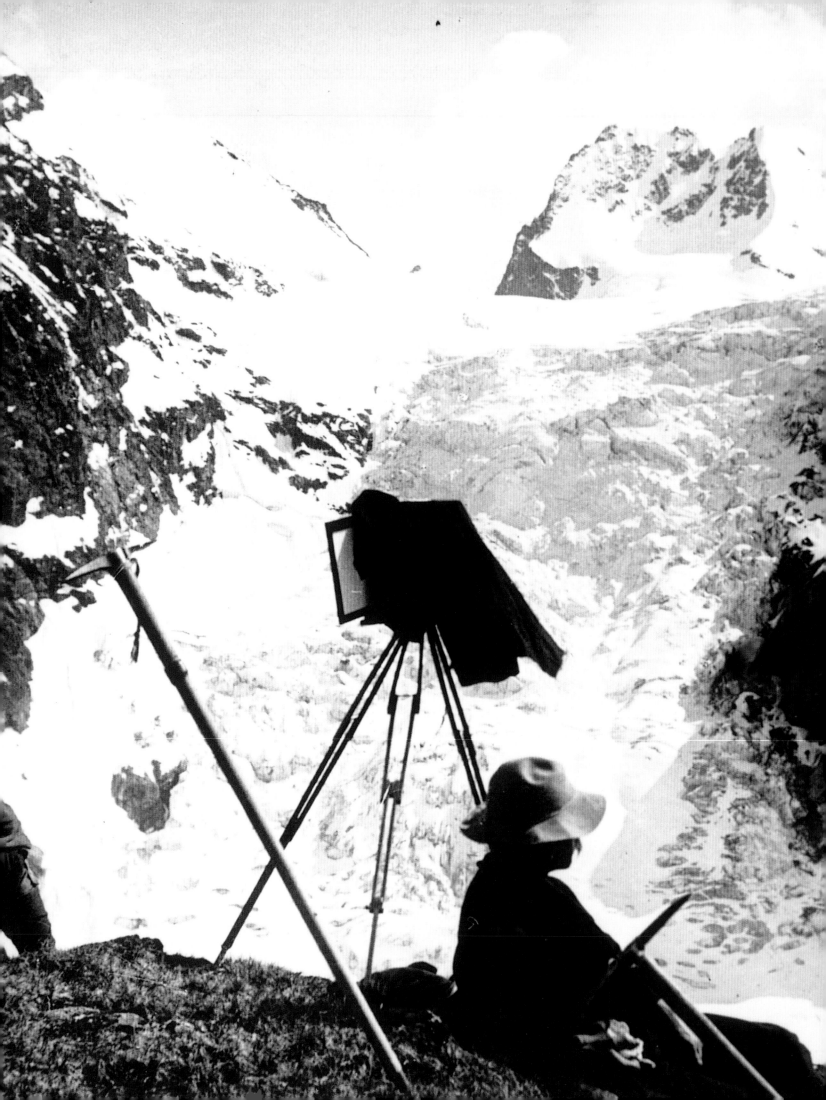

INTRODUCTION

Every climber is a tourist in the mountains. No matter how seriously the sport is taken, what climbers do is for enjoyment, and as an escape from day-to-day life.

WHY CLIMBERS TAKE PHOTOGRAPHS

Tourists have always defined their experiences by means of the souvenirs they collect, and mountaineers are no exception. They bring home from climbing trips all manner of mementoes: pieces of rock, wildflowers – even ancient pitons found rusted in crevices. No souvenir of this kind, however, has the power to recall an event, a place, or an experience as clearly as does a photograph.

For a climber, mountains are not simply places of great beauty to admire from below; they represent the high arena, or playing field, upon which feats of athleticism, strategy, and daring are performed. These feats may vary in their levels of danger and difficulty, but they are always highly personal. The mountain experience is very much an active, participatory affair.

This was perhaps the chief reason why, as soon as photographic technology permitted, climbers began to turn their cameras away from studies of the mountain landscape, as a subject in its own right, in order to focus on recording human activity in that landscape. It is through these images, together with the artists' sketches of mountain activity that preceded them, that we are able today to reconstruct the history of the pictorial representation of climbing, in all its various forms.

It is due to more than mere circumstance that early developments in the sport of mountaineering, and in the art (or science) of photography, reveal many parallels. Both activities were encouraged by increases in leisure activity brought about by the Industrial

LEFT The equipment and methods used by climber-photographers in successive eras explain much about why photographs considered state-of-the-art for their time now appear so different. A comparison of techniques used by the Abraham brothers (whose awkward view camera is seen here in 1890; see also pages 60–61) and of today's sport-climbing photographers (an example is shown overleaf, right) reveals two entirely dissimilar pursuits.

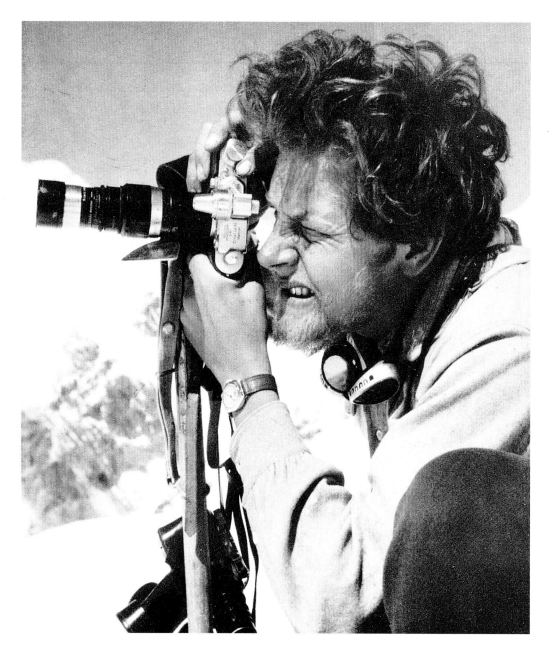

ABOVE Bridging the gap between old and new: the technique and photographic equipment of Ludwig Schmaderer – shown here on Nanga Parbat in the Himalayas in 1934 – seem relatively modern.

RIGHT The photographic style today: Robert Bösch captures Alain Robert in action during a solo climb in the Verdon (1997).

Revolution, and both had distinct links with the 19th-century philosophy of Determinism, in striving to comprehend – and ultimately to control – the physical world.

Mountaineering and photography first came to public notice and steadily grew in popularity during the same period. Apart from the activities of a few very early proto-alpinists (radical visionaries who entertained the odd notion of climbing mountains just for the pleasure of the experience), the first ascent of Mont Blanc in 1786 is usually taken as the inauguration of mountaineering as a sport.

Furthermore, although mountain pursuits had been recorded in sketch and painting form since the 18th century, the "birth" of photography in around 1827 (see page 35) meant that climbing activity could be recorded with an authenticity never seen before.

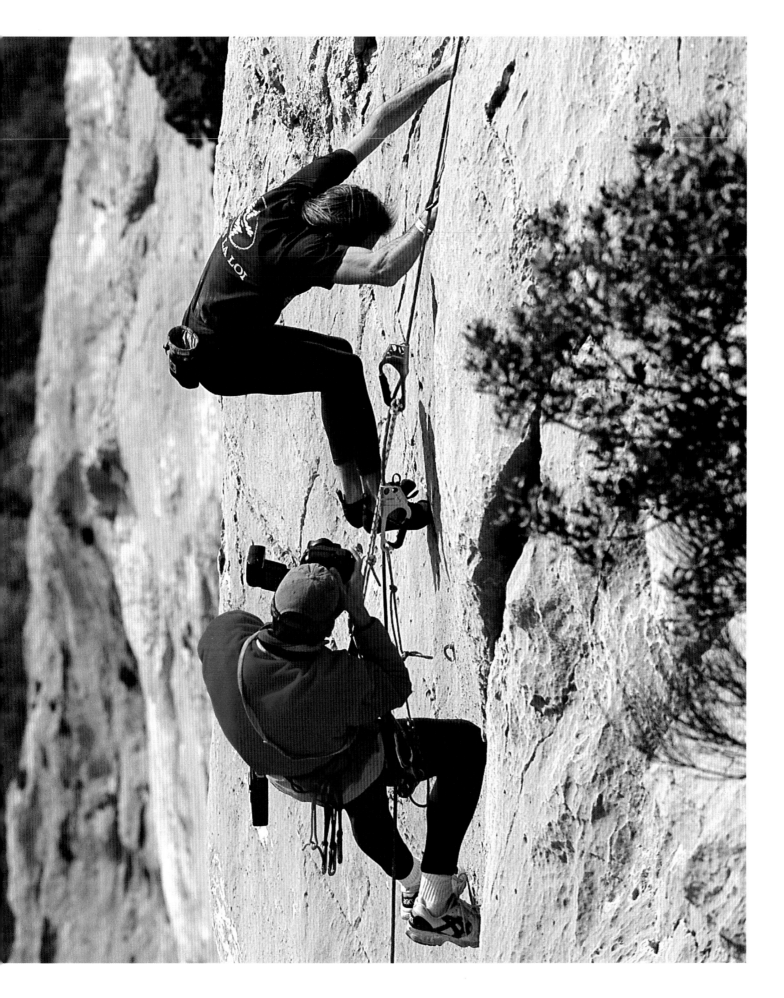

VISUAL RECORDS OF CLIMBING

Photographic history is, to a great extent, the history of interaction between emerging technologies and a consumer public. In the case of mountaineering photography, the latter meant a climbing public, whose members had specific interests both in the grandeur of high places and in creating a record of their personal accomplishments.

The so-called "Golden Age" of pioneer climbing and conquest in the Alps, from the mid-1850s to the mid-1860s (see pages 29–30), coincided fairly closely with the great photographic discoveries of the period. From the mid-19th century onwards there was a public demand for photographic equipment that was cheaper, more compact, and easier to use. This consumer demand has always been pronounced among travellers wishing to record their experiences, and most of all among mountain travellers. The resulting technical advances in photography, combined with the opening up of climbing to a broader spectrum of society, allowed for a proliferation of climbing images and for a marked alteration in their character.

The single most significant change in photographs made of and by climbers over the past 125 years lies in their sense of immediacy. This "focusing in" on climbing action has mirrored the inexorable trend towards greater challenges in tackling routes of more extreme drama and difficulty, both on rocky crags and in the high mountains.

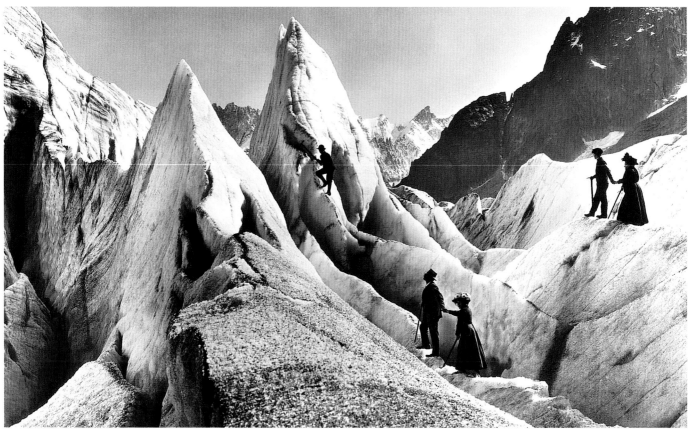

Developments in climbing and photography allowed for the gradual democratization of both activities so that, as more people climbed, more pictures – and from a broader range of often exotic locations – were made; these images in turn sparked greater interest in climbing and expedition activity. In this way, a very important symbiotic relationship has always existed between the two leisure pursuits.

Mountaineering photography, as a record both of expedition endeavours in the high mountains and of gymnastic cliff-climbing, represents some of the most spectacular imagery in the entire field of photography. Part sports and part landscape photography, it combines the dramatic visual elements of one of the most exciting of all recreational activities, played out in some of the world's most extraordinary and beautiful landscapes.

THE ROLE OF PHOTOGRAPHY

This book traces the history of a specific photographic genre. In a very visual sense it is also a history of mountaineering, for within this record of mountain imagery through the ages a great deal is revealed of climbing's image over the years: of climbing styles and fashion, of the society of climbers, and, not least, of the tremendous sense of personal physical accomplishment that has always stood at the very heart of the sport.

The vast majority of the images collected in this book were made by climbers, as a record of activities with which they were associated. This element of direct involvement is perhaps the main difference between climbing photography and many of the more

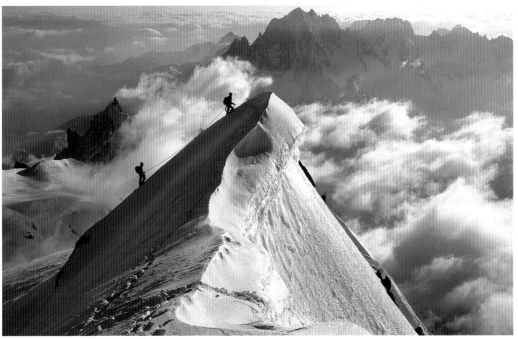

Photographs taken by members of the Tairraz family: Joseph (1827–1902), Georges Sr (1868–1924), Georges Jr (1900–75), and Pierre (b. 1933). Over four generations, this remarkable Chamonix family has maintained a tradition whose roots trace back to the very earliest days of climbing photography. Within their work, a progression can be seen from the most antique form to the full realization of modern work.
OPPOSITE, ABOVE *"The Junction" at the Glacier des Bossons, Mont Blanc* (Joseph Tairraz, *c.* 1885).
OPPOSITE, BELOW *Tourists on the Mer de Glace* (Georges Tairraz Sr, *c.* 1910).
ABOVE LEFT *Traverse of the Courtes, Mont Blanc* (Georges Tairraz Jr, 1926).
LEFT *The north ridge of Mont Blanc du Tacul* (Pierre Tairraz, 1977).

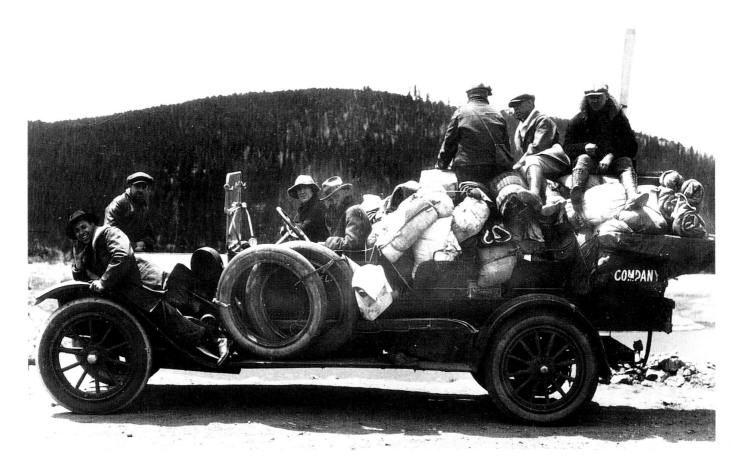

popular forms of sports photography. Just as in sailing, hunting, and fishing, most of the accomplished mountaineering photographers have been participants themselves. Many of these images will be familiar to readers of climbing literature, while others have until now been buried in Alpine-Club libraries and private collections.

There are many talented photographers, past and present, whose work could not be included here. No claim is made of having collected the finest images ever created of mountaineering activity, but the work shown is highly representative of the styles and subjects of mountaineering image-making in different eras.

There is a wealth of information present in these pictures: of times gone by, of great achievements, and of the preoccupations of climbers and photographers working at different periods in history. Much has changed in mountaineering since the first pioneers ventured on to the high Alpine glaciers and ridges – and yet, for the modern observer looking back, it may be surprising how much has actually remained the same.

In every period of climbing history, there have been individual photographers who stand out in terms of the quality of their work and reputation among their peers. It was true in the 19th century and, as the ranks of amateur and professional photographers swelled, it became even more evident as the 20th century progressed.

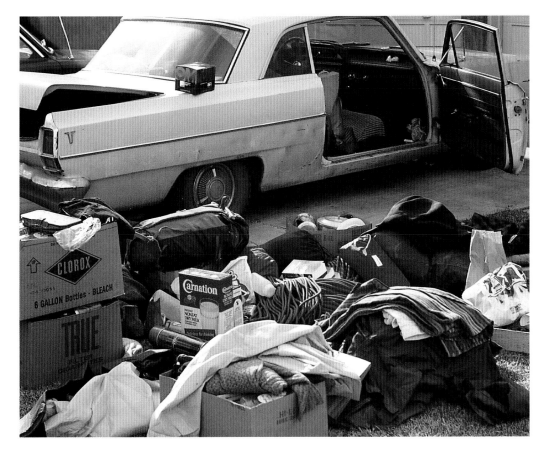

This book recognizes the work of some of the acknowledged great masters of mountaineering picture-making – images that represent the highest state of the pictorial climbing art through successive eras. Unlike the histories of photography that may limit themselves to great works and outstanding individual achievements, however, this is also the story of photographs taken over the years by the many thousands of ordinary citizen climbers who form the real backbone of the sport.

We certainly cannot help but admire the masterful work of famous photographers such as Vittorio Sella, the Abraham brothers, and the four generations of the Tairraz family, and we look forward to being dazzled by the latest published pictures of contemporary professional photographers. Yet it may be convincingly argued that the most important of all climbing photography continues to be the souvenirs brought home by legions of amateurs, for the sole purpose of reliving their moments of mountain pleasure.

Today it would be almost inconceivable for a climber to venture into the mountains without memorializing the occasion with photographs. Through these pictorial souvenirs, all the exquisite moments, great and small – from the beauty of sun-warmed vertical rock to the intimate bond of the rope – can evoke for us all the magic of the world's high places.

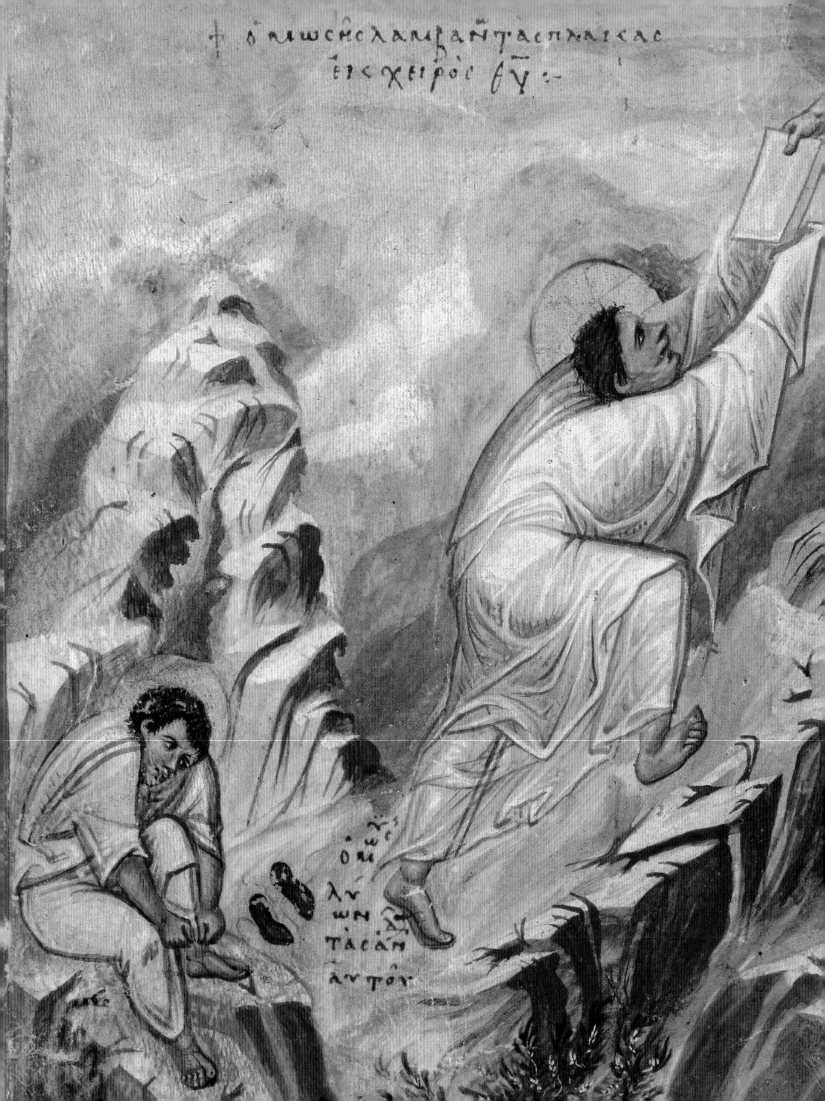

† ὁ ΜΩΣΗΣ ΛΑΜΒΑΝ͞ΤΑΣ ΠΛΑΚΑΣ
ΕΙϹ ΧΕΙΡΟϹ θ͞Υ :-

ο͞ς
ὁ ΜΩ
ΛΥ
ΩΝ Δ
ΤΑϹ ΑΝ
ΑΥΤΟΝ

THE EARLY VISUAL RECORDS OF CLIMBING

Long before the birth of climbing as a sport, or of photography as a medium with which to record it, people memorialized their mountain adventures.

THE FIRST MOUNTAIN ACTIVITY

Recreational pursuits were seldom associated with the mountains until about 200 years ago, but humans have for centuries worked in the high places and, perhaps more significantly, have also worshipped there. Since before recorded history, mountains have been places of wonder and awe, and have been revered as the source of supreme spiritual power. The ancient gods dwelled there, and people knew that this was where the rains came from, giving life to the earth.

It is small wonder, then, that from the earliest days artists have viewed mountains as a fount of inspiration, even though little was known about them until the dawning of the Age of Enlightenment. Mountains were viewed not only as mysterious but also as a little ominous, and any human presence was generally limited to the summer grazing of animals, to hunting forays made by adventurous Nimrods, and to travel by those intent on taking the shortest distance between points (usually for military or mercantile purposes).

In short, mountain activity was almost entirely utilitarian. The first representations of human involvement focused on these practical matters, as well as, of course, on the mythological and Biblical.

FAR LEFT Detail from *Moses receiving the Ten Commandments on the summit of Mount Sinai* (the full image is shown **LEFT**). As well as its obvious purpose of depicting an important religious event, this beautiful page from the Bible of the Patriarche Leon (5th century AD) provides a remarkable very early representation of a human form in climbing posture.

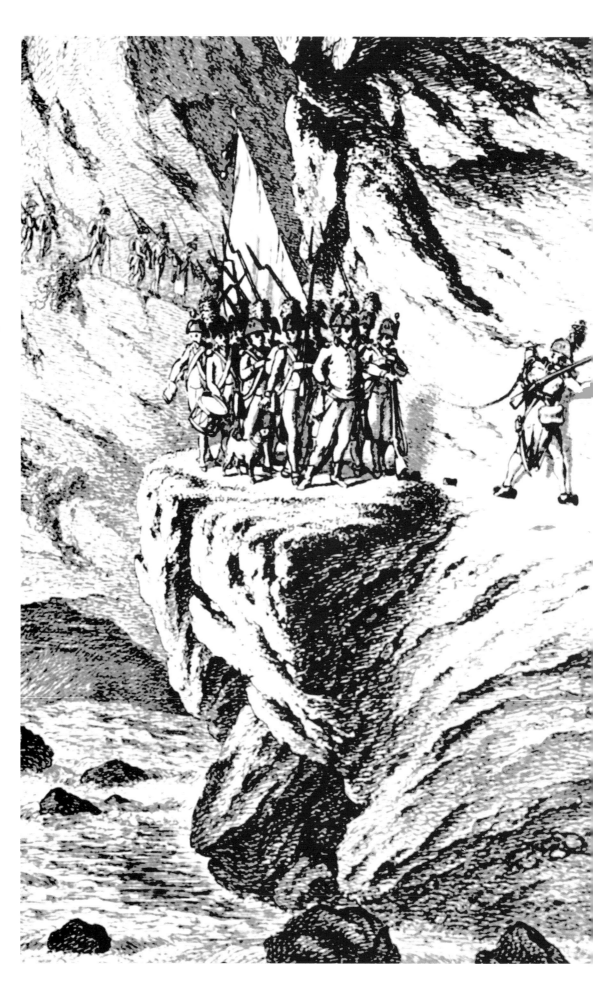

RIGHT *Traverse of the Simplon Pass by a battalion of Napoleon's Army* (F N Konig, 1800). It may not be recreational climbing, but this French soldier is clearly leading out on a traverse. The image also demonstrates the considerable difficulties involved in moving troops through the Alps.

OPPOSITE, ABOVE AND BELOW Two woodcuts from *Theuerdank*, the account of the adventures of German Emperor Maximilian I (attrib. Leonard Beck, 1515). In the top picture, Theuerdank is shown using his "climbing irons" (crampons). These images are, in concept, not unlike the thousands of climbing photographs brought back as souvenirs from the mountains every year by today's recreationalists.

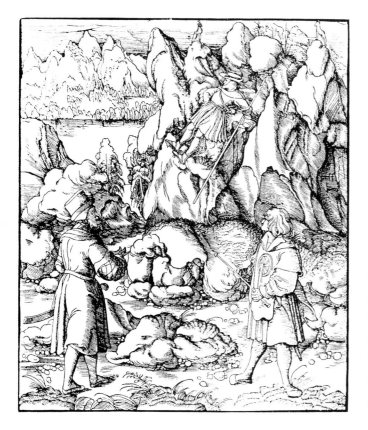

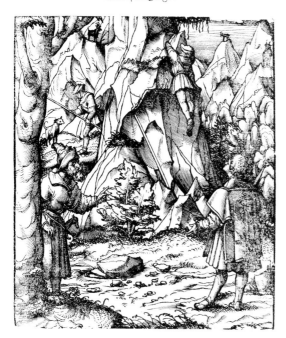

Die XXII. Figur.

Eine andere Gefährligkeit/darein

Fürwitz den Edlen Theurdanck führt/ auf einer
Gemsen Jagt.

JN Oesterreich ob der Ens/kam Er abermahls in einem
Gemsen steigen in Gefahr/ von wegen deß Schnees/so
sich zwischen den Fuß-Eysen geballet hatte/ also/ daß Er sich
nirgend anhalten könte/ und gar nahe zu todt gefallen wäre;
Aber GOtt half Ihme wieder glücklich darvon.

Early records of a human presence in the mountains are scarce not only because there was very little organized activity in the high places, but also because mountains played such a minor role in the history of Western art right up until the end of the 19th century. Indeed, landscape of any description was not generally considered a proper or worthwhile subject for depiction until the latter part of the 18th century; prior to this, it was primarily employed as a background device, in particular for religious scenes.

A few of the northern Italian painters working in the 15th and 16th centuries used distant mountains as backgrounds for their paintings – most notably Leonardo da Vinci (1452–1519), whose personal interest in mountains reportedly included the ascent of at least one outlying peak of Monte Rosa in the Alps; and Titian (Tiziano Vecellio, 1477–1576), who was born in the Dolomites. Early Chinese painters were considerably quicker than most of their European counterparts to comprehend the evocative nature of mountain forms and weather, and who used a specific term, *Shan-Shui* ("mountain and water"), to describe landscape.

An important distinction may be drawn between "mountain" art and "mountaineering" art: the first is a form of landscape painting, while the second – although typically set in a landscape context – is a means of depicting a pursuit. In addition to mountains appearing in landscape paintings, occasional early examples of climbing-related illustration do exist, dating back to the Renaissance.

As early as the beginning of the 16th century, the German Emperor Maximilian I (1459–1519) commissioned a trio of artists to make woodblock prints memorializing his adventures in the Alps (two examples are shown above left and left). The book in which the resulting 100 illustrations appeared, entitled *Theuerdank* (probably a term of religious gratitude), was printed in six editions between 1517 and 1679. Maximilian's highly stylized souvenir pictures from his Alpine exploits show for perhaps the first time equipment and techniques that would become central to the (as yet uninvented) sport of climbing. To view these images four centuries later, one might wonder how different they are – conceptually, at least – from photographs taken every year by today's mountain recreationalists.

Theuerdank represents one of the earliest examples of personal souvenir images from the mountains being collected and presented to the public (even though there must certainly be some question as to what "the public" meant in the largely illiterate 16th century). In a sense, the book may be viewed as the primogenitor of a long

tradition in adventure literature: a steady progression that passed from Maximilian through Edward Whymper and Frank Smythe (see pages 26–30 and 87–8), and on to the professional mountaineering photo-journalists of today. Shortly after the first publication of *Theuerdank*, Josias Simler, a Swiss naturalist and leader of an early cult of mountain enthusiasts, published *De Alpibus Commentarius*. This instruction manual on travel in the mountains, complete with woodcuts demonstrating the use of the rope and alpenstock, was one of the first books to deal with purposeful human activity in the Alps. It would be another two centuries, however, before scaling mountain peaks for recreation would have any real public appeal.

SCIENTIFIC AND PLEASURE EXPLORATION

By the 18th century, a combination of enlightened philosophical mood and increasingly ambitious scientific inquiry created an atmosphere in Europe that was highly conducive to exploration and discovery. This growth of curiosity about the world united with the demands and fruits of the Industrial Revolution (such as increased leisure time) to ensure great activity in the fairly convenient Alps.

Philosophers and scientists – at that time often one and the same – focused their attention on a range of Alpine phenomena. They studied glaciology, meteorology, and flora and fauna, and the published accounts of their explorations and adventures sparked a considerable public interest in the mountains. It was then a relatively small step forward from examining natural phenomena for scientific reasons to mountain exploration for its own sake. From the time of the landmark ascent of Mont Blanc – the highest peak in Europe – on 8 August 1786, climbing was to grow both in popularity and in technical sophistication.

Thanks to the Industrial Revolution, there developed in Britain and continental Europe, in addition to the wealthy leisured class, a professional class with the time and economic means to roam the world. Travelling for pleasure, in what came to be described as tourism, developed into a new industry, and the facilitation of travel encouraged more ambitious excursions in the Alps. In turn, centres for Alpine tourism sprang up in areas such as Chamonix and Zermatt, together with hotels to accommodate the holidaymakers and a growing local force of mountain guides and porters.

Participation in hobbies (many of which were directly linked to scientific pursuits) and in sports was also growing in popularity. The British in particular took a keen interest in games of all kinds, and the new fascination with climbing to summits in the Alps simply for

Two stages in the ascent of Mont Blanc (engravings by George Baxter, chronicling John MacGregor's ascent of 1855). These are purely souvenir images of mountain sport, with no pretence made of climbing for any reason beyond reaching the summit, and thus revealing the second impulse behind the great progress made in mountaineering during the early 19th century. In the top picture, the climbers celebrate their arrival at the summit with champagne; the lower picture shows the Mur de la Côte.

LEFT The frontispiece from *Naturhistorische Alpenreise* (*Natural History Travels to the Alps*, 1830). This imaginative depiction of an expedition led by Swiss geologist Franz Joseph Hugi represents the long tradition of climbing primarily for scientific research. Hugi and his party are shown tackling a wall of the Bärenwand, in order to reach the foot of the Jungfrau in Switzerland.

fun seemed just the right sort of physical challenge for the vigorous British gentleman. These early climbers had little in the way of specialized equipment, and dressed much like other travellers.

The written and visual records of early mountain-sports activity do indicate, however, that during the first half of the 19th century most really ambitious Alpine feats were by local European climbers. In this new sport, the pattern that developed was one of first ascents for the more daring proto-alpinists, and of guided walk-ups on well-known peaks for the more pedestrian mountain tourists.

THE INFLUENCE OF THE ROMANTICS

Alongside the increased scientific and leisure activity in the Alps during the 18th and 19th centuries, a corresponding interest was building among poets and artists. Mountains were by this time appreciated not merely for their physical form and beauty (qualities that had made them suitable backgrounds for paintings in the past), but also for a certain spiritual strength that they represented.

The emergence of the Romantic movement in literature and in the arts finally brought mountains to centre stage, and the German artist Caspar David Friedrich (1774–1840), and British painters J R Cozens (1752–99) and J M W Turner (1775–1851), were among the first to make them the subject of their paintings. Friedrich's evocative masterpiece *Wanderer above the Sea of Fog* (1818; see opposite) clearly exhibits this new awareness of the spiritual quality and experience of the high places. The subject's

posture on the mountain top suggests a heroic communion of human being and nature, and is a convention that can be seen repeated on the pages of souvenir photograph albums put together by mountaineers throughout the history of the sport.

The British artist and critic John Ruskin (1819–1900) was an early member of the Alpine Club of Britain (founded in 1857). His work had an especially profound impact on the aesthetic values of the 19th and 20th centuries, particularly in relation to the way in which artists looked at and interpreted the Alps.

Through the medium of his paintings and sketches, and, more importantly, in his writing, Ruskin declaimed the wonders of the Alpine landscape, and of its weather and light. In his influential book, *Modern Painters*, he even went so far as to express his hopes that Alpine scenery might be treated as a link between heaven and earth. His contribution to mountain depiction also included early photography of the Matterhorn (see page 36).

Ruskin was evidently not interested in the Alps for anything other than aesthetic reasons, however. Just as his predecessors (including Turner, his favourite artist) had done, he preferred to sketch his mountains from a distance, maintaining that they always looked their best when viewed from below.

In the meantime, adherents of the new sport began to record their own mountain experiences. Since perhaps no other recreational activity is so closely tied to an appreciation of the landscape, it should not seem surprising that, from the very beginnings of

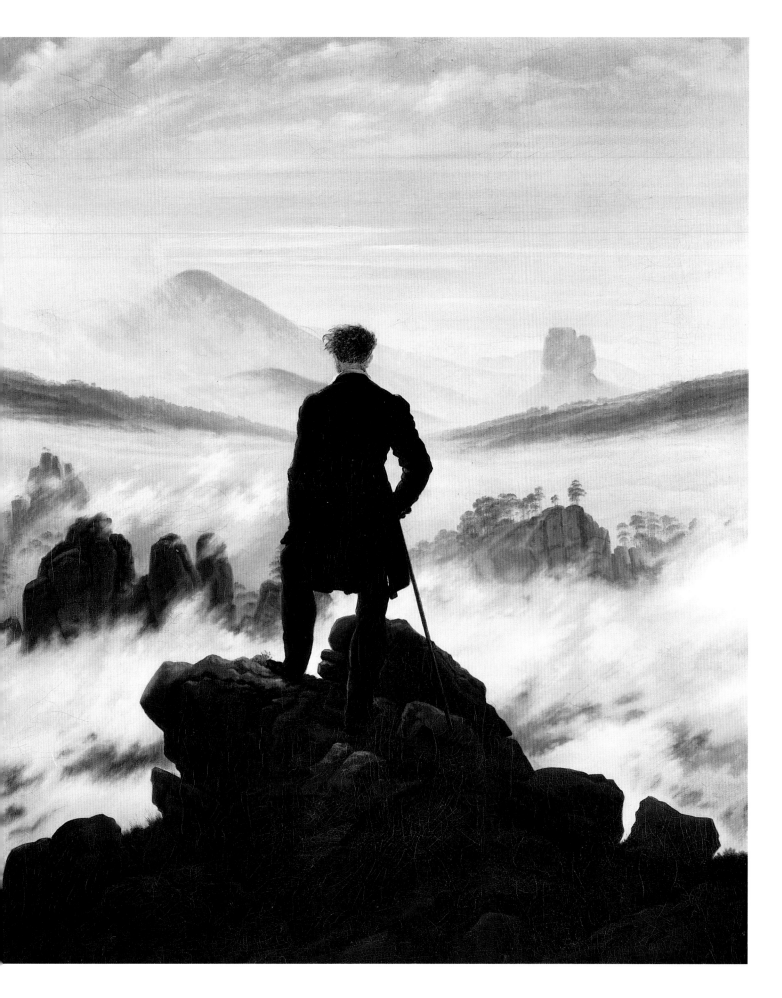

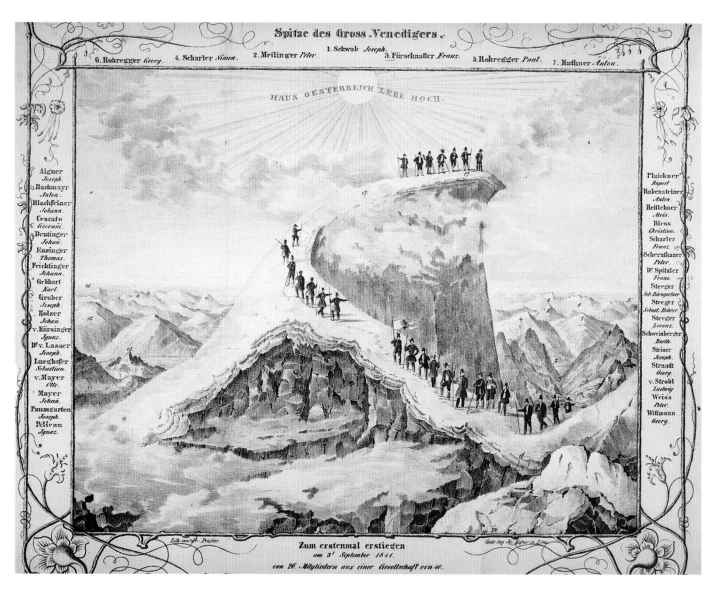

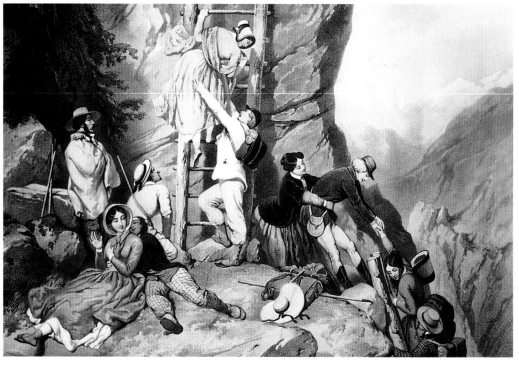

ABOVE *Spitze des Gross Venedigers* ("Summit of Gross Venediger"; Franz Pracher, 1843). The image commemorates the first ascent of this important Austrian mountain, made on 3 September 1841 with a party of no fewer than 39 people.

RIGHT *Der leiterweg bei albinen* ("The way of the ladders"; lithograph by Eugène Guérard, 1850). Reproductions of scenes such as this were often referred to as "Swiss prints". They became very popular souvenirs among tourists who, by the mid-19th century, were flocking to the Alps each summer.

OPPOSITE *Aufstieg vom Faulhorn* ("Descent from the Faulhorn"; lithograph by Eugène Guérard, 1850).

climbing, its participants have frequently taken up sketching or painting as a means of souvenir recording, or simply because they have appreciated the beauty of the mountains. Several of the more ambitious painters of mountain landscapes were also gifted climbers.

ADVANCES IN MOUNTAIN DEPICTION

By the mid-19th century, mountaineering as a recreational activity had come entirely into its own. Although not yet embraced by a mass public (it was, after all, still an élitist pursuit available only to those with time and money), the sport had not only been accepted as worthwhile but was looked upon with a certain admiration.

At this juncture a new school of Swiss genre painting developed, in which the rapidly expanding mountain-tourism trade was celebrated in the most delightful fashion. In a departure from earlier idyllic Swiss representations of pastoral mountain folk tending their herds, or engaged in folk ceremonies and surrounded by glorious Alpine scenery, artists such as Eugène Guérard (1821–66) painted images depicting the recreational, lighter-hearted aspect of mountain life (see opposite, below; and below).

Another movement began when certain artist-alpinists began to climb up out of the valleys specifically in order to capture mountain scenes on canvas. Edward T Coleman, for instance, one of the founding members of Britain's Alpine Club, made several painting expeditions in the vicinity of Mont Blanc, twice reaching the summit. Elijah Walton (1832–80), considered perhaps the finest mountain artist of the period, was said to be a first-rate climber and was also a member of the Alpine Club. These painters were finally becoming involved with their subject, and were starting to understand the nature of mountains as only true climbers can do.

An interesting progression can thus be traced in the history of mountain representation. Mountains began as backgrounds for scenes first of religious and then of pastoral activity; painters such as Turner, Friedrich, and Ruskin then made them the central focus; and, finally, the mountain landscape receded into the background once again, but this time as a context for the new recreational activity of climbing. From this point onwards mountaineering art can be viewed as a distinct genre, entirely separate from depictions of the landscape in its focus on human activity and on all the incidentals of mountaineering such as equipment and climbing huts.

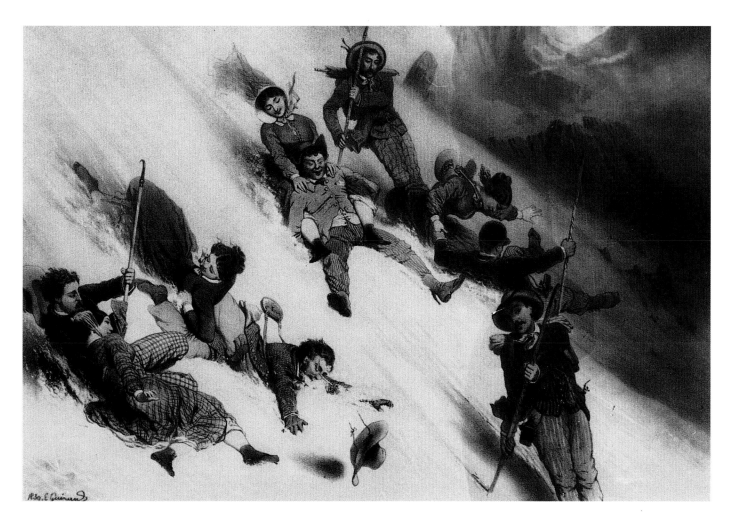

ARC DE TRIOMPHE.

NOTRE DAME.

DUNGEON OF CHILLON.

BOURSE.

14.

13.

MER DE GLACE

SOURCE OF THE ARVEIRON

PALAIS ROYAL.

12.

35.

34.

BATHS OF ST GERVAIS.

11.

LAST SLIDE BACKWARDS.

33.

PARIS STATION.

COURT YARD OF THE HÔTEL.

10.

MUR DE LA CÔTE.

32.

48.

47.

STREET OF CHAMOUNI.

9.

AMIENS.

46.

31.

A SICK TRAVELLER.

30.

VALLEY OF CHAMOUNI.

8.

BOULOGNE STATION.

RAND PLATEAU.

29.

7.

28.

THE TETE NOIRE.

6.

GRAND RUE, BOULOGNE.

ST BERNARD DOGS.

5.

BOULOGNE CUSTOM HOUSE.

4.

ONE.

CROSSING THE CHANNEL.

DOVER.

OF MONT BLANC.

FROM C. ADLER's PRINTING ESTABLISHMENT HAMBURG

LEFT The mountaineer Albert Smith regaled London audiences for six years with his immensely well-received illustrated lectures on Mont Blanc; the evening entertainments became so popular that they inspired this delightful board game, produced c. 1850. After the first successful ascent of Mont Blanc in 1786 – the culmination of quarter of a century of effort – hundreds of people went on to climb it in the 19th century, most of them via a typical tourist ascent of the trade route.

In the 19th century there were several well-known mountain artists at work who specialized in sketches for commercial reproduction. Some were true mountaineer-artists, and as interested in the activity of climbing as they were in the grandeur of mountain landscapes. By the middle of the century photography had become established as an important visual form, yet it did not immediately supersede painting and sketching as the primary means of communicating information about mountains and mountain activity.

During the latter half of the 19th century, the mountain artists had a real impact on the public perception and acceptance of mountain sport; their work was also in demand to illustrate the many popular books starting to be published on the Alps, as well as the journals of the national Alpine Clubs. Today, these images are an important record of activity in the great pioneer era of mountaineering.

Sketches remained the chief source of illustration for the early journals and books on mountain subjects until almost the end of the century. This was for the same basic reason that the commercial sketch artists of the period continued to supply the illustrated press with most of its pictorial reporting: namely, that the printing processes could not reproduce photographs directly on the page. Until the introduction of the halftone process in the mid-1880s (see page 51), all images – including photographs – had to be rendered as engravings before being mass-reproduced. As a result, although there was a real attraction in the claim of "truthfulness" attached to photographs, and in their high-tech novelty, there was no great advantage to publishers in working from photographic prints.

Early camera equipment was also very slow and cumbersome, and was incapable of recording low-light or action scenes. Since photographers could therefore only produce static "views", the sketch artists (who can properly be called "illustrators") maintained their status even after the first appearance of photographs in the *Alpine Journal* (1880–82; the journal came out every two years at first) and in the journal of the German Alpine Club (1881).

The greatest of the 19th-century mountaineering illustrators – in terms of the pictorial record he produced and of his impact on the sport – was Edward Whymper (1840–1911), the conqueror of the Matterhorn (see pages 29–30). Whymper was not an artist in the fine-arts tradition, and was certainly not a landscape artist. His forte lay in capturing climbing action and fine detail, including not only the climbers but climbing paraphernalia and rock stratification – the types of features a climber would notice and care about.

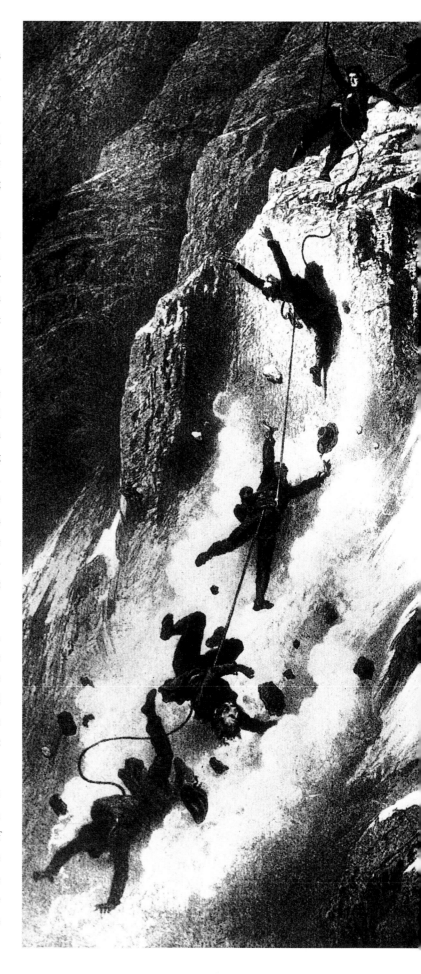

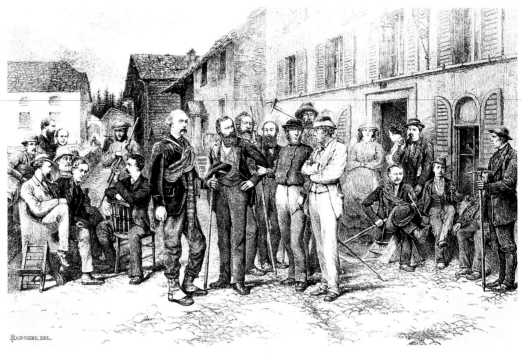

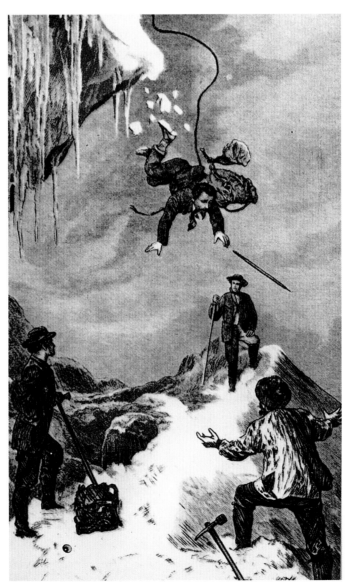

FAR LEFT *The Matterhorn disaster* (lithograph from Heinitzer's *Climbing the Alps in Pictures*, 1865). The picture was drawn by Paul Gustave Doré and printed by Eugène Cicéri, two great illustrators of the day. The tragedy on the Matterhorn – the most sensational of 19th-century mountain disasters – was the subject of much artistic and dramatic portrayal.

ABOVE *The Club Room at Zermatt* (J Mahoney, 1864; engraved from a sketch by Edward Whymper). This composite image commemorating some great figures of the era – including John Tyndall, John Ball, Leslie Stephens, A W Moore, Alfred Wills, and Lucy Walker – is a distinct type of souvenir picture, very like the organized team-sports photographs of today. For pioneer climbers of the time, inclusion in the portrait would have been seen as a great honour.

LEFT *Reynaud falling from a bergschrund* (Edward Whymper, *c.* 1865). Whymper was renowned for his portrayal of climbing action, of which this sketch is a typical example.

RIGHT AND OPPOSITE Two murals based on the Matterhorn disaster (Ferdinand Hodler, 1894). Shown here are *The Ascent* (right, far right, and below left) and *The Plunge* (below right and opposite page). Hodler, a Swiss artist (1853–1918), was well known for his monumental paintings of historical events. Note that he has the climbers dressed more in the style of the 1890s – when he produced the murals – than of the 1860s when these events actually took place.

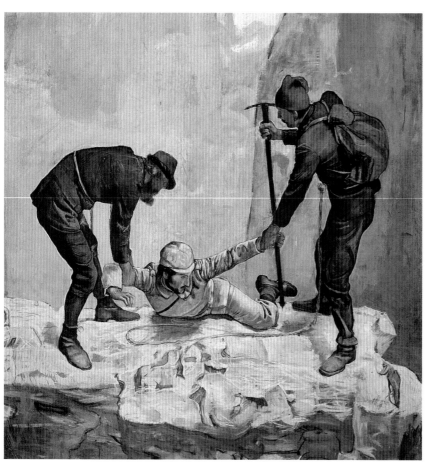

In 1860 William Longman, the London publisher, despatched Whymper – then 20 years old – to the Alps to collect sketches for Longman's growing trade in mountain books. This marked the start of Whymper's development into a true pictorial reporter of the high-mountain climbing scene, and he went on to illustrate several of his own books. In all, he spent almost five decades climbing and sketching throughout the world, and remains one of the towering figures in the history of the sport.

THE "GOLDEN AGE" OF MOUNTAINEERING

The period from the mid-1850s to the mid-1860s is popularly known as the "Golden Age" of Alpine mountaineering. Prior to 1854, the groundwork had been laid for what would become the single greatest concentration of pioneer climbing activity either before or since. The Alps had, by this time, been fully explored and the most attractive climbing objectives identified. Transport improvements made access easier, and an efficient mountaineering infrastructure had also been developed throughout the new Alpine centres, with knowledgeable local guides and comfortable accommodation available for climbers in the villages. The scene was now set for a full-scale assault on the remaining unclimbed summits.

Prior to this key period in mountaineering history, the main peaks of the Alps had been won only slowly, with perhaps one successful new ascent every few years. For the next 10 years, however, the peaks were conquered at the rate of two or three per year. Between 1863 and 1865 there were almost 100 first ascents, with the watershed year of 1865 witnessing no fewer than seven first ascents of peaks over 4,000 m (13,100 ft). By the end of that year, every 4,000-m peak in the Alps except the Meije had been climbed. The British clearly led the way in these achievements; once they had accepted the sport of mountaineering, they embraced it wholeheartedly. Although they typically relied on the help of local guides, over 75 per cent of all major climbs in the West Alps from the 1850s to the 1870s were undertaken by British amateurs, who represented the greatest force in this progressive period of Alpine climbing.

The "Golden Age" brought with it many remarkable triumphs, but also some terrible disasters. No single ascent is more symbolic of the era than the dramatic conquest of the Matterhorn, considered at the time the ultimate Alpine challenge and a summit that many thought would never be won. Edward Whymper made seven attempts on the 4,482-m (14,700-ft) peak between 1861 and 1863, before finally succeeding in 1865 with a team of three other Britons, two Swiss guides, and one French guide. The success came

at a high price, for on the way down a broken rope sent four of the climbers to their deaths. The sensational nature of this first ascent both shocked and fascinated the public. Sketches of the climb and of the disaster on the descent – made even more vivid by artists and engravers of the time – were reproduced in the popular press. In many ways, the Matterhorn triumph and tragedy established the dramatic, heroic image of alpinism that has endured to this day.

THE CONTINUED GROWTH OF CLIMBING

The 19th-century sketch artists were, in some respects, precursors of today's photo-journalists, functioning more as reporters than as salon artists. They provided the visual material used to illustrate accounts of contemporary climbs as well as the many instructional manuals and articles appearing in response to increased public interest.

Sketches by R C Woodville and H G Willink (two of which are shown opposite, above and below) would at the time have been used to demonstrate proper climbing procedure. Today they perform a completely different – although still very important – function: that of historical record. These images provide a clear impression of how the sport looked, and of how climbing was done a century ago. Yet they do more than merely provide visual data. In mountaineering (if not in high-angle rock-climbing), how much has actually changed from the days when these robust Victorians took their mountain exercise? As quaint as the images appear today, it is hard not to relate to the experiences of the climbers portrayed.

The same cannot be said of the cartoon drawing by Karl Reinhardt (right) in bringing to mind an actual experience, although it may well strike a familiar chord. This caricature also points to a critically important social phenomenon that occurred in European climbing in the second half of the 19th century: the appearance of organized clubs for climbers. The founding and rapid growth of the various national Alpine Clubs was indicative of the growing popularity of climbing from the mid-century onwards. Starting with the Alpine Club of Britain, established in 1857, climbing organizations were quickly founded in each of the major Alpine nations.

By 1890 Britain's Alpine Club boasted almost 500 members, but the growth of the continental clubs was even more dramatic. By the end of the century the combined Austrian-German club had nearly 20,000 members, the French over 5,000, the Italian 4,000, and the Swiss 3,000 members. These organizations did much to promote the growth of mountaineering, while their illustrated journals served to chronicle the continuing progress of the sport.

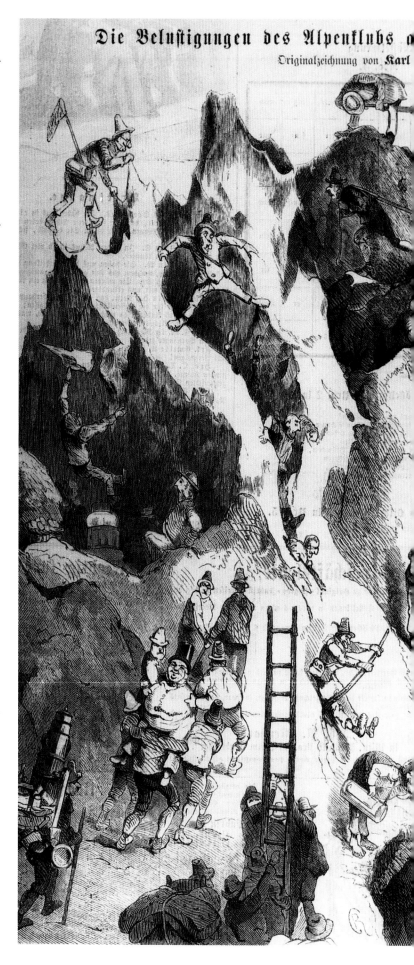

der Spitze der Jungfrau.

nhardt.

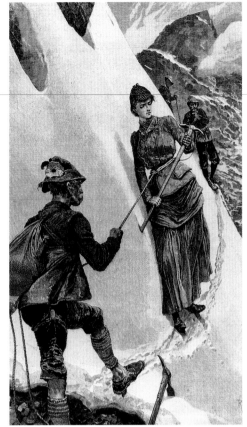

FAR LEFT *Die belustigung des Alpinklubs auf den spitze der Jungfrau* ("The amusement of the Alpine Club on the summit of the Jungfrau"; Karl Reinhardt, 1868). What is remarkable about this illustration is its early date: already, the sport had matured to a point at which climbers could poke fun at themselves.

LEFT *Climber traversing a steep slope* (R C Woodville, 1885). This quaint sketch of a woman being assisted on this traverse reveals much about basic climbing techniques of the time.

BELOW *Between the lights* (H G Willink, 1888), part of a series used to illustrate *Mountaineering*, a technical book on climbing by Clinton Dent, published in 1892.

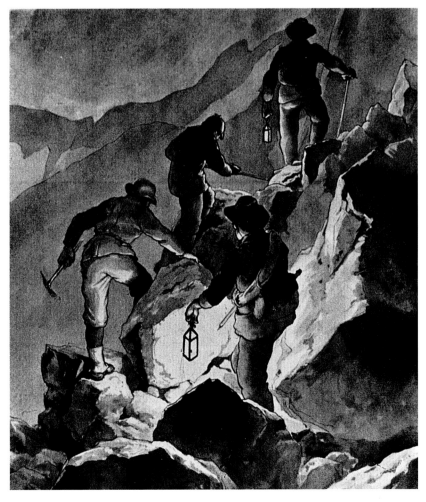

RIGHT *In den wanden uber dem Rothen Loch* ("On the precipice over the Rothen Loch"; Ernst Platz, 1896). Platz was known for producing dramatic visions, as shown here, of what would at the time have been the cutting edge of climbing experience.

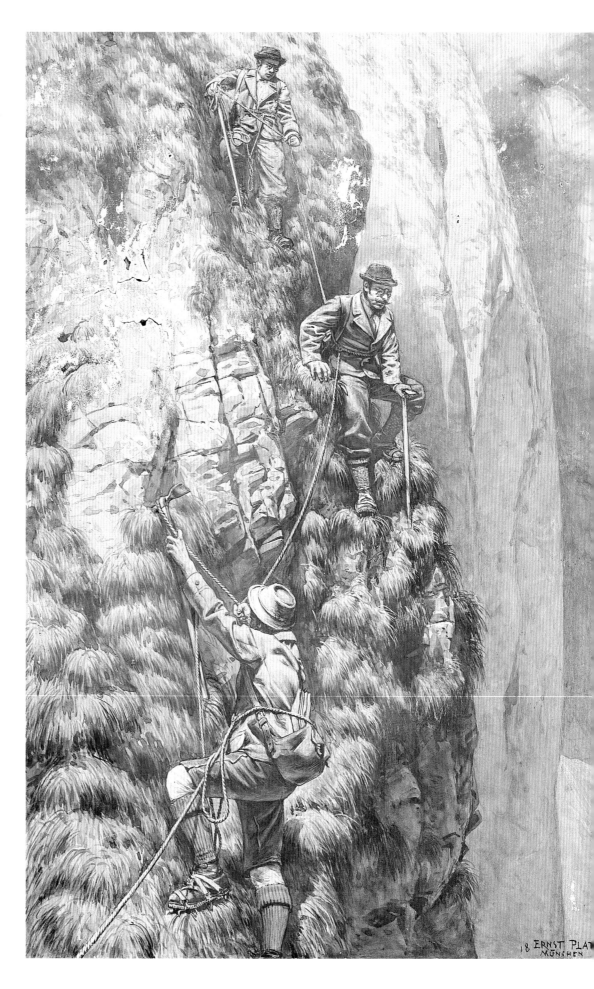

ACTION-CLIMBING ILLUSTRATION

At the end of the 19th century, British painter Edward T H Compton (1849–1921) became the unrivalled master of high-mountain painting, in a career that inextricably mixed climbing and art. Extremely adept at both, Compton was one of the first fine-artists to work in a new genre of action painting (see below). The emergence of this style represents perhaps the ultimate realization of the sport's dramatic ideals, yet these are still the images of a true climber. Most of Compton's paintings were drawn from first-hand experience, and he brought home hundreds of sketches from the Alps, Corsica, the High Tatras, the Balearic Islands, and the North Cape. A devoted mountaineer all his life, he reached Grossglockner's 3,798-m (12,460-ft) summit when he was 70 years old.

Compton's German contemporary Ernst Platz worked in a similar style, producing dramatic visions from the forefront of climbing experience (see opposite); indeed, the images of both Platz and Compton anticipate today's high-action climbing photographs. These artists recorded real mountaineering experiences, but in a way that contemporary photographers would never have been able to capture using the slow equipment and insensitive films of the day.

In these paintings it is obvious that by the close of the 19th century mountaineering had evolved far beyond the original aspirations of getting to the tops of the peaks. Climbers craved the excitement of difficult routes, and new techniques and specialized equipment were developed to meet the ever-increasing challenges of the sport.

There are still climbers today who carry their sketchpads with them in the hills, and the impact of photography on the visual arts has not completely eliminated the impulse to draw and paint mountain scenes. However, the days of using pad and pencil as the principal means of recording mountain activity passed long ago, as advances in technology made photography more practical. At this point in the story, the focus must therefore shift to photographic representation.

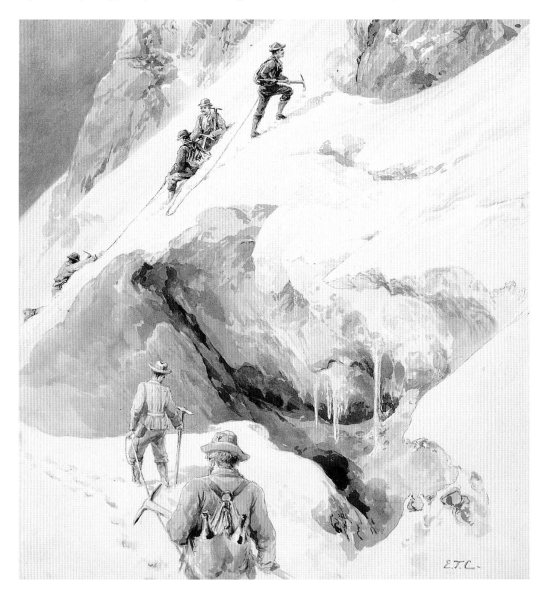

LEFT *Crossing a Bergschrund* (Edward T H Compton, 1901). In Compton's new style of action painting, the climbing activity took absolute precedence over the landscape.

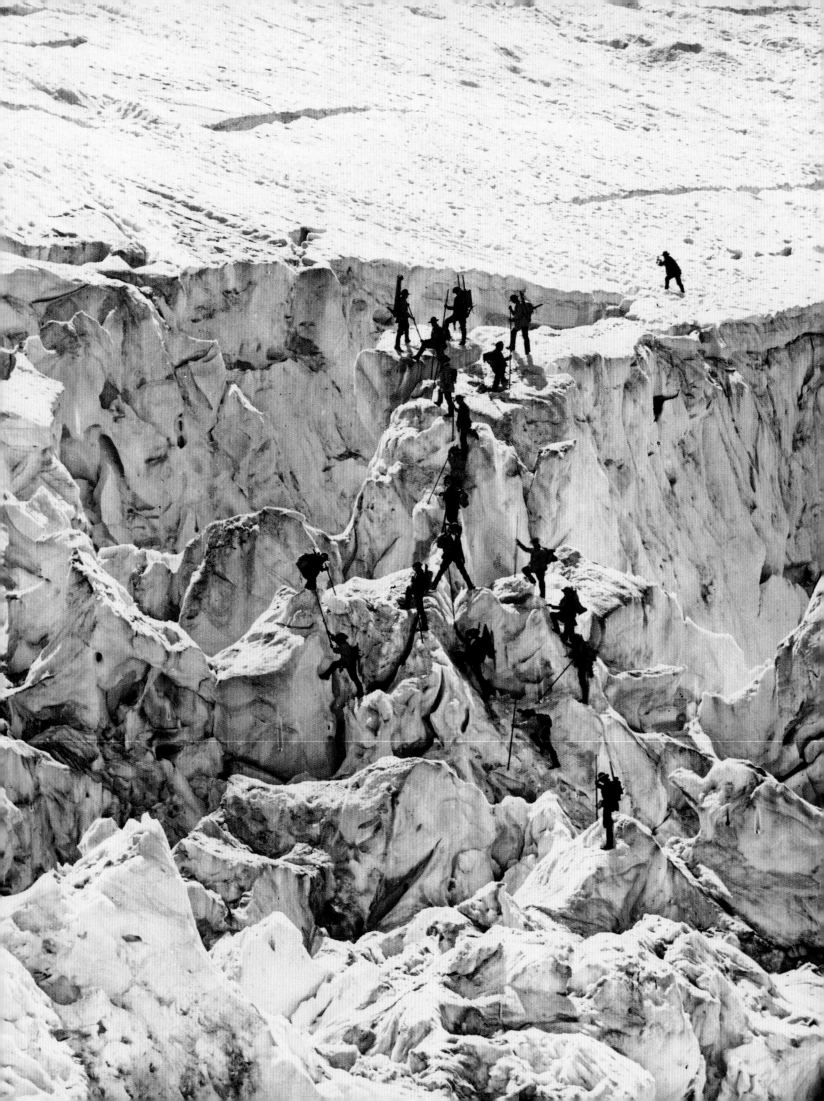

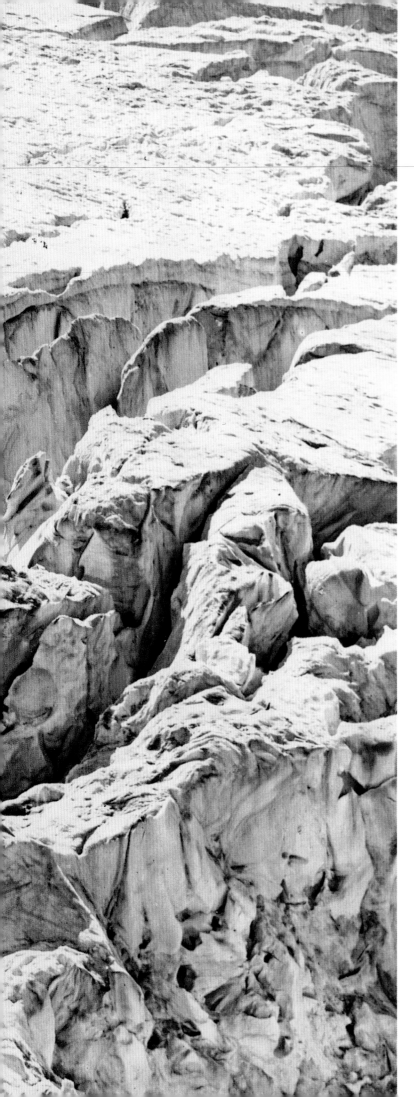

MOUNTAINEERING PHOTOGRAPHY IN THE 19TH CENTURY

The 19th century was the great pioneering era of both mountaineering and photography, when every advance made was hailed as a major milestone.

INFANCY AND GROWTH: A NEW ERA

Primitive cameras existed prior to the invention of photography: the *camera obscura* (a darkened room with a hole in one wall through which, on a bright day, an image was thrown on to the opposite wall) was mentioned by Leonardo da Vinci in the 16th century, and the principle was certainly known long before that. The *camera obscura* underwent many transformations; meanwhile artists and scientists tried to capture images on paper, glass, and other materials. In 1827 Joseph Nicéphore Niépce made the first "heliograph" directly from nature; another breakthrough came in 1839, when the French Government announced Louis Daguerre's production of a photographic image described as a Daguerreotype. At about the same time in England, William Fox Talbot developed an image on paper.

The earliest photographic recording by mountaineers consisted almost entirely of landscapes. This was largely a technical issue that would only be resolved with advances in equipment and materials. Yet, despite the slowness of the new medium to evolve to a point at which it could record climbing activity, pioneer photographers were quick to train their lenses on the high places. Shortly after the birth of photography in around 1827, they were hauling their unwieldy contraptions into the mountains to capture the views.

The very first photographs of mountains, made before methods for permanently fixing images had been discovered, are doubtless long lost. It is known from written records that Friederich von Martens (a German living in Paris, and one of the earliest people to take mountain photographs) was appointed photographer to an Alpine

LEFT *Ascent of the Bossons Glacier, Mont Blanc* (Auguste-Rosalie Bisson, 1861). This large-scale image is remarkable both for its depiction and its beauty.

expedition in 1844, sponsored by the French Government. Five years later, John Ruskin (see page 20) is purported to have made the first "sun portraits" of the Matterhorn, probably as Daguerreotypes. It can often be difficult, however, to substantiate who did what, first, in either mountaineering or photography. For instance, it is thought that early photographs may have been taken from the Mont Blanc summit by Joseph Tairraz, one of an illustrious family of Chamonix photographers (see also pages 10–11). Unluckily, almost the entire collection of this pioneer photographer was lost in a flood in 1920.

The images generally acknowledged as the earliest extant examples of climbing photography are those of the Bisson brothers, made on an 1861 ascent of Mont Blanc (an example is shown on pages 34–5). In 1860 France had acquired Savoy from Piemonte, and the next year the Bissons – owners of a prominent Paris studio – were invited to accompany Napoleon III and Empress Eugénie on a tour of the Haute Savoie, including the grand peaks of the Mont Blanc massif.

PHOTOGRAPHY IN WIDER USE

At the birth of photography, recreational mountaineering was still in its infancy. By the end of the 19th century, however, the foundations for both activities had been laid, with each established as a common pursuit for the wealthier classes. Although mountaineering has never become a mainstream activity, by this time it was recognized as an élite public-participation sport, at least in Europe. Photography, on the other hand, had by 1900 been embraced by much of society. Cameras were becoming more common, and their ability to record everyday events and make souvenirs was very exciting. From then on there would be no stemming the tide of personal picture-making.

The tremendous potential of photography for providing factual evidence was also quickly recognized by scientists. The photograph had an authority far beyond that of the sketch, making it extremely valuable to the new age of discovery. There had already been written evidence on the attractions of mountain activity for recreation (see also pages 18–20), but much of the foundation for climbing was justified by the contributions it could make to science. It was almost a heresy to undertake a climb in the first half of the 19th century without a barometer or mapping instruments, and the camera quickly took its place within the new apparatus of rational science.

It was this important function of photography that produced what is perhaps the oldest surviving photograph of climbing on rock (see right). Oddly enough, the image comes not from the Alps, but from the American frontier. It shows the renowned American geologist

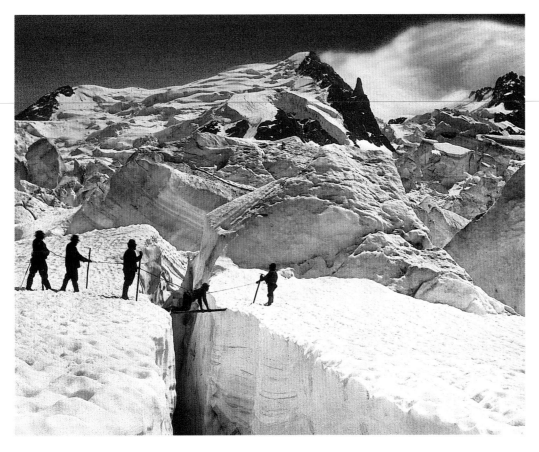

OPPOSITE The geologist Clarence King (attrib. Timothy O'Sullivan, 1867). King is shown in action here in an early image of climbing on rock.

LEFT *The Glacier des Bossons, Mont Blanc* (Joseph Tairraz, *c.* 1885). Joseph was the scion of the noted Chamonix family of guides and photographers.

BELOW *Excursionists on the Mer de Glace, Chamonix* (anonymous, *c.* 1865). This was a very common type of early souvenir image of a typical tourist outing in the mountains.

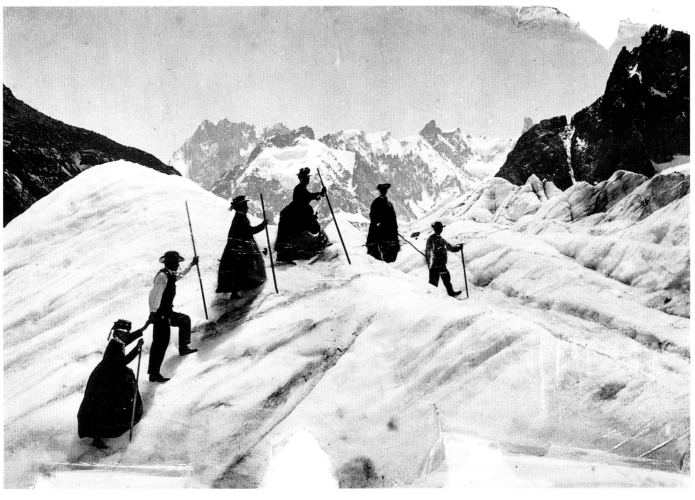

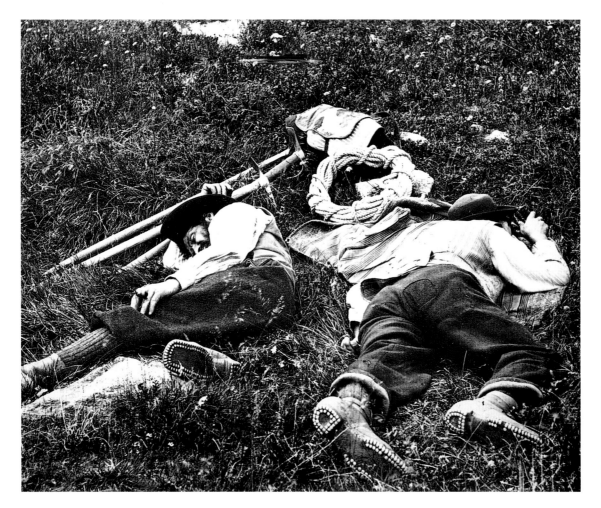

ABOVE *At rest* (William Frederick
Donkin, 1884). Although Donkin's
primary interest lay in recording
landscapes, he also showed his personal
mountaineering orientation in his
many images of climbing huts and
equipment, and in casual images such
as the example shown here.

RIGHT *Finsteraarjoch vom
Grindelwaldgletscher* ("Finsteraarjoch
from the Grindelwald Glacier";
attrib. Jules Beck, 1868). Finsteraarjoch
is a pass on the Finsteraarhorn in the
Bernese Oberland.

OPPOSITE *The summit of the Grépon*
(W F Donkin, *c.* 1880). A serious
alpinist and a scientist, Donkin
combined his almost obsessive
technical virtuosity with a climber's
appreciation of alpine terrain.

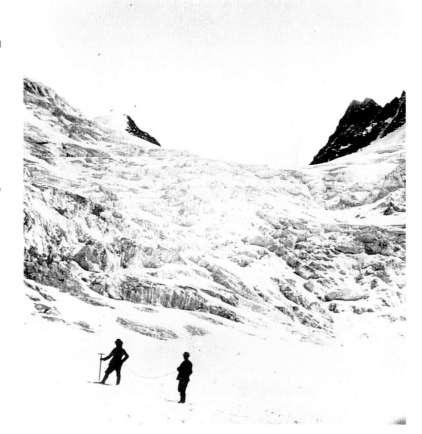

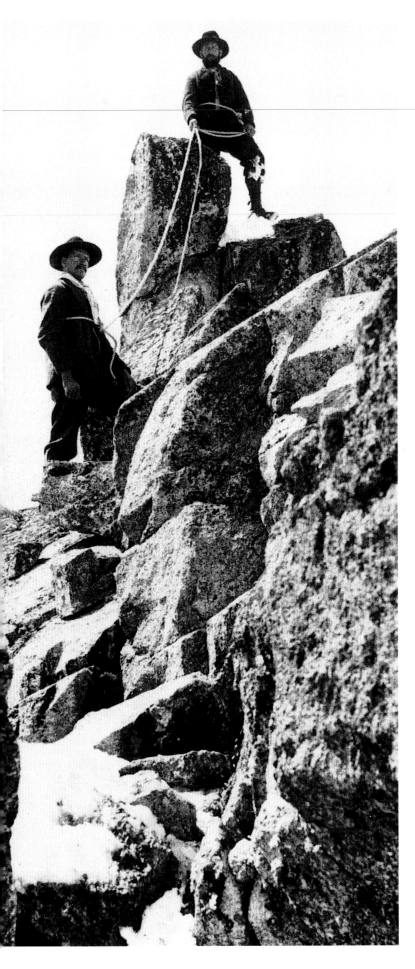

Clarence King, and was probably the work of noted American landscape photographer Timothy O'Sullivan, taken during a geological expedition to map the 40th parallel in 1867. King and O'Sullivan were roaming the American West as professional survey agents, yet this casual image also conveys a sense of spontaneous pleasure. It also proves that, although the Alps were the incubation ground for climbing, and remained the "schoolhouse" where techniques were advanced, it was not an exclusively European pastime. By the 1860s people were climbing in North America in particular, and by the close of the 19th century the sport had spread extensively.

THE BRITISH CONTRIBUTION

In many ways, the new pursuits of climbing and photography, together with the rise of tourism, stimulated one another's growth. Towards the mid-1850s, Alpine tourism was given a big boost by the improvements in transport, as well as by the increased political stability in Europe. To the growing numbers of European climbers was added a dynamic new force: the British had arrived *en masse*. They brought with them the typically British passion for strenuous leisure activity, and quickly moved to the forefront in pioneering new routes, especially in the accessible West Alps. The period known as the "Golden Age" of mountaineering (see also pages 29–30) was largely spearheaded by the activities of the most serious of these amateur climbers, together with the best local guides.

The British were as enthusiastic about photography as they were about climbing. The nation's scientists and inventors had been leaders in the search for a true photographic method, and continued to play a central role in introducing new processes and disseminating photographic information to the public. By the mid-century, British photographers were visiting some of the most remote areas on earth, and bringing back exotic "views" to show to a fascinated audience.

The Englishman William Frederick Donkin (1845–88) was a master of Alpine landscape photography in the second half of the 19th century (see opposite, above; and left). Indeed, many experts claim that he was the greatest mountain photographer of his time. Donkin was an enthusiastic supporter of the great Italian climbing photographer Vittorio Sella (see pages 54 and 56–7), who considered him both a friend and a photographic rival. Donkin was the honorary secretary of the Alpine Club of Britain, as well as of the Photographic Society of London (the latter was founded in 1853, and later renamed the Royal Photographic Society). He disappeared in 1888, on an expedition to the Caucasus.

Meanwhile, amateur climbers were already becoming enthusiastic picture-collectors even before advances in camera technology allowed them to take their own photographs. Picture libraries and studios at the early mountain resorts ran a brisk business in standard Alpine views, as well as in action photographs from popular routes, for these tourists to take home as souvenirs. Camera-less climbers could also visit portrait studios in the major climbing centres in order to have their own heroic souvenir portraits taken. These highly stylized images – often replete with fake rock outcrops and colourfully painted backgrounds – were extremely popular. A few decades later the images were considered to be ridiculously theatrical and absurd, yet today it is precisely because of their obvious artificiality that they may strike us as charming.

NEW CHALLENGES

At the close of mountaineering's "Golden Age", pioneers of the sport turned to new challenges. These included establishing more difficult routes on conquered peaks, climbing without the help of local guides, climbing solo, and making winter ascents. Expeditions were also undertaken to distant mountain regions: first to the Caucasus, and then to the Andes, the Canadian Rockies, and the Himalayas. The first-ascent routes (generally the easiest line of attack on a mountain) were by no means ignored, however, as increasing numbers of enthusiasts converged on the established climbing centres in accessible areas such as Chamonix and Zermatt to enjoy this exciting pursuit.

One photographer to take advantage of the new enthusiasm for picture-collecting was Jules Beck (1825–1904), an Alsatian with a photography business in Strasbourg, and a member of the Swiss Alpine Club. He was one of the earliest true climber-photographers, and was equally at home taking pictures on glaciers or on rock ridges. His publicity catalogues stated that he would only take orders from September through to May, so he was evidently busy with his own mountain pursuits during the summer months.

Jules Beck's 1882 photograph of an early rock route on the Finsteraarhorn (see opposite) provides an important glimpse of the contemporary level of alpine climbing, and also of what was possible in mountaineering photography at the time. The rock gully that the men are ascending would appear to be an easy scramble for a climber today, but this route would have been considered formidable at the time – formidable enough, at least, to warrant recording with a photograph. Historically, the image is significant

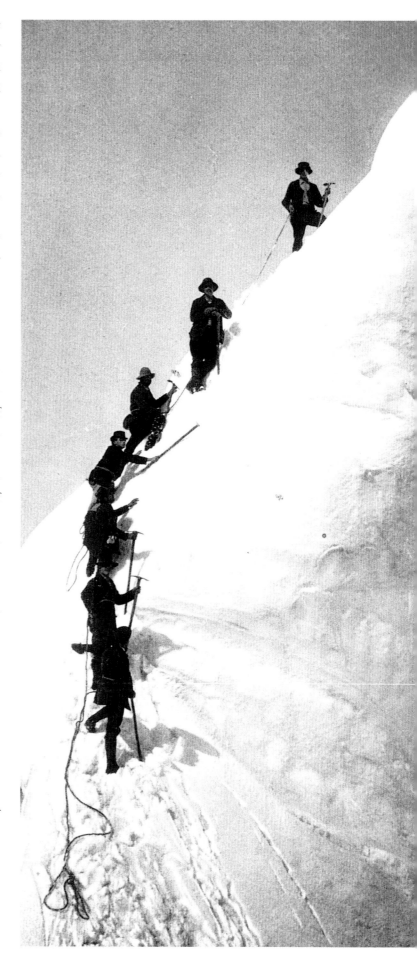

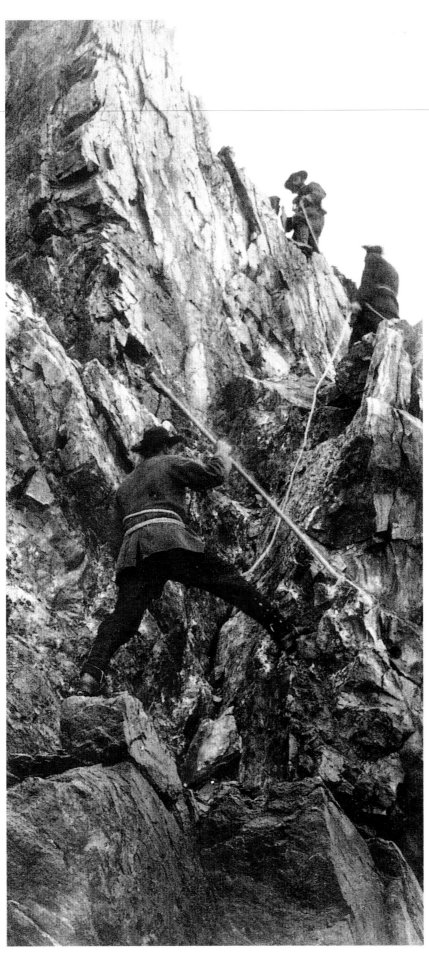

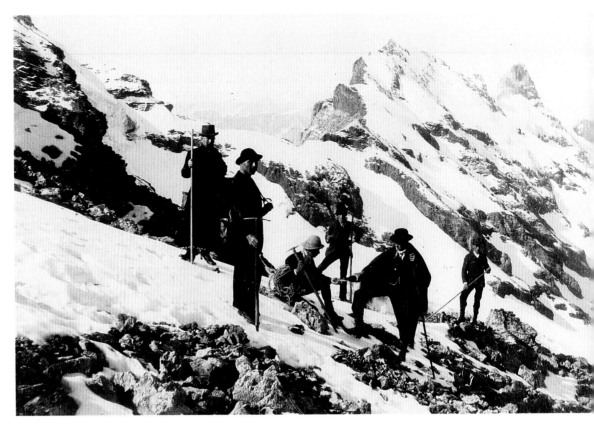

RIGHT *Alpinistenpartie in Engleberg* ("Climbing party on the Engleberg"; Hans Brun, *c*. 1895). Even at this late date, climbers dressed in much the same way as other travellers.

BELOW *Auf dem gipfel der Jungfrau* ("On the summit of the Jungfrau"; Hans Brun, 1890).

OPPOSITE, BELOW *Grodner Tal* ("The Grodner Valley"; anonymous, possibly Fritz Benesch, *c*. 1890).

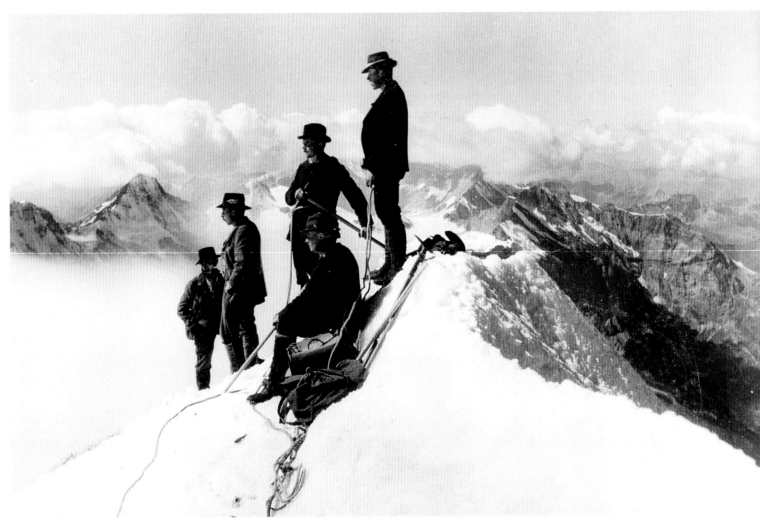

because of the rarity of photographs depicting rock-climbing from the period; it was made at a time when alpinists were starting to abandon the technically straightforward snow slogs to the mountain summits and were pioneering increasingly challenging new routes, although generally along the most moderate ridges.

Rock-climbing was at this period still in its infancy, with only rudimentary equipment used (the leader, climbing unprotected, trailed a rope; the following climbers had a top belay for security). In terms of photography, equipment constraints would not yet allow close-ups, so "action" was shot at middle distance, if at all. Generally, it was more a matter of posing stationary climbers in the setting.

The much earlier Timothy O'Sullivan photograph of Clarence King on rock (see page 36) is something of an anomaly; it can perhaps be attributed to the fact that Americans in 1867 had no real climbing conventions to which they could adhere. King was demonstrating here a typically American, highly independent approach to the sport that would find its fullest expression 100 years later in California's Yosemite Valley (see pages 106–109, 113–16, and 122–4).

TECHNICAL DEVELOPMENTS

The work of all the 19th-century pioneers of photography was very much constrained by cumbersome cameras and by the lack of sensitivity of their photographic materials. Prior to the introduction and public acceptance of smaller field cameras at the end of the century (see pages 52–4), photographers were limited to static views and to the choice between foreground or distant focus; they were also restricted in the number of images they could produce on any particular foray, due both to the slowness of their plate cameras and to the considerable weight of the equipment they had to carry.

The early cameras were generally huge. The Bisson brothers, for instance (see pages 34–6), exposed plates as large as 30 x 45 cm (12 x 18 in). When they climbed Mont Blanc in 1861, with the aid of 25 guides and porters to carry the equipment, they proceeded to make a grand total of three panoramas. Naturally, this situation would have to change before the rank and file of mountain-sports enthusiasts could begin to chronicle their exploits, and photography in the mountains remained practical only for those professionals with the means to have their equipment hauled, and with the technical knowledge (and patience) to prepare and process the plates.

The mid-19th century was, however, one of the most active periods of photographic advancement, and improvements made during the 1840s to lens design and to sensitizing chemistry made photography outside the studio much more viable. In 1851, in an advance on Fox Talbot's production of images on paper, the British inventor Frederick Scott Archer (1813–57) developed the collodion wet-plate sensitizing process, which involved coating fragile glass plates with a light-sensitive liquid emulsion just prior to exposure. This was a laborious affair requiring a light-proof tent and a considerable quantity of clean water for field photography; the photographer also had to develop the plate immediately after exposure, before it dried and lost its sensitivity. A further drawback was that the glass plates were more fragile than the metal plates used for Daguerreotypes. However, although the collodion process was inconvenient, tedious, and often unstable, it was still 20 times more sensitive to light than previous methods. It produced beautiful results, and would remain the most important photographic process for the next 25 years.

Significant headway was also made in producing photographic equipment that was lighter and more compact, making it much easier to carry. These improvements were spurred largely by the demands of travellers, among whom mountaineers – because of the strenuous nature of climbing – were among the most vociferous.

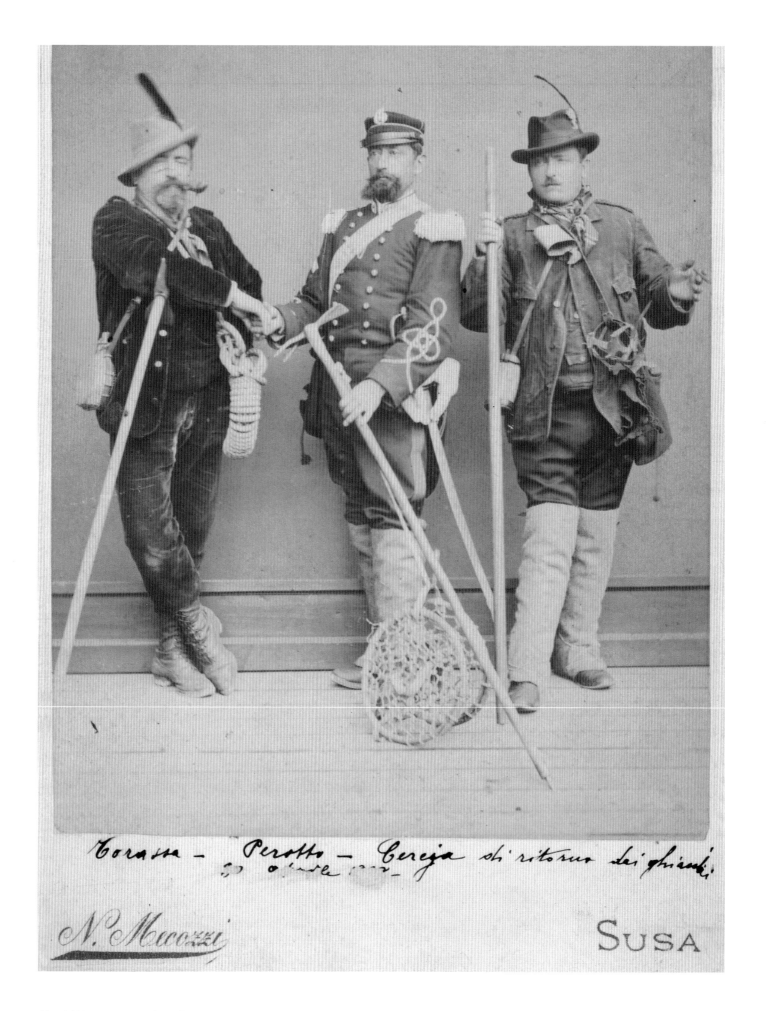

Corassa — Perotto — Cereja di ritorno dei ghiacci.

N. Micozzi

SUSA

Sketching and painting continued well beyond the advent of photography as the primary visual record of mountain sport. This was partly because early photographic equipment was incapable of recording action, but also because of the technicalities of reproducing images in books and journals. Until the mid-1880s (see page 51), there was no way to reproduce a photograph directly on the page using the same presses as for type. Where photographs did appear, they had to be printed separately and then bound with the pages – an expensive and time-consuming process, although a fairly common one in high-quality travel books. As a result, hand-drawn art was still used in the majority of publications at this stage.

In 1865, the Reverend H B George (first editor of the *Alpine Journal*, published by the Alpine Club from 1859, initially under the title *Peaks and Passes*) took London photographer Ernest Edwards

to the Swiss Oberland to make illustrations for a planned book on the region. One of the images from this expedition, entitled *The Jungfrau from the Steinberg Alp*, had the honour of being the first photograph to appear in the *Alpine Journal*, in December of that year. This early date is a good indication of just how aggressive the Alpine Club was about embracing photography.

Another advance came in 1869, when the *Alpine Journal* published an essay by the Reverend George entitled "Notes on Photography in the High Alps" – the first in a long tradition of photographic-advice articles to appear in the various Alpine-Club journals. In the article, George outlined his aim: "It is only within the last two or three years that it has become possible to do what I hope to persuade many members of the Alpine Club to do – take photographs anywhere and everywhere that the climber chooses to go." He recommended, for instance, that climbers try the new generation of

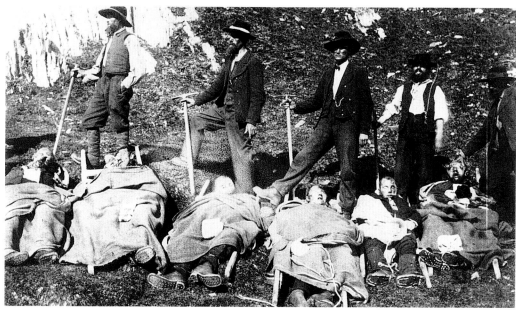

OPPOSITE *Di Ritorno dai Ghiacciai* ("Return from the glaciers"; Studio Mecozzi, 1890). Early photography was directly linked to ceremony and commemoration, while at this stage mountaineering still had a relationship to military conquest.

LEFT, ABOVE *Les six victimes de la catastrophe de la Jungfrau* ("The six victims of the Jungfrau tragedy"; Charles Hotz, 1887). This remarkable photograph speaks volumes about contemporary mountaineering and photography. It serves as a grim reminder that then, as now, climbing could be a deadly serious activity. The photograph follows the same visual conventions as fishing and hunting trophy photographs of the era, with the dead spread out in macabre display before the stalwart mountaineers.

LEFT, BELOW *Séracs au Aiguille du Midi* ("Séracs on the Aiguille du Midi"; Chernaux brothers, 1885). Early stereo views, such as this one, were popular as tourist souvenirs during this period. Stereo cameras represented a great step forward in climbing photography, in requiring shorter exposures than the large-plate cameras and therefore allowing for unposed, "action" shots.

"miniature" cameras. His own system, which weighed less than 2 kg (4 lb), was state-of-the-art, and ideal for travelling light. It consisted of a 9 cm- (3½ in)-square box with two lenses, and a small stock of glass plates; he also adapted his ice-axe to make an ingenious support.

What made this kit so compact was the use of the first generation of dry plates, made available to the public in 1867. The plates were coated (in advance, by the manufacturer) with a light-sensitive emulsion, and required none of the cumbersome wet-plate equipment or technical coating skills. The photographer simply plugged the plate into the camera and took the picture. The only real disadvantage of these early prepared plates was that they tended to be less sensitive than the wet plates, requiring long exposures even in bright sunlight. The second advance, explained by George, was the perfected method of enlarging pictures taken on very small plates.

NEW CAMERA FORMATS

At about the time that the first dry plates came into use, new types of small-format cameras were being developed. One very popular example was the stereo camera, first introduced around 1850. This twin-lensed camera made two images, side by side and slightly out of register (see page 45, below; and page 54). When seen through a special viewer, the image looked three-dimensional.

One interesting effect of the stereo camera that made it particularly useful in climbing was its ability to make exposures of far shorter duration than the contemporary large-plate cameras. As the image size was much smaller, the lenses were of shorter focal length and allowed a great deal more light to strike the plate; a scene that required a full minute to expose on a large-format camera could therefore be captured with a stereo in one second or less. These short exposures made it possible to record unposed scenes, and even action if it was slow and in bright light. Stereo views had fair value as commercial souvenir images – especially when, as was often the case, they showed climbing action better than large-format prints of the same date. Throughout the second half of the century, these commercially produced "stereographic views" sold in their millions.

The 1875 image (see right) of the opening ceremonies for the Payerhutte by the Prague section of the German–Austrian Alpine Club presents a striking example of just how high the quality of

RIGHT *Commemoration ceremonies, Payerhutte* (B Johannes, 1875). This image reveals a wealth of information on current dress and equipment.

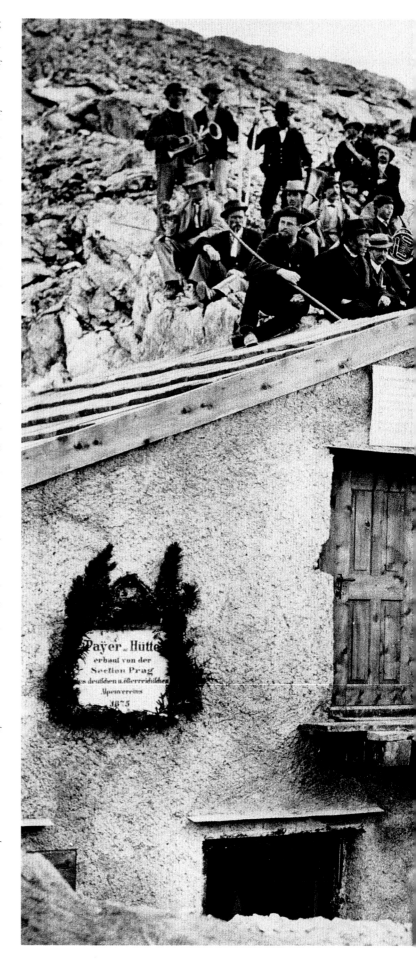

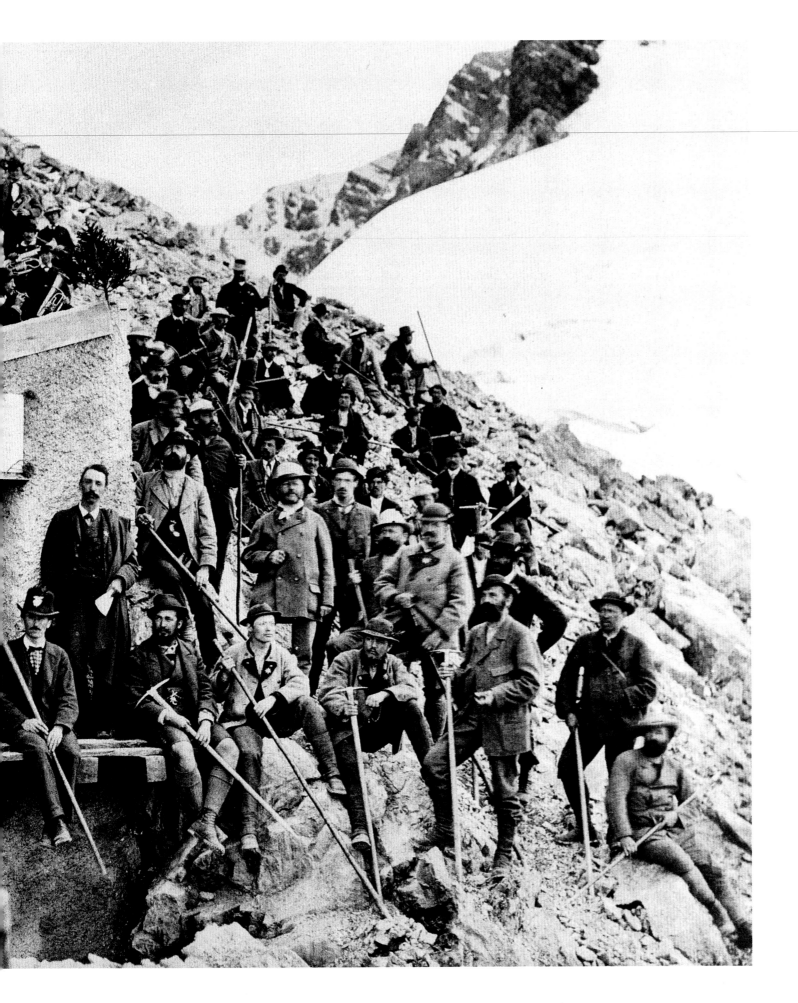

some of these early images could be. The huge camera format provided a very large glass negative which was then contact-printed (with the sensitized paper in contact with the negative), with none of the degradation produced by an enlargement. Everything stands out in sharp detail, in a quality that would not even be equalled by the small-format cameras commonly used in the mountains today.

WOMEN IN THE MOUNTAINS

Mountaineering in the 19th century was, like many other activities, decidedly male-dominated. There is, however, an ample record of women's participation in almost every aspect of expedition and recreational climbing, with their input evident both in front of and behind the camera. Photographs abound of Victorian ladies in long black dresses blithely ascending snow couloirs and crossing Alpine glaciers. The most striking aspect of these images is the way the women make the activity seem so civilized, with their dress even more incongruous than the tweeds of their male counterparts.

Contemporary records show that women such as Mrs E P Jackson, Katherine Richardson, and Elizabeth Le Blond (the latter was also known in climbing circles under the names of her first husbands, Burnaby and Main) were hardly dilettantes. Women participated in early mountain sport at all levels: from casual tourists on glacier outings undertaken within sight of their hotels, to climbing on the most challenging Alpine ridges and most remote Andean peaks.

The 19th-century fascination with photography seemed to have a special appeal for women. Female photographers displayed their work widely in the various exhibitions of the time and in galleries; indeed, photography was one of only a handful of professions deemed "acceptable" for Victorian ladies.

The first image reproduced in the *Alpine Journal* using the new halftone printing process (see page 51) was credited to Mrs Main. The only surviving image of famed British mountaineer Albert Frederick Mummery (1856–95), making the first ascent of the crack named for him on the Grépon, was taken by his climbing partner, Lily Bristow. She also made the following observation in the *Alpine Journal* on her souvenir picture-making from that climb of 1893:

"It is really a huge score for him to have taken me (*and* the camera) on such an expedition. I took six photographs, and have developed two, one of which is a failure ... then I took some more photographs, and as the situation did not admit of setting up a tripod Mr Hastings [a friend of Mummery's] made a support for me by wedging his head against a rock."

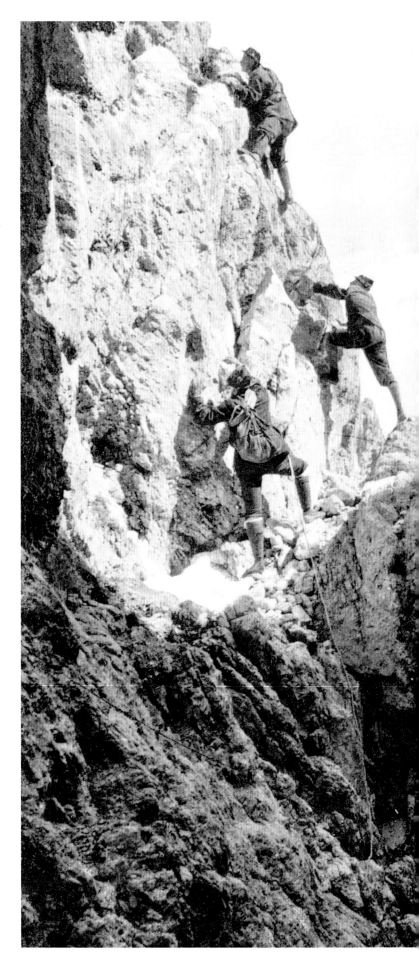

Lily Bristow was one of a growing number of amateurs who applied the craft of photography to their recreational interests. By the last quarter of the 19th century there was little need to rationalize mountaineering as an essential element of exploration or scientific experimentation: men and women climbed because they enjoyed doing so, and the activity had become a sport in its own right.

Mountaineering photography was also now well developed as a distinct genre, with skilled professionals and accomplished amateurs dutifully recording not only the great Alpine peaks, but also the activity of the climbs. By the end of the century the mountaineering community was plentifully stocked with the widest range of photographers, from rank amateur to accomplished professional.

ABOVE *Early rock-climbing in Norway* (anonymous, *c.* 1885). Note the long black dress worn by the woman – still considered at this time the only acceptable attire for female mountaineers to wear.

LEFT *Kletterei am Fermedaturm* ("Rock-climbing on the Fermeda Tower"; Fritz Benesch, 1893).

RIGHT *An alpinist, his guide and his porter, back from Mont Blanc* (studio portrait by Joseph Tairraz, *c.* 1880).

OPPOSITE, ABOVE *Der Rote Tresch* ("The Red Tresch"; anonymous, *c.* 1900).

OPPOSITE, BELOW *Christian Almer and his wife* (anonymous, 1896). Almer was one of the great mountaineering guides of his day, and is pictured here with his wife on the occasion of their golden wedding anniversary. The couple – aged 70 and 71 respectively – celebrated by climbing to the summit of the Wetterhorn in Switzerland.

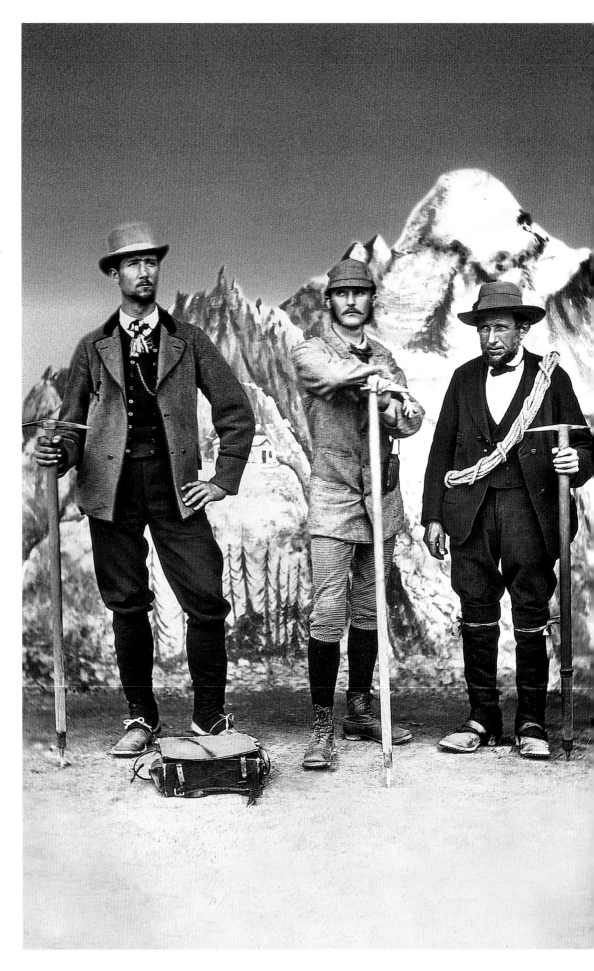

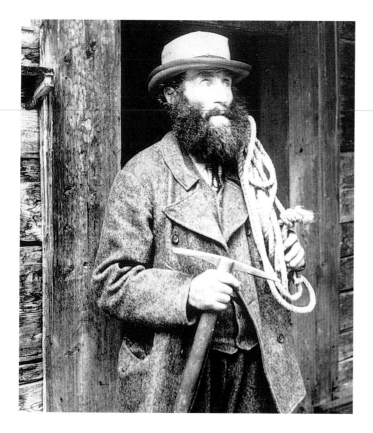

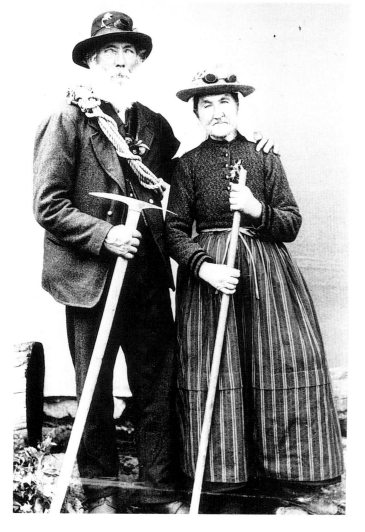

Photographic technology continued its progress in the last quarter of the century. The introduction of pre-coated dry plates (see page 46) was fully realized in 1878, with gelatin used to hold the emulsion during the coating procedure. The plates could be developed some time after exposure – a great advance, even though the equipment was still cumbersome and the plates heavy and fragile.

The new emulsion proved to be up to 60 times as sensitive to light as the original dry plates, yielding considerably shorter exposures and bringing climbing action well within the realm of possibility for photographers. Better shutters were devised to facilitate shorter exposures, freeing the camera from the tripod, while the advent of a new celluloid/gelatin "film" in 1883 (available in roll form by 1889) relieved photographers of the awkward glass plates.

These advances were accompanied by the increased appearance of photographs in the many new books on mountain exploration and in the club journals. The latter were by this time featuring numerous articles on the craft of mountain photography (both landscape and climbing action), in the tradition established by the Reverend H B George in 1869 (see pages 45–6). Prior to the mid-1880s, publications illustrated with photographs needed first to render the photographs as engravings, just as with sketches. So great was the importance placed on the authenticity of the photographic original, however, that it became common practice to identify the engraved image with the phrase "*from a photograph by …*".

Following its groundbreaking publication of Ernest Edwards's photograph of the Swiss Oberland in 1865 (see page 45), the *Alpine Journal* included a panorama by William Donkin in 1881 and, later that year, the German-Austrian Alpine Club journal featured a photograph. The concept of such high-tech imagery was still so new that both the photographer and technician who made the reproduction were credited, as in the earlier practice of listing both the artist (or photographer) and engraver. The Italian Alpine Club followed suit in 1884, and the Swiss Alpine Club three years later.

With the adoption of the halftone printing process in the mid-1880s, the book and journal publishers substantially increased the numbers of images used to accompany the copy. The process evolved slowly, and the early halftones were of such poor quality as to be aesthetically inferior to the beautiful engravings that had preceded them. Their quality improved rapidly, however, reaching near-perfection by about 1905 and culminating in an effective method of offset-printing images together with text.

The Alpine-Club journals – as well as continuing to publish articles on photographic matters – promoted photography further still by encouraging members to produce pictures for exhibition. In the Alpine Club of Britain, election to membership could even be based partly on a newcomer's photographic qualifications.

Another distinct category of mountaineering photography at this time centred on numerous commercial portraits of notable Alpine guides. These guides were admired as a distinct type of adventurous individual, with the more accomplished among them achieving a real celebrity status, especially in the major Alpine climbing centres.

HAND-HELD CAMERAS

In 1888 the American inventor and entrepreneur, George Eastman, revolutionized amateur picture-making by introducing the Kodak hand-held camera. Essentially the precursor of today's point-and-shoot models, this had a fixed-focus lens, and was loaded with a film comprising a flexible gelatin emulsion coated on to a roll of paper. The entire camera was returned to Kodak for the film to be unloaded, developed, prints made, and a new film reloaded. There was no longer any need for the user to have special skills to produce acceptable souvenir photographs – an aim declared in the Kodak motto "You press the button, we do the rest."

Made possible by the development of faster lenses and the new film, the hand camera represented arguably the single greatest technical advance in the entire history of photography – at least in terms of its acceptance by the masses. (The recent advent of digital imaging is perhaps the most revolutionary advance in photography *since* the appearance of the hand-held camera.) These advances made possible a new form of "candid" photography, with a clear emphasis on the climbing itself – not on the surroundings.

The hand-held camera was not, however a good instrument for making beautiful landscape photographs. The images it produced were a little rough (in fact, barely sharp) and lacked the brilliance of those made with traditional view cameras with their larger film size and finer lenses, but it was perfect for spontaneous "snapshot" records. In the closing years of the century, a rapid succession of more efficient, better-quality miniature cameras became available to the public. In 1892, Jules Carpentier released a hand-held camera loaded with 12 small sensitized plates that could be changed by a small push-rod. The camera had a shutter set at ⅒th of a second, and

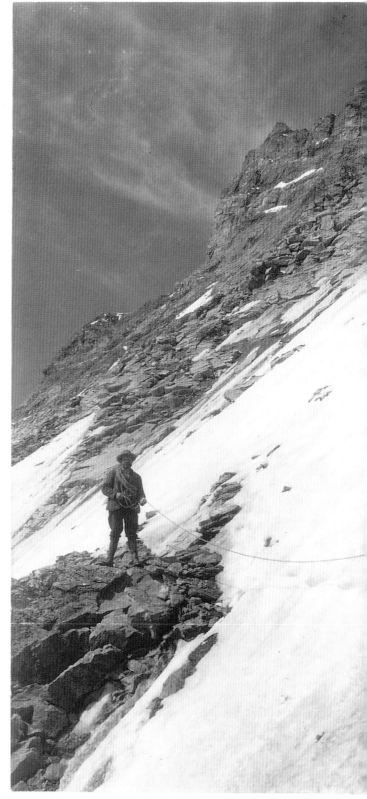

RIGHT A page from a photgraph album (prob. Alfred Holmes, *c*. 1890).

chia del Cervino

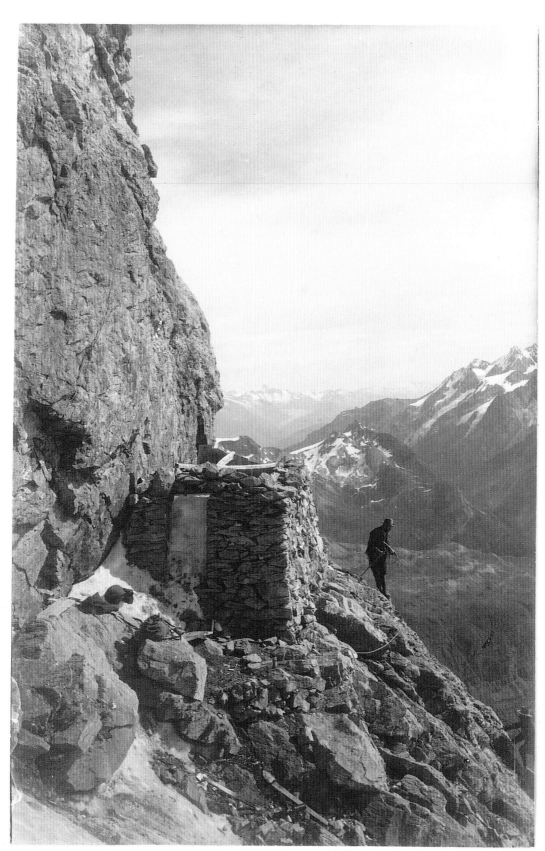

Capanna vecchia del Cervino (3818 m)
(versante svizzero).

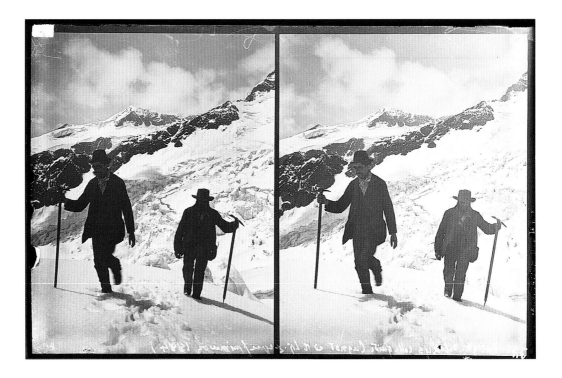

RIGHT *Roped climbers* (Vittorio Sella, 1884). Produced by a twin-lensed stereo camera, these side-by-side images appeared three-dimensional when seen through a special viewer.

OPPOSITE *The summit of Longs Peak, Colorado* (anonymous, *c.* 1890). The conventions for climbing equipment, clothing, and technique were by this time becoming standardized among recreational climbers, as were the conventions for the photographic record: locals guided tourists to summits such as Longs Peak, where they posed for the requisite souvenirs.

a fixed-focus, fixed-aperture lens. With such a camera, a complete amateur might spend an entire day in the mountains and come home with a substantial souvenir record. From this point onwards any climber could make his or her own souvenir pictures, and so they did – in ever-increasing numbers. Picture archives and the greater number of photographs in club journals show that the climbing establishment at the end of the 19th century had become extremely visual in its attitude towards mountaineering, and that climbing and photography were now inextricably bonded.

MOUNTAINEERING WORLDWIDE

By the 1890s, more adventurous climbers were starting to range far beyond the established "playground" of the Alps. The Caucasus, still nominally in Europe, witnessed several notable expeditions at the end of the century. Edward Whymper (see pages 26–30) helped to popularize climbing in the Andes with his book *Travels Amongst the Great Andes of the Equator*, published in 1892. British mountaineers Cecil Slingsby and the Revd Walter Weston introduced recreational climbing to Scandinavia and Japan, where it was enthusiastically received; Britons also transplanted their sport to all corners of the Empire, the most propitious sites for this recreational colonialism being northern India, New Zealand, and western Canada.

It is certain that native Americans had climbed mountains, both in search of game and for spiritual reasons, long before Europeans arrived. They may even have climbed for the same reason as the European tourists: from curiosity and for the sheer fun of it.

Since they left no record of climbing for sport, however, we must assume that the first true tourists to reach the American summits were Americans of European origin.

Early climbing in the Canadian Rockies was largely a transplant of an established pursuit (effected mainly by British tourists and their Alpine guides), but earlier developments south of the border were rather different. And while Canadian climbing did not really get underway until almost the turn of the century, there had been numerous American ascents since about 1860. Excepting rare visits by adventurous foreigners, the mountains of the American wilderness were climbed by Americans. Although knowledge of the new "sport" of climbing would have filtered through from Europe by the early 19th century, Americans of the mid- to late years of the century bagged peaks according to their home-grown aesthetic.

The concerns of western Americans were generally too practical to include climbing for its own sake, and there were few members of the leisured class which had provided so much impetus for opening up the Alps. Some prospectors and cowboys did climb mountains on larks, and in the Pacific Northwest there was some interest among settlers, but 19th-century mountaineering in the American West consisted mainly of ascending easy peaks. The wilderness aspect of American climbing, and the non-conformist spirit, informed an approach to the sport that was far less formalized than the European variety. Photographs of climbing parties in the popular Rocky Mountain centres towards the end of the century do, however, resemble similar scenes in Europe (see opposite).

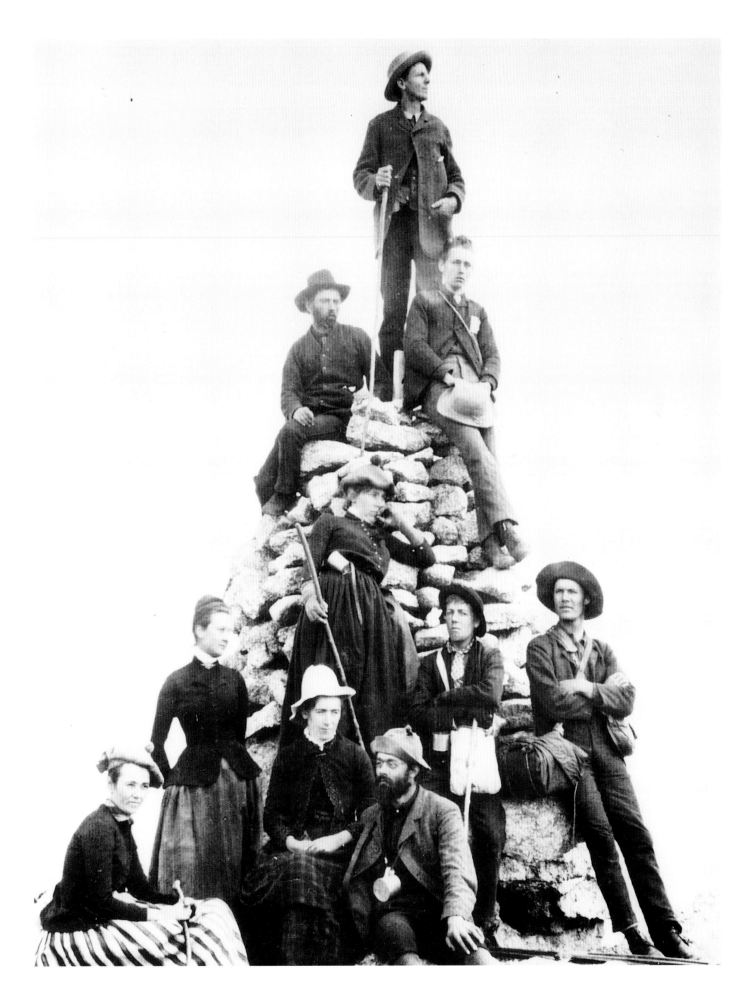

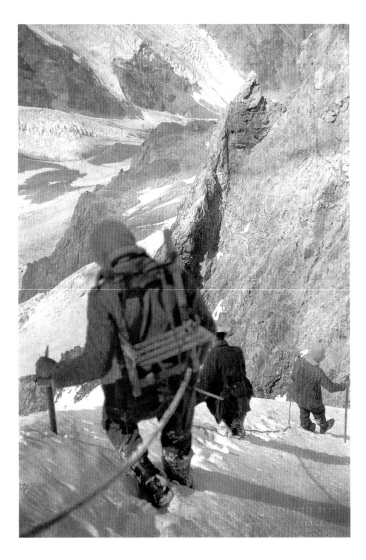

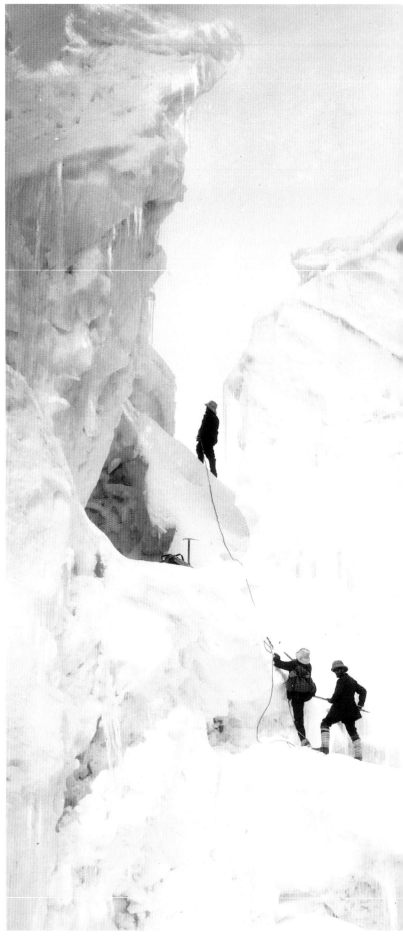

ABOVE *Roped descent in the Caucasus* (Vittorio Sella, 1896). By the end of the 19th century, capturing spontaneous action-climbing images on film had become a reality. In the next century, it would go on to reach greater levels of sophistication.

RIGHT *The Duke of the Abruzzi, with guides: high-altitude exploration on the Chogolisa Glacier, Karakoram* (Vittorio Sella, 1909). The Duke, pictured in the centre, is attacking the séracs on this Baltoro Glacier tributary in order to facilitate his progress.

THE WORK OF VITTORIO SELLA

Alpine photography in the 19th century came to its ultimate fruition in the work of Vittorio Sella (1859–1943). For over 40 years he was the pre-eminent master of mountain photography, and was arguably the greatest mountain photographer of all time. Born in Biella, Italy, Sella was involved with climbing and photography from an early age. His uncle was a founding member of the Italian Alpine Club (and the first Treasurer of the newly formed nation of Italy), and his father – a serious amateur photographer – wrote the first technical manual on photography in Italian, published in 1856.

Sella's climbing career included such remarkable achievements as first winter ascents of the Matterhorn, Monte Rosa, and Liskamm. His status as a highly skilled alpinist and photographer secured a place on numerous large expeditions to far-flung mountain regions. In addition to a lifetime's exploits in the West Alps, he made three trips to the Caucasus (in 1889, 1890, and 1896), accompanied British climber-explorer Douglas Freshfield on the circumnavigation of Kangchenjunga in 1899, and acted as official photographer on the Duke of Abruzzi's important exploratory expeditions to Alaska (1897), the Ruwenzori (1906), and the Karakoram (1909; see left).

The vast majority of Sella's photographs were large-format land-scapes. His favourite camera was immense, even by 19th-century standards, with plates as big as 35 x 45 cm (14 x 18 in). Excepting Sella's many beautiful images of climbers within the mountain land-scape, one must dig a little to find examples of real climbing action. These were generally made when he was experimenting either with a small-format stereo camera, or with the new folding Kodak.

In 1896 Sella made his final trip to the Caucasus (see opposite, above). He had already noted in his writing that he had been exper-imenting with a hand-held camera that he might use to record climbing activity but he was evidently unimpressed with the results, referring to the small-format images as being of inferior quality.

Sella's images from the hand camera are certainly not up to his tech-nical standard, although they are remarkable for their immediacy and sense of action. This was Sella changing tack: from the landscape artist producing exquisite views to the mountain journalist record-ing the incidents of a climb. These rougher, more spontaneous images have a look unlike anything else being done at that time in the mountains – a look that is unquestionably modern. It was this transition from the static views of the tripod-bound plate cameras to the more candid capability of their hand-held cousins that marked the next great revolution in mountaineering photography.

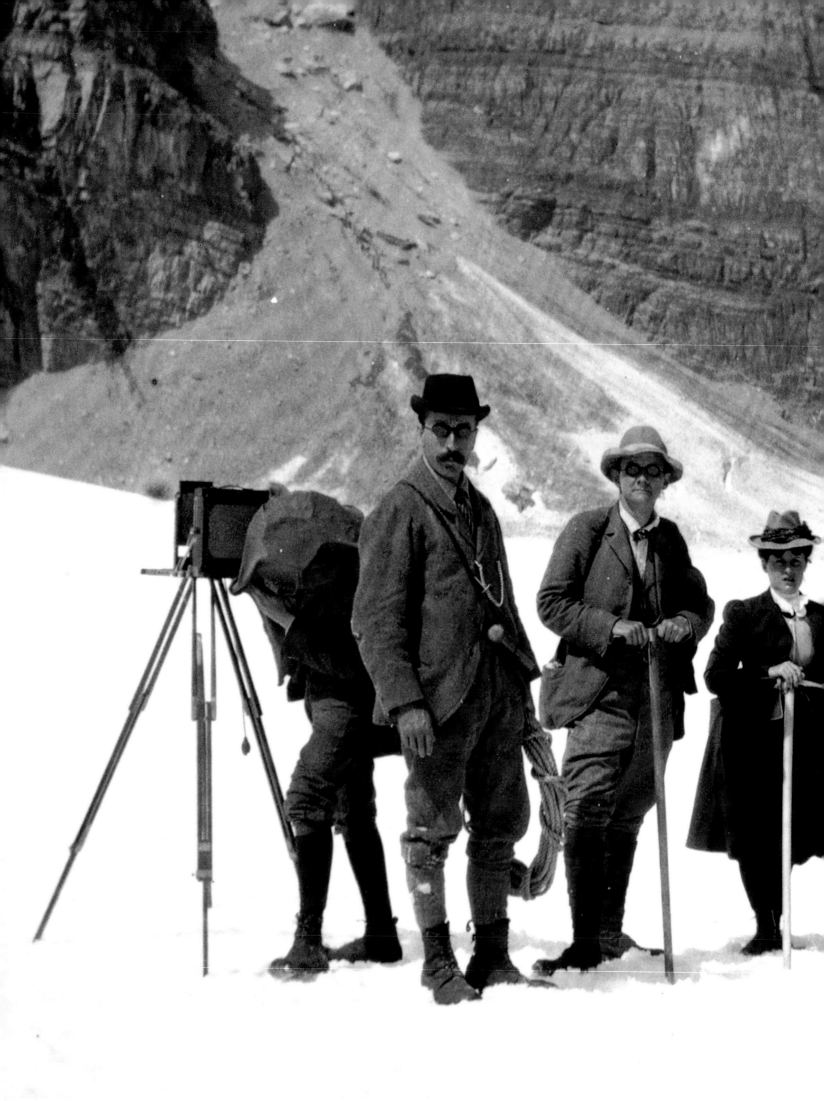

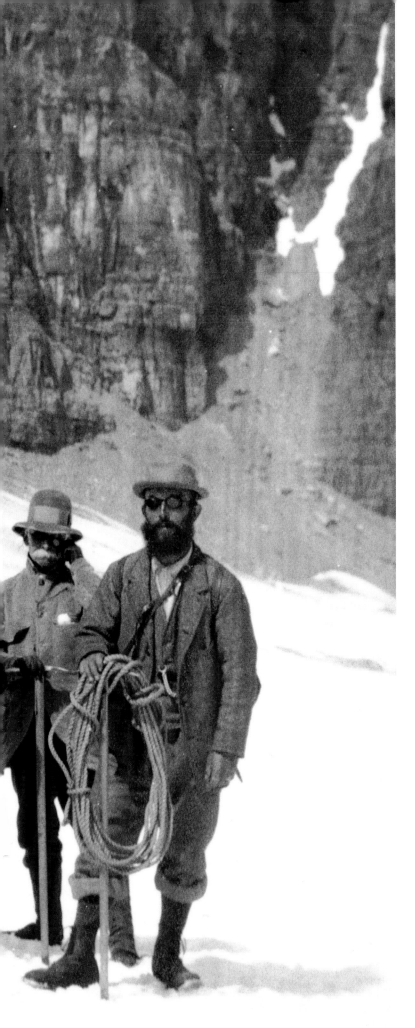

CLIMBING PHOTOGRAPHY 1900–1945

The foundations for both photography and climbing had been firmly established by the start of the 20th century, yet they still remained fairly élitist pursuits.

RECORDS OF GREAT CHANGE

While climbing would stay well out of the mainstream for some years after World War II, photography at the turn of the century was on its way to becoming a universal art form, and the only piece of new technology embraced by almost every member of society.

By 1900, every major peak of the Alps (and most of the subsidiary points) had been climbed; the challenge that remained to those intent on breaking new ground lay either on distant ranges, or in forging more difficult routes on the Alpine peaks. It was a challenge met with enthusiasm, and the sport continued to expand both in the number of its participants and in the scope of projects undertaken.

The arena of climbing was also expanding far beyond Europe, but activity in the more remote ranges was still essentially an extension of the techniques and philosophies pioneered in the Alps – at least until the advent of the new movement in extreme technical rock-climbing that took root in California's Yosemite Valley in the 1930s.

As with most histories, the history of mountaineering is generally described in terms of its highlights: the breakthrough climbs, and the major figures tackling cutting-edge routes on major peaks. After all, this is how the sport progressed, and what caused the techniques and equipment to evolve in order to solve increasingly difficult problems. It is also, of course, the highlights that capture the public's attention, and set the standard for other climbers.

LEFT *Climbers and photographer at the Victoria Glacier* (Vaux family collection, 1900). George Vaux, his daughter Mary, and sons George and William were wealthy Philadelphians and amateur scientists. The family made numerous visits to the Rocky Mountains of western Canada, where they studied glaciers and amassed a large body of alpine photography.

However, even as ambitious climbers pushed the limits further back – motivated equally by the pursuit of personal and national glory, and by the sheer sense of challenge – there was a growing body of ordinary climbers, not seeking to astound the mountaineering world with their accomplishments, but simply climbing for the pleasure of it. These people, enjoying themselves on established routes of all levels of difficulty, have formed the backbone of the sport since the close of mountaineering's "Golden Age" in the Alps.

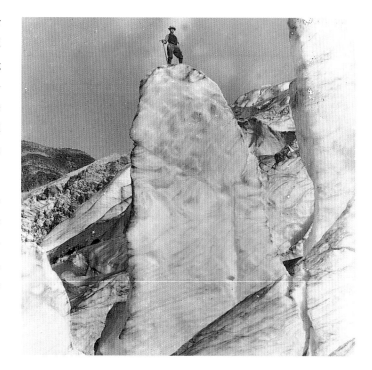

Although still a fairly esoteric activity, climbing continued to gain in popularity among the leisured class, and increasingly among the working classes too. This progress was assisted by rapid improvements in transport: cars and buses made local crags more accessible, while improved rail and steamship transport helped to open up the vast potential of the distant ranges to expedition climbing.

THE EMERGENCE OF ROCK-CLIMBING

At about the turn of the century, rock-climbing came into its own. The exhaustion of the easier routes to untrodden Alpine summits meant that ambitious climbers focused their attention not on the peaks themselves but on their unclimbed features, including the steeper ridges and sheer faces. For many people, another appeal of rock-climbing lay in the fact that cragging areas could be reached more easily than the major Alpine centres; this type of climbing also required less time and less in the way of equipment, and could be done without the assistance of guides.

In Britain, as in Germany north of the main tract of the Alps, this activity centred on the climbers' local crags and on good climbing areas such as north Wales and the Lake District. Here there were indeed challenges available for those who were willing to accept the new sport of technical rock-climbing. Even though it was not yet as celebrated as mountaineering, it was at least something considered worth doing for its own sake and not merely as practice for the Alps. A distinct local climbing culture and infrastructure evolved in the handful of British cragging centres. Much to the chagrin of many in the traditional climbing establishment, some of the local climbers went into business as professional guides; the ethics of publishing guidebooks to the British rock-climbing centres also became a point of dispute with the traditionalists.

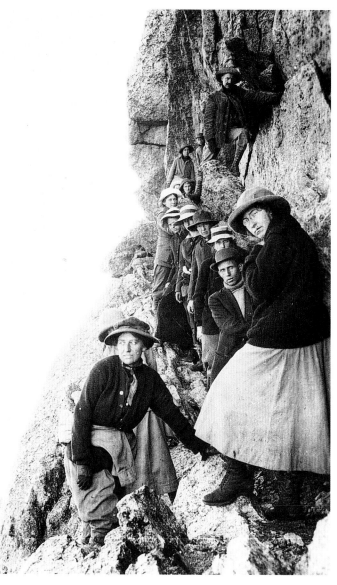

The brothers Ashley and George Abraham (1876–1951 and 1870–1965 respectively) were central figures in Britain's emerging rock-climbing society. Although they had actually begun producing climbing images in the preceding century, their groundbreaking

OPPOSITE, ABOVE *Climber on a Sérac*
(Vaux family collection, 1905).
This picture was taken on one of
the family's trips to the Rockies.

OPPOSITE, BELOW *Climbers on Longs
Peak, Colorado* (anonymous, *c.* 1905).
Climbing in America lagged behind
that of Britain and continental
Europe, both in technique and in
the ambition of projects undertaken.

LEFT *Barndoor Traverse at the Wastwater
Hotel* (Ashley and George Abraham,
1900). Some aspects of the climbing
sensibility have changed very little: this
image shows the same compulsion to
climb competitively on vertical walls
that has been the impetus for today'
rock gyms and climbing walls. Despite
the costumes, this is a remarkably
modern sport-climbing photograph.

BELOW LEFT *George Abraham leading
brother Sydney on Blencathra, north Wales*
(Ashley Abraham, 1890). This is the
earliest known Abraham climbing
image. Climbers today may either
be impressed by the great confidence
shown by two roped climbers moving
simultaneously on what appears to be
dangerous (loose) rock, or appalled
by the complete absence of security.

photography has more in common with the work that followed it than with what went before. During the pre-World War I period, the Abraham brothers stood at the very forefront of pure rock-climbing photography long before it became an established form, and their speciality images of cliff-climbing can in many ways be regarded as prototypes for the dramatic, innovative work of today's sport-climbing photographers.

Like Vittorio Sella (see pages 54 and 56–7), Ashley and George Abraham were photographers on the cusp of both old and new traditions, straddling the conventions of 19th-century mountain-landscape photography and the fresh impetus towards recording climbing action. In common with other professional mountain photographers at this time, the Abrahams worked primarily with the larger-format plate cameras of their predecessors, favouring them for their superb quality. However, the nature of the images that the brothers produced – high-angle rock and alpine-style climbing action – represented a distinctly new photographic approach.

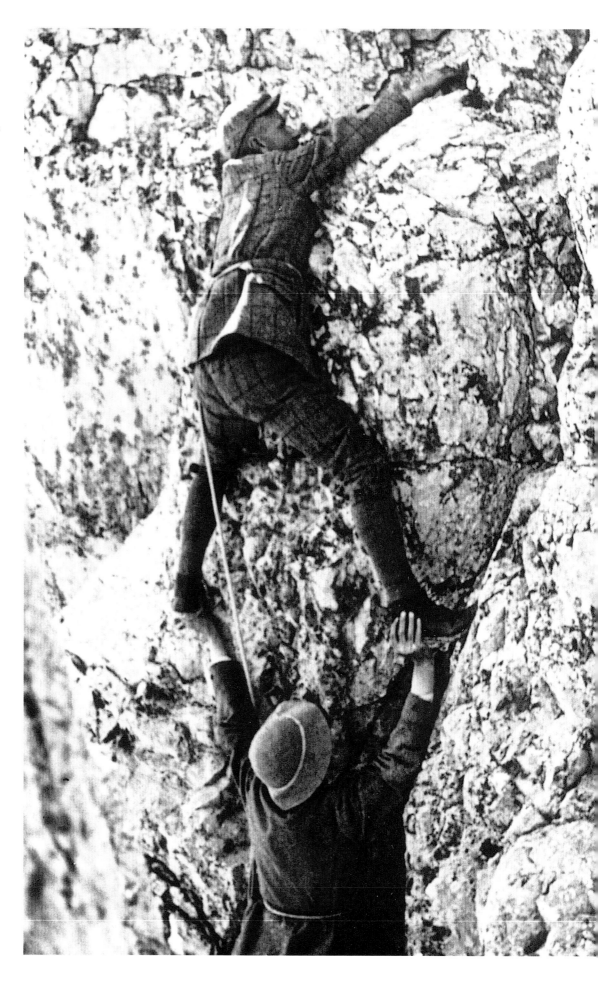

RIGHT *Der Menschliche Steigbaum* ("The Human Climbing Tree"; anonymous, Switzerland, *c* 1910). This was a common technique, developed on the steep sandstone cliffs of Saxony, whereby a climber stood on his or her partner's shoulders in order to reach a hold.

OPPOSITE, ABOVE A photograph-album page showing two British climbers on the summit of Mount Crown in the Canadian Rockies (A T Dalton, 1902).

OPPOSITE, BELOW *Bergführer Johann Steiner* ("The mountain guide Johann Steiner"; Gustav Gotzinger, 1904).

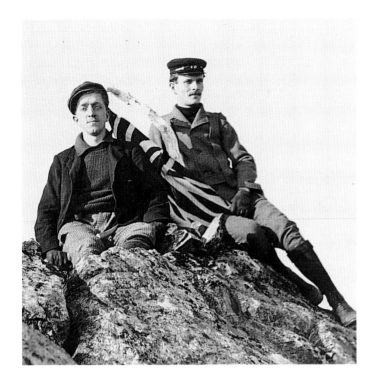

The only items of specialized climbing equipment in general use prior to World War I were the manila rope, long ice-axe, and nailed boots. Typical climbing attire for men comprised tweed jackets with wool trousers (just as they would have worn for work or for general travel), while female climbers were just starting to make the transition from dresses to trousers. There were no truly waterproof outer clothes. All this would change dramatically in the first half of the 20th century, as new techniques and new equipment (such as pitons for safety) developed to meet changing demands.

The relationship between photography and climbing continued to solidify in the early decades of the 20th century, bringing particular benefit for the amateur mountaineer-photographer. The succession of easy-to-operate hand cameras that had come into general use just before the turn of the century – such as Jules Carpentier's camera of 1892 (see pages 52–4), and the resilient and more sensitive silver-gelatin films – meant that any climber who wished to do so could make souvenir records of climbs without inviting along a specialist.

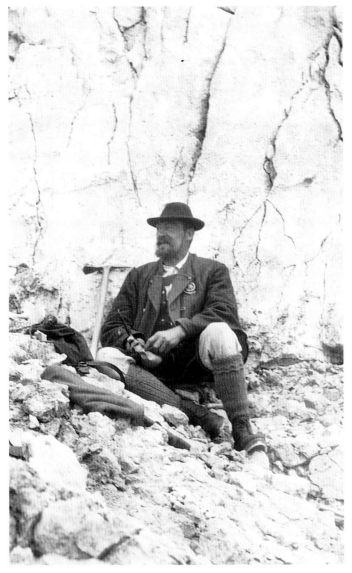

The small, hand-held camera had in fact been around since before 1860. In 1865 the British astronomer Charles Piazzi Smyth used a miniature camera during a research trip to Egypt. On his return he enlarged the 2.5 cm- (1 in)-square negatives, and in the process established new approaches to cropping images; prior to this, all images had simply been presented as they were taken. After the turn of the century, the introduction of better enlargers and printing paper meant that this procedure became standard practice, which in turn revolutionized theories of picture composition.

These technical advances did not entirely destroy the trade of the professional photographers, who still used the larger-format plate cameras; commercial souvenir photographers were also still in great demand in the mountain resorts. One enterprising photographer in the Sudtirol resort of Meran (now Merano) ran a business making souvenir postcards of his customers in dramatic climbing poses (he supplied the props) on steep rock just a few feet off the ground.

The various Alpine-Club journals continued to publish articles on photography in the mountains and to encourage their members to make pictures. The increased public interest in climbing created a greater market for photographs taken on climbs, and at about this time more monographs of mountain landscape and mountaineering photography began to be published. The realization began to dawn more widely that good photographers might actually be able to make a living by recording mountain experiences.

In the early years of the century the Alps remained the prime destination for mountain tourists. In addition to the challenging new routes being pioneered throughout the range, an entire holiday culture had evolved by this time, based on the less dramatic pleasures of simply hiking up to well-trodden summits. As a popular form of tourism and recreation, however, climbing was by no means restricted solely to the Alps. By the outbreak of World War I, the sport had also been well established in the Americas, New Zealand, Scandinavia, and Japan.

Canada in particular continued to form a focal point for climbers, and the town of Banff developed as a true mountaineering centre in much the same way as the Alpine resorts had already done. The advance of mountaineering here was influenced to a great degree by climbers trained in the Alps. In addition to the many British mountaineers, there was a large contingent of Swiss and Austrian professional guides resident in the Canadian climbing centres, many of them recruited and imported by the Canadian Pacific Rail Road in order to bolster the tourist industry.

One of the earliest photographers to capitalize on the industry of Canadian recreational tourism was a transplanted American named Byron Harmon (1876–1942). He arrived in Banff in 1903 and decided to stay, going on to become the leading photographer in the Canadian Rockies through the first half of the 20th century.

In addition to producing a huge variety of landscape views, Harmon specialized in photographs of the various forms of tourist activity in the Rockies: camping, trekking (horse-packing), and climbing. He sold many of these images locally as commercial souvenir photographs, providing tourists with a form of technically perfect representation of what they had already done and seen themselves during their holidays. One common characteristic of Harmon's images was their element of adventure and fun – of real enjoyment in the natural world. The pervasive spirit of nostalgia gives his photographs a continued popularity with tourists today.

The Canada of Byron Harmon's era was still a wilderness. Simply gaining access to the remaining unclimbed peaks involved serious expeditions, and hence discouraged the ambitious pioneering of new routes of a calibre equal to those being forced in the Alps. These expeditions thus followed the patterns of Alpine climbs of previous decades, with the first ascensionists seeking out the easiest routes to the summits, and second ascents generally taking place much later on. The great prize of Mount Robson, the

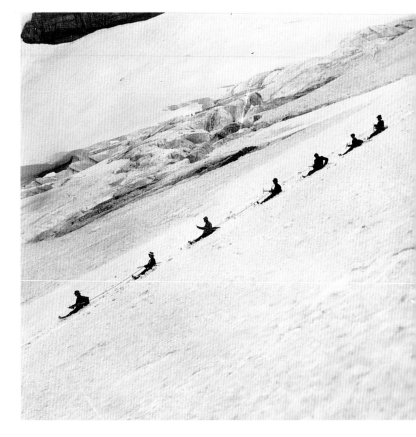

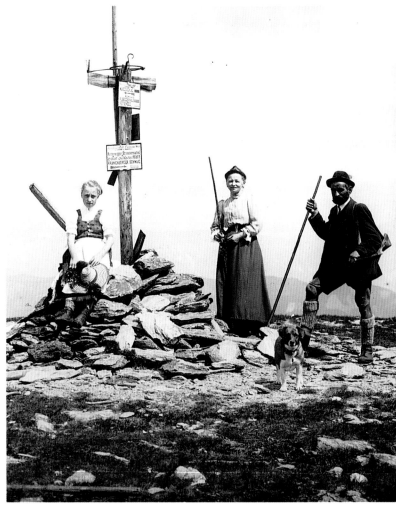

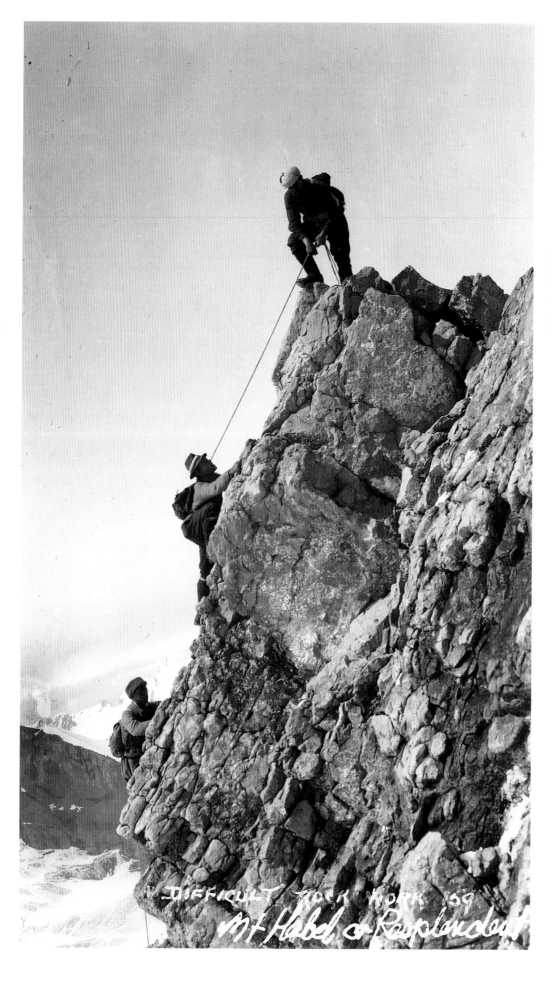

DIFFICULT ROCK WORK 159
Mt Habel or Resplendent

OPPOSITE, ABOVE *Group glissade
in the Canadian Rocky Mountains*
(Byron Harmon, 1909).

OPPOSITE, BELOW *Two women,
a guide, and dog on a walk-up summit*
(anonymous, Austria, *c.* 1910). This
photograph may represent the
most pedestrian type of mountain
recreation, but this *was* climbing
for a great many holidaymakers
in the early part of the century –
as of course it still is today.

LEFT *Difficult rock work* (Byron
Harmon, *c.* 1914). This picture of
climbers in the Canadian Rockies
was typical of the type of souvenir
photograph sold by Harmon to
the many tourists visiting the area.

RIGHT *The Grandes Jorasses, Mont Blanc* (Gugliermina brothers, *c.* 1910). Giovanni Battista and Giuseppe Gugliermina (1874–1962 and 1872–1960 respectively) were prominent climbers in the West Alps prior to World War I; they were also accomplished photographers who exhibited their work in the leading international shows.

OPPOSITE, ABOVE *Cresta Leone on the Matterhorn, with the Luigi Amedeo Hut visible below* (Mario Piacenza, *c.* 1910). The hut was named for the famous mountain-expedition leader, the Duke of the Abruzzi.

OPPOSITE, BELOW *Climbing in the Japanese Alps* (Mitsumaru Fujimoto, *c.* 1910). Fujimoto (1877–1940) was a chemist by profession, which probably explains his interest in photography.

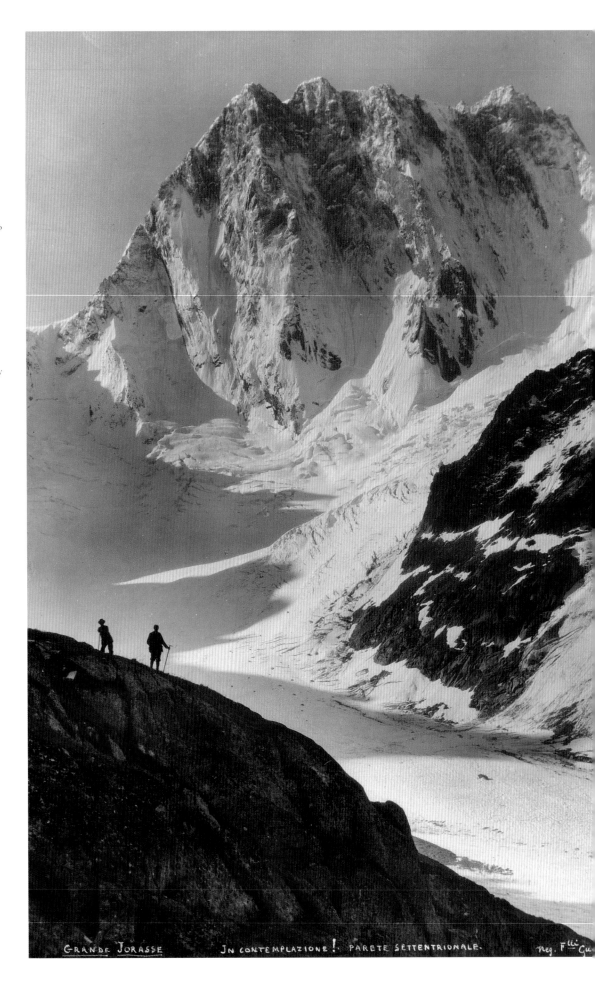

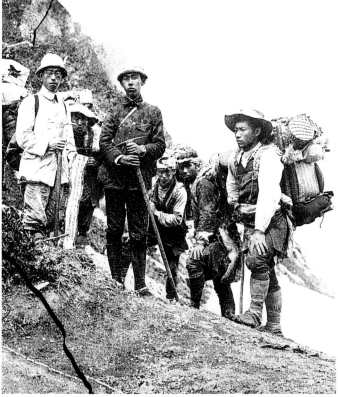

highest point in the Canadian Rockies at 3,950 m (12,960 ft), was finally claimed in 1913 by the Americans Albert MacCarthy and William Foster, led by the greatest of all the expatriate European guides, the Austrian Conrad Kain.

FURTHER INTERNATIONAL PROGRESS

The well-established tradition of climbing in the Alps exerted a huge influence on rapid photographic advances among European climbers. Now that the equipment made it possible to be both a serious climber and a photographer, the recording of ambitious climbing activity represented a new mountaineering challenge. Mario Piacenza (1884–1957) was both a dedicated alpinist and the second leading mountaineering photographer – after Vittorio Sella (see pages 54 and 56–7) – to come from the northern Italian mill town of Biella. Piacenza's many photographs from the Matterhorn (one of which is shown left) clearly demonstrate the new concern for taking pictures in real climbing situations, as well as the shift towards greater immediacy in mountaineering imagery.

The embracing of photography by greater numbers of climbers, combined with the rapid spread of mountaineering to the far corners of the globe, had a dramatic effect on the number and nature of the images being produced by climbers. Mountaineers had brought home photographs from distant lands before, but now it was no longer simply a case of European mountain tourists (mainly the British and Italians) gathering souvenir records of their exploits in the remote ranges. The locals were also becoming involved, and visual records of the period begin clearly to indicate that climbing – and photography – had truly become global pursuits.

Japan was another area of increasing interest in the mountains. Recreational climbing had been introduced to the country at around the turn of the century by a British missionary called Walter Weston. It became an "acceptable" activity, and the Japanese took to the pursuit with great zeal on their own mountains and abroad. One notable participant was the energetic and enterprising Japanese climber, Yuko Maki, who – to the delight of his fellow mountaineers at home – made the first ascent of the north-east ridge of the Eiger in 1921. Four years later Maki, together with five compatriots and three Swiss climbers, would snatch one of the real remaining plums of the Canadian Rockies with the first ascent of Mount Alberta; and, in 1938, a mixed Japanese-Swiss team made the first ascent of the north-east face of the Schreckhorn. These highlights were to set the stage for a huge surge in Japanese mountain activities after World War II, closely followed by Korean and Chinese involvement.

Climbing had always been a more democratic activity on the European mainland than in either Britain or America, especially prior to World War II. The inter-war period saw the rapid expansion of the Youth Hostel movement, which proved an important affiliate of mountaineering – especially among the growing body of student and working-class climbers.

While there were greater numbers of climbers emerging from the working class, the more important demographic distinction between 19th-century climbers and those of the inter-war years was one of age. Gone were the days when the cutting-edge climbs were made by sober, middle-aged mountaineers, and when the avant-garde climbing element mainly comprised members of the professional and leisured classes, or professional guides. This new group of climbers was different: they were young, and many were students with little money.

By now climbing clubs were cropping up everywhere. Unlike the exclusive Alpine Club of Britain, the other European clubs were fairly open to anyone with an interest in climbing. In North America, the members of the Alpine Club of Canada and of the two eastern clubs, the Appalachian Mountain Club and American Alpine Club, were drawn primarily from the professional class. However, local clubs – especially in the Northwest and Colorado – enthusiastically recruited newcomers from all walks of life.

The result was an era of club-related mountaineering activity. Membership fees and volunteer work enabled the development of a system of huts throughout the Alps, and of marked trails in North America; club members were also responsible for the growth of an industry devoted to outdoor recreation. And it was not only the business of guiding tourists on mountains or of providing transport and lodging that flourished; new enterprises also sprang up to provide growing legions of climbers with equipment.

This was a period of rapid progress in climbing technique, especially on rock. Artificial aid in climbing was not a new concept – Edward Whymper (see pages 26–30) had used a grappling hook, and the 1882 ascent of the Dent du Géant in the Mont Blanc massif (by cousins of the photographer Vittorio Sella) had involved iron pegs, fixed ropes, and even chipped holds – but the inter-war years saw the development of equipment and techniques for out-and-out warfare on the last great Alpine challenges. The East Alps, and the limestone buttresses of the Dolomites in particular, were the first great testing grounds for modern aid climbing, as pitons pounded

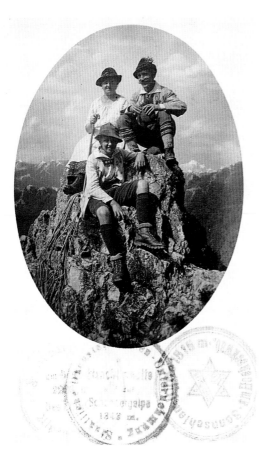

into rock to provide grips and footholds, together with sophisticated rope-handling strategies, allowed previously "unclimbable" cliffs (including overhangs) to be climbed for the first time.

Once these techniques had been proven, it became obvious that virtually anything could be climbed, given time and the correct equipment. This opened up tremendous possibilities, as well as great debate over climbing ethics. The one undeniable fact was that challenges inconceivable at the start of the century were being embraced, at least by younger climbers, as part of the new "game" – and the game had by now become much more dramatic.

In the West Alps, the older traditions and styles held on more persistently. There were still problems to solve on unclimbed ridges, but they could be overcome by traditional means. The top young French climbers of the immediate post-war years went on to form the élite *Groupe de Haute Montagne*, and became widely known for their daring free-climbs (they resisted at first the eastern trend towards finding any means to overcome obstacles, eschewing the new aid techniques as "engineering"). The push was on to succeed on ever-harder routes but, until the 1930s, there were few radical departures from traditional alpine technique in the West Alps.

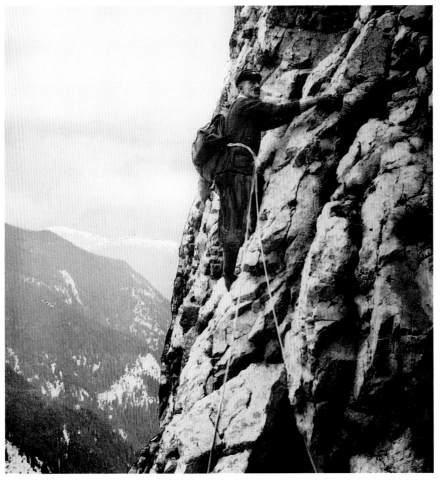

OPPOSITE *Climbers in the Mont Blanc Massif* (Georges Tairraz Sr, 1920). This is an early example of a photographer and climbers creating an image of excitement and daring purely for the camera. There is no reason why these alpinists would approach such a cornice other than to make a dramatic photograph.

ABOVE LEFT A record of a family outing, with souvenir hut stamps (anonymous, *c.* 1925).

LEFT *Zimmersteig in Gross Hollental* ("Stepped ascent in the Gross Hollen Valley"; anonymous, Austria, 1925).

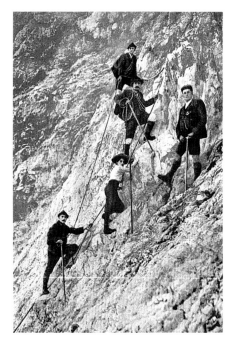

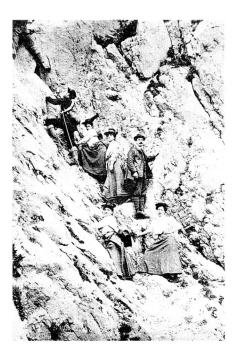

RIGHT AND OPPOSITE The postcard is the consummate souvenir image. It is an ideal way of sharing adventures with friends, and is something to keep as a personal memento. This selection of early 20th-century cards is part of an excellent collection owned by the German Alpine Club.

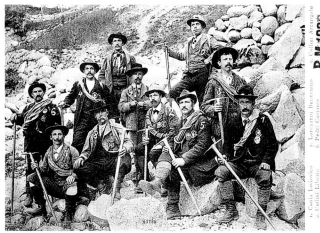

Gaisloch im Winter.

Rax 2009 m.

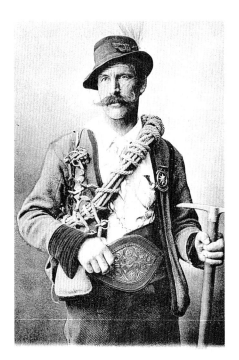

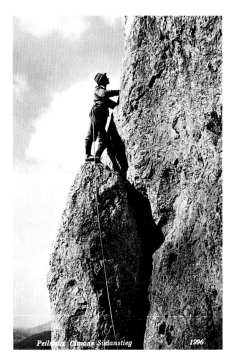

Peilstein Cimone Südanstieg 1996

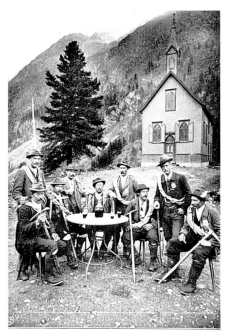

Bergführer vor der Gepatschkapelle (1928 m).

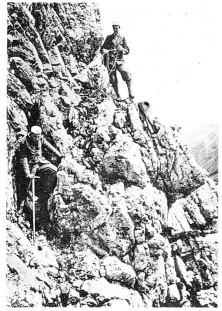

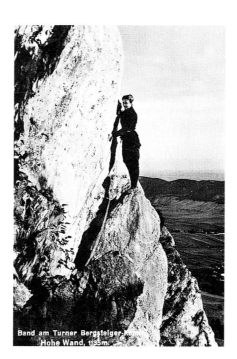

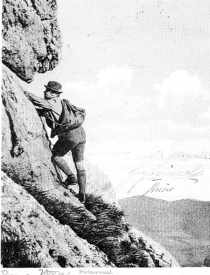

Kletterei auf der Hochschwab-Südwand.

Band am Turner Bergsteiger-kam
Hohe Wand, 1155m.

Preinerwand.

Rax

o. Verlag: C. Kronich, Otto Haus, Rax. Nachdruck verboten.

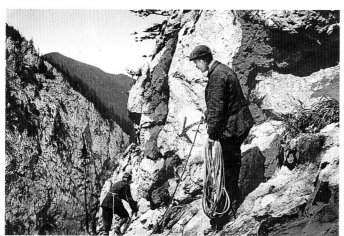

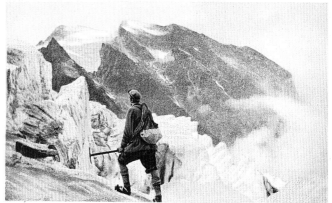

Stubaier Alpen — Lisenzer Fernerkogel

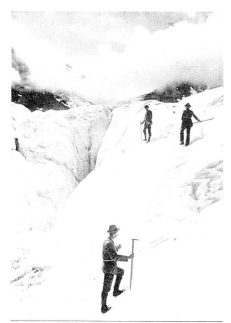

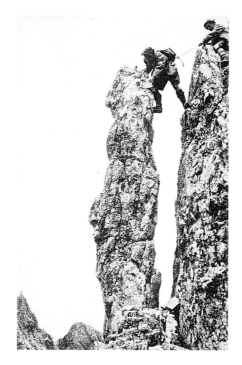

Auf dem Gepatschferner. Tirol.

spalte beim Anstieg zum Hohen Dachstein 2996 m
Salzkammergut 8918. Monopa

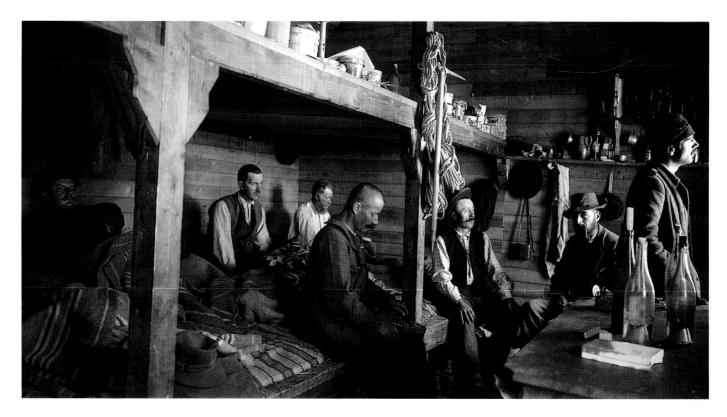

SMALL-FORMAT CAMERAS

Photography quickly resumed its progress following World War I, with innovations in camera equipment and use forming a bridge between images past and present. Jules Carpentier's hand camera (see pages 52–4) had proved so successful that many competing models followed, and these were improved, made foldable, and given wider-aperture lenses to allow photography in lower light. The small-format plate camera reached its zenith in 1924 with the German-produced Ermanox and Lunar cameras; these had lenses of very wide aperture, allowing photography in dim light and giving an extraordinary top shutter speed of $\frac{1}{1000}$th of a second.

Another significant advance came in that year when the Ernst Leitz company, also in Germany, released its new-format camera, the Leica. The key to the Leica's development was its use of 35-mm film, a material that was readily available and perfect for amateur photography. The film had previously been introduced for cinematic use, and had become a standard for film-makers; it gave reasonably high image quality for enlargement, while the perforations allowed the film to advance smoothly and remain flat. This 35-mm film was also extremely compact, and well protected in its spooled rolls.

As in other areas of documentary photography, the development of compact cameras created a totally new way of making climbing photographs. The small-format camera, with its capacity to hold numerous frames on a single roll of film, and with interchangeable

lenses, would revolutionize photography on both amateur and professional levels. The Leica was followed quickly by the Contax, manufactured by Zeiss Ikon, and the 35-mm format has dominated mountaineering photography ever since.

In the Alps, new standards in photography were set by several leading alpinists, including André Roch and Georges Tairraz Jr (examples of both men's work are shown here). Tairraz – the third in the family dynasty (see pages 10–11) – was intent on completing a comprehensive documentation of the Mont Blanc massif. He made his first climbing film in 1924 and achieved greatest success as a documentary film-maker, but continued to produce spectacular still photographs and to undertake ambitious climbs in the West Alps.

The new light, self-contained cameras were perfect for climbers. There have subsequently been many improvements – better films, more efficient light meters, improved lenses, and features such as motor-drives and automatic settings – but by the mid-1920s the equipment had reached a sophistication with which mountaineering photography could move forward as quickly as climbers wished to take it. Until this point, advances had been tied to changes in the photographic industry but, from here on, progress had more to do with changes in the sport and with the imagination of individual photographers than with developments in their equipment.

There were still changes to come before climbing photography would lose its antique look. Colour process was slow to develop. As early as 1903, a pioneer form of colour photography appeared in the Alpine Club's annual exhibition. For the first three decades of the century the antique Autochrome process remained in use; developed in 1903 by the Lumière brothers, this used a positive

OPPOSITE, ABOVE *Ancien refuge du Couvercle* ("The old Couvercle hut"; Georges Tairraz, Jr, *c.* 1933).

OPPOSITE, BELOW *Traverse of the Aiguille du Midi* (Georges Tairraz Jr, Mont Blanc, *c.* 1933).

LEFT *André Roch and his girlfriend resting on the Salève* (André Roch collection, 1926). The career of Roch, a Swiss alpinist, spanned five decades and included important ascents in the Alps as well as in the higher ranges of Asia and North America. His images frequently appeared in the Swiss Alpine Club journal, and illustrated his books: *The World of the Haute Route Summits* and *Classic Climbs in the Alps*.

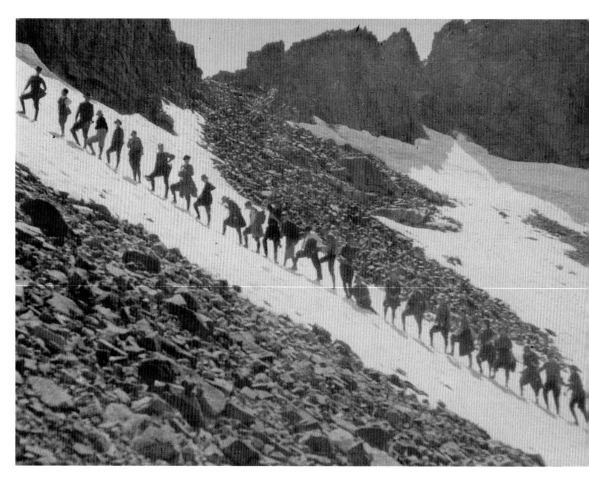

Five lantern slides from the library
of the Colorado Mountain Club
(anonymous, USA, *c.* 1920–25).
CLOCKWISE FROM TOP LEFT *Climbing
Aztec; Serious work; Climbing Eolus*
(two images); and *Wild Basin outing.*

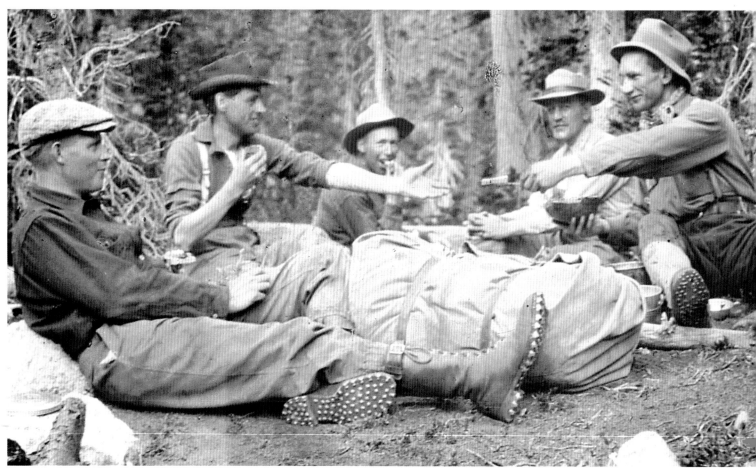

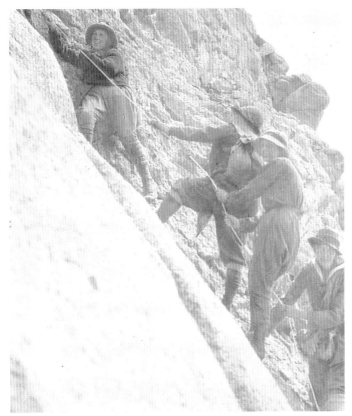

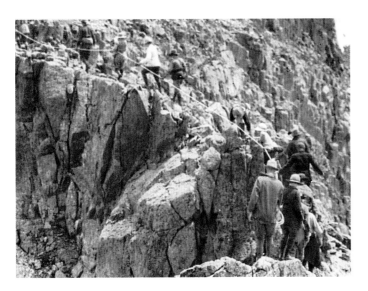

(rather than a negative) transparency, and was marketed until 1932. The next real revolutions only came with the introduction of Kodachrome slide film in 1936 and Kodacolor print film in 1941. Although colour is almost universal among amateur photographers today, it was surprisingly slow to catch on, and black-and-white photographs continued to dominate publications until the 1970s.

ACTIVITY IN NORTH AMERICA

Until just after World War I, American climbers were primarily peak-baggers in the traditional 19th-century sense (see page 54). Their climbing was still tied to wilderness exploration, and they were not yet concerned with embracing difficult routes just for the sake of the challenge – the object was simply to get up mountains.

Excepting the mountain playground of western Canada, the two major areas of climbing activity at the start of the century – Longs Peak and the Cascades – were within range of Denver and Seattle. Longs Peak became the Colorado version of the many notable Alpine scramble-ups; local clubs also promoted a (low-key) approach to mountaineering, with many organized group climbs. In the Cascades, climbing remained essentially peak-bagging for an even longer period than in Colorado. The long tradition of guides herding long lines of tourists up Mount Rainier dates back to before the turn of the century, and club climbing typically consisted of snow slogs up the gentle slopes of volcanic cones. It would be the mid-1930s before anything even marginally ambitious was attempted in the Northwest, although one tradition that did develop here was that of toughness in the face of bad weather and difficult approaches.

In North America, most of the real technical progress was initiated in the eastern states, for much the same reason that the new wave of "high-tech" rock-climbing in Europe was advanced primarily in the lower East Alps and even in the German hill country, quite distant from the Alps. In other words, when climbers have no great choice of dramatic peaks on which to practise their art, they must find challenges where they lie. For a Bostonian, that meant crag-climbing in summer, and iced gullies and frozen waterfalls in winter. In the east there was also a greater awareness of progressive trends in Europe, and these climbers embraced the new techniques for technical crag climbs and for their winter ascents of the gullies.

The aesthetic that developed here focused on short, hard, technical climbs, with activities led by members of the Appalachian Mountain Club, and of the clubs at Harvard, Yale, and Dartmouth. European-trained eastern-American climbers such as Robert Underhill (see

page 82) marked the first wave of influence, in the 1920s. The German-born Fritz Wiessner – a talented mountaineer who had pioneered hard rock climbs in Saxony and the East Alps, and who led the 1939 American assault on K2 (see page 87) – was to prove the guiding light from the east through the next decade.

THE MUNICH SCHOOL

If mountaineering appeared to be just muddling along in North America, this was certainly not so in the Alps. The phenomenon of high-performance climbing known as the Munich School, with its seriousness and forcefulness of purpose, did not simply spring fully formed from the collective imagination of the East Alp climbers. Nor was it, as some have maintained, entirely a manifestation of the socio-political atmosphere of inter-war Germany.

There can be no doubt that the waste of life in World War I had a chilling effect on the European psyche; the war also intensified feelings of national pride and prejudice. With its strident call to ultra-performance, filled with Nietszchean undertones and Aryan smugness, the Munich School was – for most students of climbing history – firmly tied to Nazism. The dynamic, ambitious qualities promoted by the School were, however, largely just a matter of progress, and part of the mountaineering spirit. The 19th-century push to conquer unclimbed Alpine peaks had been the earliest manifestation of the need to move forward, and this was inevitably followed by the progression to more difficult routes on climbed peaks, and to the search for unclimbed summits in more remote ranges. Yet by World War I climbing had reached a plateau – and a plateau is not an interesting place for a mountaineer to reside.

In order truly to progress, climbers needed to break ranks with the protocols of the previous generation. The great British mountaineer, Albert Frederick Mummery, had understood this well before the advent of the Munich School, and was sometimes criticized by the staid British climbing community which often looked askance at his progressive approach. Mummery, who had disappeared in the first serious attempt on an 8,000-m (26,200-ft) Himalayan peak in 1895, was greatly admired by disciples of the new German movement.

Fuelled by the enthusiasm of a new breed of hard young climbers, the Munich School during the 1920s was progressive in technique and aggressive in attitude. Climbing may have been a sport, but it was taken very seriously indeed. In the East Alps, rock technique (both free-climbing and aid-climbing) developed rapidly, and there also continued a long tradition of unguided and even solo climbing.

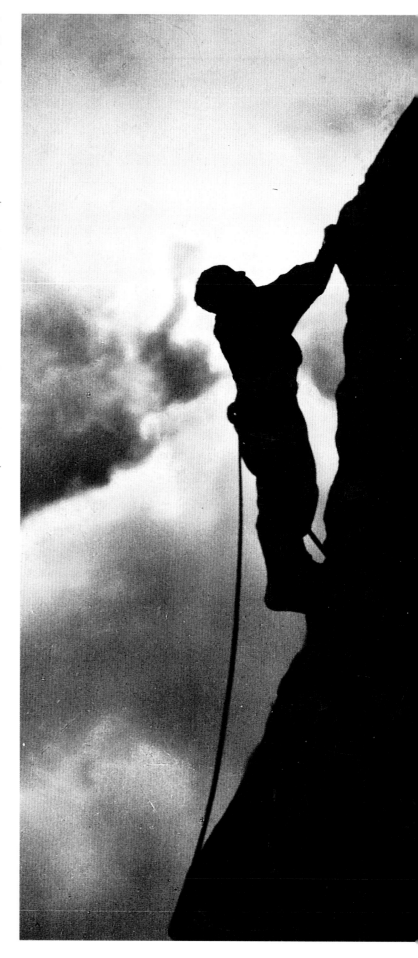

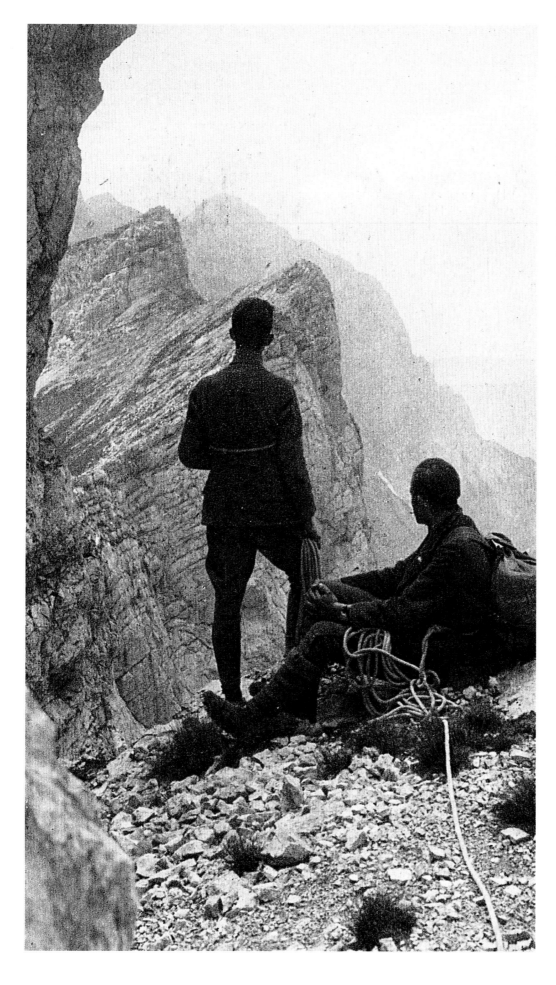

OPPOSITE *Approaching an overhang* (anonymous, *c.* 1930). Now that small-format cameras made picture-taking so much easier, photographers began to progress from purely documentary images to more atmospheric shots.

LEFT *The Rosskuppengrat* (anonymous, *c.* 1925). Even by this stage, climbers' clothing had progressed very little from that of their predecessors. It was a situation that would only change with the development of new light, waterproof materials (including nylon) during the war.

RIGHT The height of East-Alp climbing fashion between the wars (anonymous, *c*. 1925).

OPPOSITE, ABOVE *Emilio Comici* (anonymous, Italy, *c*. 1930). Comici has been captured here during a technical moment on a climb

OPPOSITE, BELOW *Alpine-style Climbing in Japan* (Shigehiro Nojima, 1933). The advances in climbing technique and the increasingly ambitious projects characteristic of the Alps were spreading by this time to other climbing areas. As far away as Japan, climbers were starting to push back the limits.

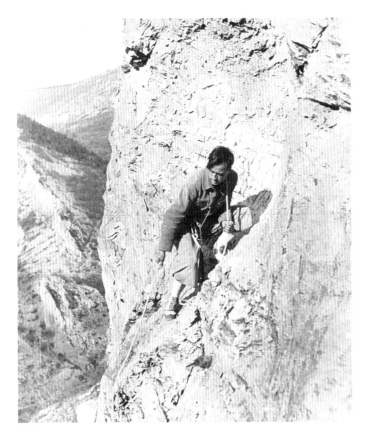

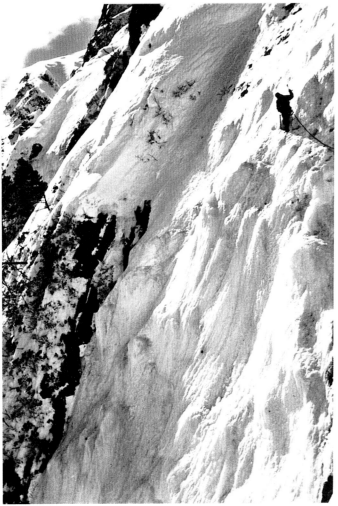

This was not strictly a rock-climbing movement; Willo Welzenbach, for instance, an influential member of the group, was known for his ice-climbing skills. He devised some of the first techniques for protecting with pitons on ice, and invented an ice-hammer that allowed attempts on ambitious routes. In many ways Welzenbach, who died with eight others in an attempt on Nanga Parbat in 1934, epitomized the Munich School character: the uncompromising pursuit of high performance, founded on innovation and hard work.

INCREASED COMPETITION

By the late 1920s, the Munich School adherents began to venture out from their East Alp enclaves to spread their style to the older bastions of alpinism. In 1930, Karl Brendel and Hermann Schaller climbed the south ridge of the Aiguille Noire de Peuterey, establishing a new standard for difficult rock routes in the Mont Blanc massif. The next year, Willo Welzenbach, after virtually exhausting north-face challenges in the East Alps, made a much-publicized ascent of the north face of the Grands Charmoz, before conquering one north face after another in the Bernese Oberland. Had he not died on Nanga Parbat, Welzenbach would surely have focused next on the prized north face of the Eiger, and may well have succeeded.

The inter-war years in the Alps were dominated by German, Austrian, and Italian climbers. Significantly, the three great north-face routes – the Eiger (see page 80), Matterhorn, and Grandes Jorasses – were all first climbed by Germans and Austrians. In August 1931, Franz and Toni Schmid bicycled from Munich to conquer the north face of the Matterhorn, one of the most compelling problems remaining in the Alps; the same year, Anderl Heckmair and Gustl Kroner cycled west to mount a strong but unsuccessful bid on the Grandes Jorasses north face (later climbed by two Germans in 1935).

These increased north-face activities coincided with the growing political friction in Europe. Many Germans and Austrians found financial support from the Nazi propaganda machine: they were sponsored climbers, striving to maintain their backing through spectacular success. When it was not Germans and Austrians claiming the prizes, it was generally the Italians. In 1933, Emilio Comici engineered an aid route up the north face of the Cima Grande di Lavaredo in what was possibly the first pure aid ascent in the Dolomites. One of the great limestone climbers of his era, Comici adhered to the ideal of the *direttissima* as the most aesthetic line of ascent. Four years later, Riccardo Cassin led a great victory on the north-east face of the Piz Badile, a climb made even more dramatic by the deaths of two young Italians from exposure and exhaustion.

The British largely relinquished their lead in the technical advance of mountaineering during the first half of the 20th century, largely due to their general rejection of the more extreme approaches being pioneered by climbers from mainland Europe. As a result, while the British climbing establishment carped about the violation of mountain ethics represented by pitons and crampons, the Germans, Austrians, and Italians moved to the fore in the push towards more ambitious Alpine projects. In the meantime, the British continued to develop rock-climbing on their home crags along traditional lines; they also became increasingly involved in Himalayan expeditions. There were seven official British expeditions to Everest between the wars. Three reached over 8,000 m (26,200 ft), including the famous 1924 attempt by George Leigh Mallory and Andrew Irvine, last seen by a team member at 8,600 m (28,200 ft) before they disappeared.

THE GREAT ALPINE CHALLENGES

Of all the great achievements taking place throughout the Alps, the north face of the Eiger attracted most attention. The media latched on to the sensational story of the race to crack this last great north wall, and the public was suitably enthralled and shocked by the attendant stories of tragedy and despair, as eight climbers died in early attempts. Two teams, from Munich and Vienna, finally made the ascent in 1938. Together with the Matterhorn triumph and tragedy of the previous century and the British success on Everest in 1953, the Eiger story was instrumental in forming the non-climbing public's perception of mountaineering.

These dramatic events being played out on the harsh north faces of the Alps, and the triumphs and tragedies of the big Himalayan campaigns, brought climbing more and more to public attention. The new element of intensity in the sport matched the growing political tension in Europe and, while there had always been adventure, now there was a real sense of courting death. There was also a distinct rise in competitiveness, as the stakes were raised higher and higher.

Despite the momentous achievements of the era, it would be wrong to assume that the extremism of the Munich School entirely defined the alpine scene between the wars. Throughout this period of rapid advancement, there were still many thousands of casual climbers enjoying themselves on recreational climbs at every level; and, of course, the competitive frenzy in the Alps had much less effect on climbing away from Europe and the Himalayas. The three images shown here, from the collection of the Austrian Touring Club, capture this opposite end of the spectrum in representing very ordinary slices of climbing life in the Alps between the wars.

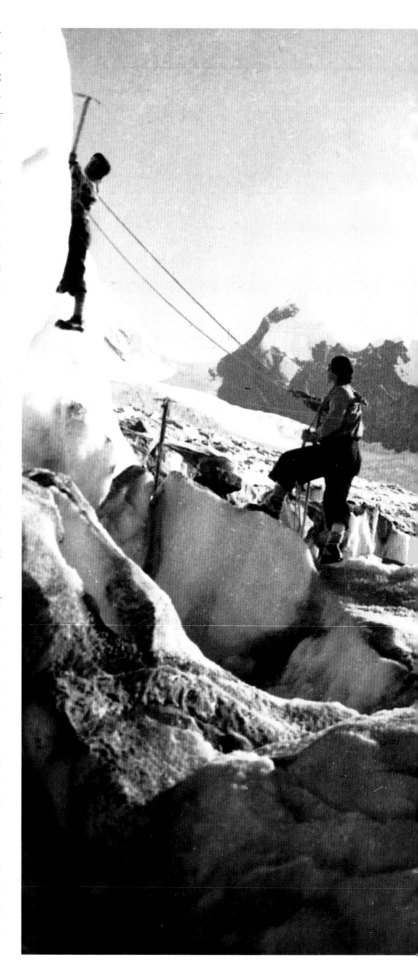

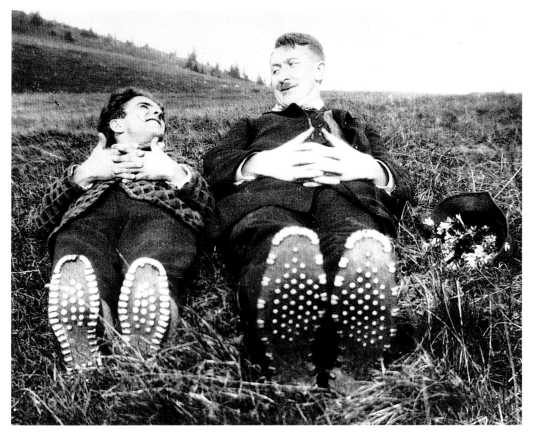

OPPOSITE *Glacier climbing* (Rudolf Sommereder, *c*. 1935).

LEFT *Nailed boots of prone climbers* (Karl Baumgartner, *c*. 1935). A century earlier, mountaineering had been a highly esoteric activity tied directly to conquest and discovery of the unknown, but the sport had by this time evolved into a multi-dimensional recreational activity enjoyed by participants of all abilities and from every part of society.

BELOW *Resting climber, Grossglockner* (Fred Mauersperger, *c*. 1935).

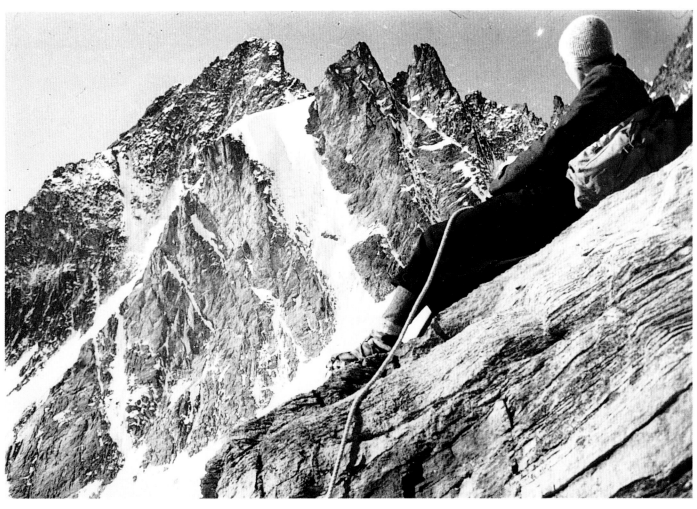

EUROPEAN INFLUENCES IN AMERICA

The efforts of the Munich School – and the standards that it set – served as an impetus for climbers of other nationalities. Even in Britain, where the mountaineering establishment looked askance both at the extreme techniques and at the hawkish attitudes of climbing's new wave, the performances were none the less admired by those who had ambition themselves. Throughout the climbing fraternity, the competitive urge of the Munich School produced a push towards ever-higher standards.

American climbers, although somewhat behind the times and generally removed from the currents that drifted through the Alps and Britain, were more apt to borrow freely from the traditions of other schools, with little regard for the parochialism that often limited more established climbing society. In truth, there was no real climbing establishment in the States, and Americans seemed to adopt the philosophy: "If it works, use it."

American climbing between the wars was, however, transformed not only by the importation from Europe of new techniques and equipment, but by a clear shift in attitude. In 1922 James Alexander forced a route up the east face of Longs Peak, and this highly popular Colorado tourist scramble soon became the focus for more ambitious climbers. In 1927, Joe and Paul Stettner (two immigrants from Germany who became leading figures in inter-war Colorado rock-climbing) put up what was at that time the most difficult rock climb in the United States, again on the east face of Longs Peak.

It was clear that climbers with European experience were making an impression; in fact, several of the most advanced climbers on the American mountaineering scene in the first half of the 20th century had learned their craft in the Alps or in Britain. Fritz Wiessner (see also page 76) and Jack Durrance – prime movers in American climbing between the wars – were both influenced by the aggressive, avant-garde approaches developed in the East Alps. Robert Underhill had climbed extensively in the West Alps prior to his important pioneering of new routes in the early 1930s in that most Alp-like American range, the Tetons; he was also a key figure in initiating technical rock-climbing in New England and California.

Underhill introduced modern rope techniques of belaying and protecting with pitons to a group of Sierra Club climbers in the early 1930s. At about the same time, a number of climbers in the San Francisco area began to experiment with advanced belaying techniques at their local practice rocks, and were the first pure rock-climbers in the land that would become the rock-climbing capital

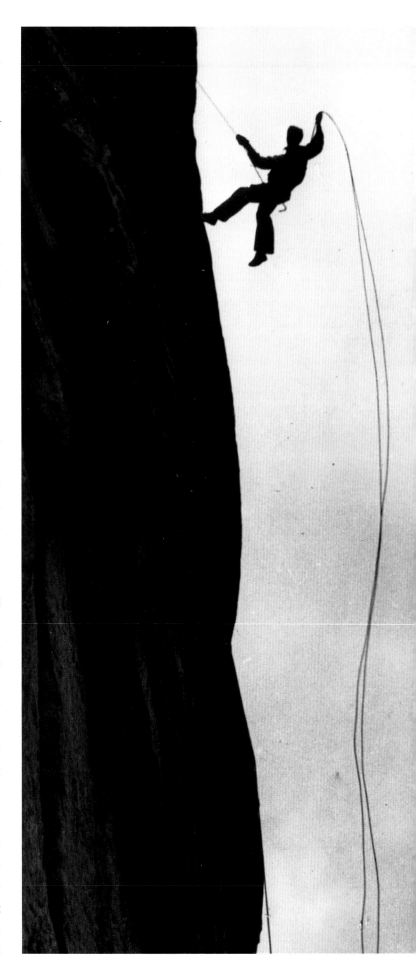

of the world a generation later. These two factions combined to make the first serious excursions into California's Yosemite Valley, and the Sierrans developed a whole series of new techniques specifically suited to the steep, smooth spires of granite found there.

By World War II, the Sierrans had evolved into arguably the most advanced rock-climbers anywhere. They set a new standard on the Cathedral Spires (the largest free-standing spires in California) and already had ambitions for the vertical Half Dome and the Lost Arrow. When they placed expansion bolts for protection on an ascent of Shiprock, a 520-m (1,700-ft) desert spire in New Mexico, the first steps had been taken in a revolution of technical climbing.

MORE AMBITIOUS CLIMBS

The inter-war period was the great era of the photo-illustrated, general-interest magazine. In Europe, especially, climbing became increasingly popular, and by the 1930s the media was technically geared up to cover it. The first non-club climbing magazine, *The Mountaineering Journal*, was launched in 1932 and ran until 1938.

OPPOSITE *Descent from Lower Cathedral Spire* (Richard Leonard, the Yosemite Valley, California, c. 1935).

BELOW *Rock-climbing on Lower Cathedral Spire* (Richard Leonard, the Yosemite Valley, c. 1935).

At the same time, the new cameras (see pages 72–3) allowed for greater immediacy in climbing photography, and for the added drama of images drawn from real climbing situations. The climbers themselves were also providing more dramatic subject matter, both with more daring climbs undertaken in their home ranges and with the exoticism of expeditions to the big ranges farther afield.

The great range of the Caucasus was seldom visited just after the Russian Revolution, but did revive for a brief but intensive period from the late 1920s until the start of World War II. It was during this time of great activity – mostly by Austrian and German parties – that the Russians themselves developed an interest in serious mountaineering, beyond the standard walk-up of Mount Elbrus.

Alaskan and northern Canadian summits were late to be climbed, due largely to their difficult access across many miles of wilderness. Amid considerable controversy over who reached which summit and when, Mount McKinley, at 6,200 m (20,300 ft), was officially climbed in 1913. Although the mercurial Duke of the Abruzzi, with Vittorio Sella (see pages 54 and 56–7), had climbed Mount St Elias, at 5,500 m (18,000 ft), in 1897, a second ascent was not made until 1946. The last major unconquered peak in the Canadian Rockies, Mount Alberta, at 3,620 m (11,870 ft), was not climbed until 1925, with no second ascent achieved for a further 23 years. Mount Waddington, 3,990 m (13,090 ft), in the Canadian Coast Mountains, repulsed several strong attempts before the American climber Bill House, together with Fritz Wiessner, succeeded in 1936.

As in other mountain regions, these first ascents were made by the routes that were deemed easiest. Even so, an Alaskan or northern Canadian expedition was a major undertaking, requiring logistical skills, determination, and great endurance. Although the technical expertise of American climbers may have lagged behind during this period, the tradition of toughness on the long hauls, and the ability to cope with the strains of big-mountain projects, continued to be a strong suit for the wilderness-oriented North Americans.

In the Andes, the lower peak of Huascaran was climbed in 1908 by the noted American climber Annie Peck with the Swiss guides Taugwalder and zum Taugwald (the higher summit would remain unclimbed until 1932, when it fell to an Austro-German party). The Germans and Austrians had a distinct advantage in the Andes, as there were many Germans residing in South America; there was even a Chilean section of the German-Austrian Alpine Club. The Andes served as a valuable high-altitude and expedition training ground for the extensive Austro-German activities in the Himalayas.

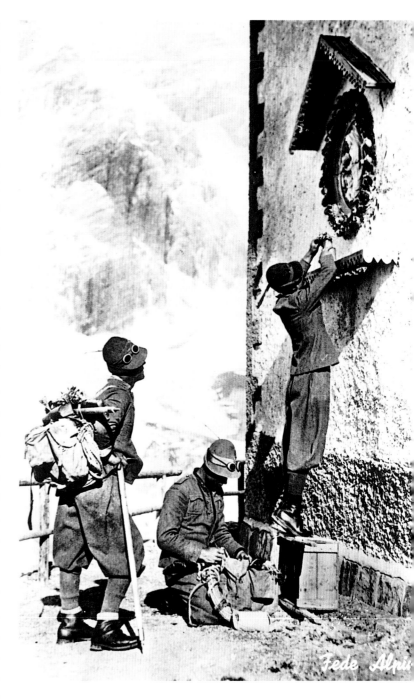

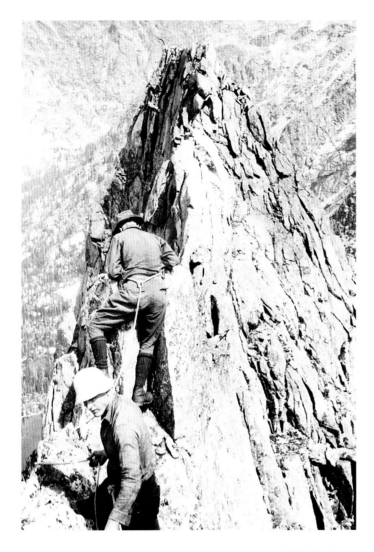

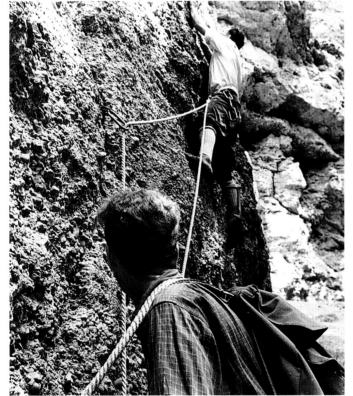

Despite all the first ascents and new routes being forged in North America, greater attention was focused elsewhere. The images that helped mountaineering to become a public sensation (at least in Europe) were those from the big Himalayan climbs of the period.

It is no surprise that the British developed a monopoly on Everest between the wars, because until Indian independence in 1948 they enjoyed a tremendous logistical advantage in the region. Nepal was closed to all foreign travel until 1950, so early Everest expeditions approached through Tibet. Through British diplomacy, the Dalai Lama's administration made Everest attempts a strictly one-nation affair. However, it was an affair fraught with disappointment, as one failure after another highlighted the risk of taking on the world's highest summit with technology that was simply not up to the task.

Much has been made of the influence of nationalism on Germany's Himalayan ambitions. The argument is that the Germans felt compelled to prove their strength according to the then current interpretation of the Nietszchean ideal, and that this was responsible for their tremendous drive and for the tragedies that ensued (two climbers died on Kangchenjunga in 1931, 11 on Nanga Parbat in 1934, and 16 on that mountain in 1937). This is doubtless true, but it was also true that the Germans – and climbers everywhere – wanted to attempt Everest, and the only way they could break the British hold was to prove their ability. They therefore made more accessible peaks such as Kangchenjunga their special arena. Like the British on Everest, however, they would have to wait until after the war to conquer what had become their chief obsession, Nanga Parbat.

There certainly was a rise of nationalism in the 1930s, and the way it manifested itself in the climbing world is clear. The climbers of the Munich School were imbued with a conquest mentality, and were intent on constantly pushing back the limits.

OPPOSITE, ABOVE Italian soldiers at a refuge (anonymous, c. 1935).

OPPOSITE, BELOW 1930s' lantern slides, wrapped in Swastika paper.

ABOVE LEFT *Lindburgh Peak, Colorado* (anonymous, USA, c. 1935). For 180 m (200 yds) the approach is a knife-edge, with a sheer drop on either side.

LEFT *Klettergarten* ("The Climbing Garden"; anonymous, Germany, 1937).

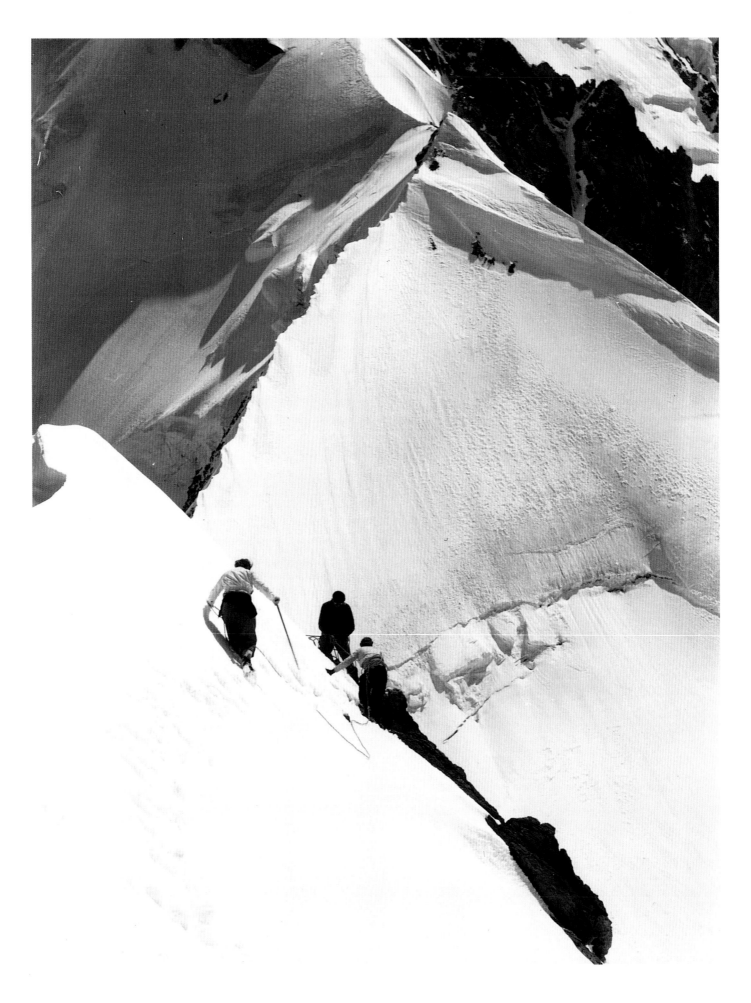

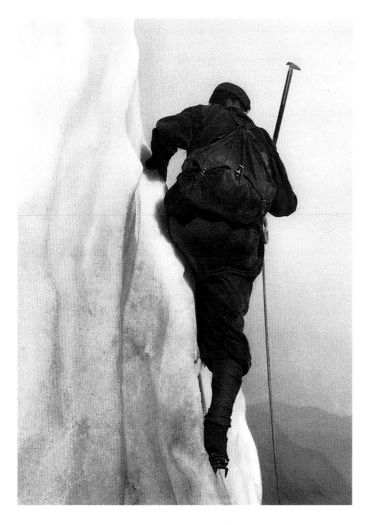

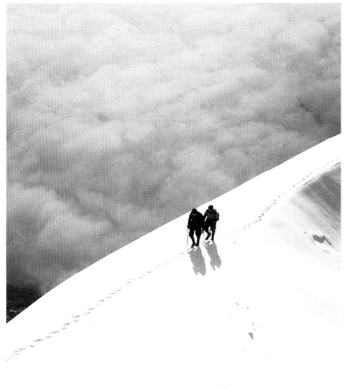

CONTINUING PROGRESS IN THE 1930S

Although American climbers had been insignificant in the advance of mountaineering in Europe, their experience of wilderness travel and climbing far from support facilities made them particularly well suited to expedition activity. Americans scored a major success in 1932 when a four-man team made the first ascent of Minya Konka, at 7,590 m (24,900 ft), in the Szechwan range on the eastern edge of Tibet. However, it was K2 that became the major preoccupation for American mountaineers. Unsuccessful attempts in 1938 and 1939 suggested that K2 might become for American climbers what Everest was for the British, and Nanga Parbat for the Germans.

Photography continued to advance, with notable work produced by individuals such as the Briton Frank Smythe (1900–49), a leading climbing photographer of the period. Smythe became a highly successful professional adventure journalist while still in his 20s; he had in fact been at the fore of the alpine climbing scene since 1927, when he and another British climber, Graham Brown, forged two new routes on the challenging Brenva face of Mont Blanc. In 1931, Smythe led the ascent of Kamet, at 7,755 m (25,445 ft) the highest Himalayan summit then attained (this was not an altitude record, however, since climbers had been higher on Everest). Two years later, he made his highest photographs, at 8,500 m (27,880 ft) on Everest. A brilliant alpinist and expedition climber, Smythe's careerist attitude caused friction among traditional members of the British establishment, for whom professionalism (along with pitons, crampons, and other progressive equipment) was anathema.

Smythe in some ways was a manifestation of a new sort of adventure photographer. Earlier photographers had often had to choose between making pictures and participating in serious climbs. Professionals such as Jules Beck or Vittorio Sella (see pages 40–43, 54, and 56–7) may have understood the importance of recording climbing activity, not just landscapes; but, aside from a handful of small-format images by Sella, their photographs were generally not made at the most dramatic moments. Smythe was the forerunner of a battalion of later professionals who have undertaken serious

OPPOSITE *Descending the Aiguille de Bionnassay* (Frank Smythe, 1939).

ABOVE LEFT *Glacier Ascent, Switzerland* (Emile Gos, c. 1930)

LEFT *Early morning on the Zermatt Weisshorn* (Frank Smythe, 1939).

climbing projects and made photographs along the way. He was more of an "adventure journalist" than a traditional photographer like Sella or even his contemporary, Georges Tairraz (see pages 72–3). The strength of his work lay in the ambition of the climbing projects that he undertook rather than in his photographic skill; like Chris Bonington and Reinhold Messner a generation later, it was a matter of doing exciting things that people wanted to read about.

THE APPROACH OF WAR

While mountaineering's star figures were chasing thrills and glory around the world, and advancing the standards and accomplishments of the sport, the home ranges and crags continued to be the scene of weekend and holiday activity for a growing number of climbers at all levels of ability. Climbs that just a decade earlier had been the exclusive domain of a handful of élite full-time climbers were now being enjoyed regularly by advanced amateurs.

As the last great north-face problems in the Alps were solved, there was no longer a sense of exploration. An extensive system of huts and trails made climbing here convenient and straightforward, even for the city dweller, while the great publicity over the major climbs and expeditions increased public interest. Although not yet fully in the mainstream, by the end of the 1930s alpinism was no longer the highly esoteric pursuit it had been at the start of the century.

It was unfortunate that all this physically and spiritually positive activity had to be curtailed, as World War II brought the advance of mountaineering to an abrupt halt. With the onset of hostilities in the Pacific at the end of 1940, it became obvious that this conflict would be far more of a global affair than the earlier "Great War". The Alps – climbing's technical and spiritual wellspring – were in the middle of a Europe in turmoil, while most of the principal climbing protagonists – the British, German, French, Austrians, and Italians – were now the major actors in a far more serious pursuit.

Even in neutral Switzerland, mountain activity slowed to a near standstill, cut off as it was from the outside world. The climbers on Swiss peaks were among the fortunate few to continue enjoying themselves on mountains during the war years.

RIGHT *Schreckhorn Westwand* ("West face of the Schreckhorn"; Oskar Hug, Switzerland, 1941).

OPPOSITE *Nordgrat des Weisshorns* ("North ridge of the Weisshorn"; Emil de Waldkirch, Switzerland, 1943).

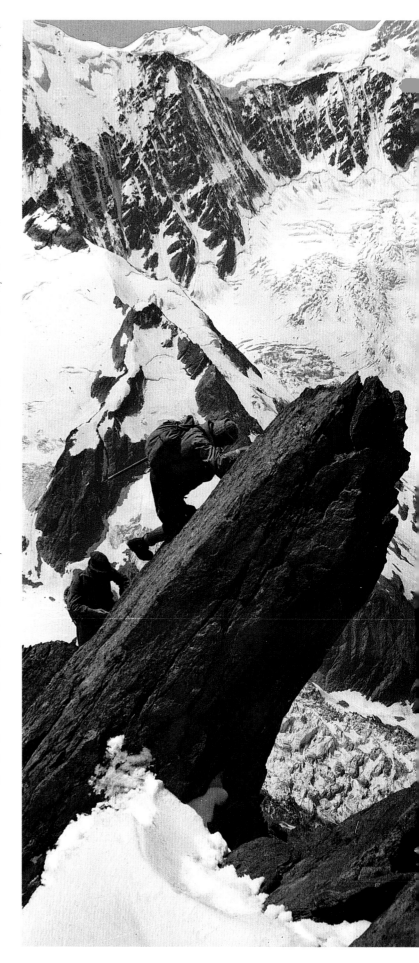

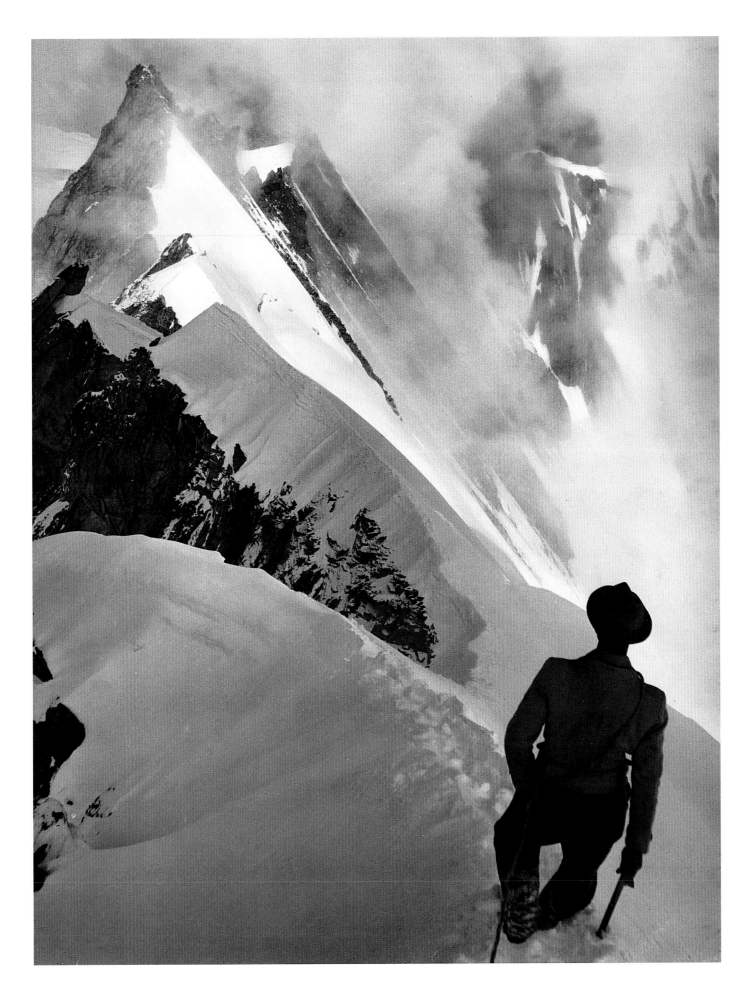

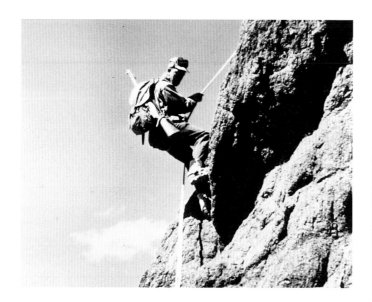

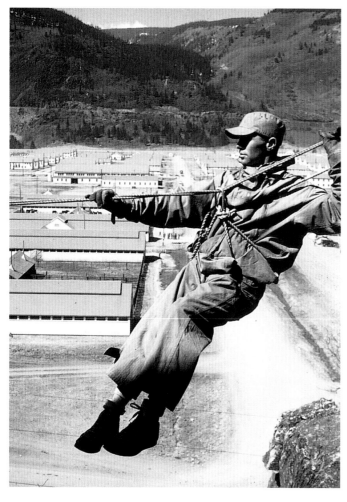

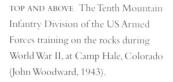

TOP AND ABOVE The Tenth Mountain Infantry Division of the US Armed Forces training on the rocks during World War II, at Camp Hale, Colorado (John Woodward, 1943).

RIGHT *The great ice cascade on Mount Deception, Alaska* (Bradford Washburn, 1944).

CLIMBING IN WARTIME

Even in areas more distant from the scenes of conflict, conscription, travel restrictions, and rationing put a damper on local climbing activity. There must also have been a sense that participating in the sport at such a time of global turmoil and tragedy was a rather trivial and wasteful pursuit. Even in the relatively safe climbing venues of the Americas, mountaineering languished as a result.

The years of conflict were, however, not entirely devoid of climbing activity, and in several significant ways the war effort would have a tremendous bearing on its post-war resumption. The training of mountain troops provided a systematic programme for introducing many young men to mountaineering, and in America and Britain this was particularly effective in bringing individuals from outside the usual class structure of mountaineering to the activity. The Austrians, Germans, and Italians had already established a high level of competence in mountain warfare, and now the British and the Americans would pursue this less attractive side of the sport as well.

In occupied France, the *Jeunesse et Montagne* (Mountain Youth) movement provided valuable training for the generation of climbers who would emerge in the following decade as some of the world's leading alpinists and expedition climbers. The great French climbing successes of the 1950s (notably on Annapurna; see page 102) were partly due to the enforced leisure enjoyed by the youth of Vichy France. They could not fight (officially, at least), but they could climb. So they kept busy in the West Alps, where, for the very first time, the French had the Mont Blanc massif to themselves.

Prior to the mid-1940s there had been little communication within the rather fragmented American climbing scene. However, the establishment of the US Tenth Mountain Infantry Division in 1943 brought together some of the country's best climbers, many serving as instructors. Climbers from the east, the Rocky Mountains, and the Northwest were gathered as part of a structure that had barely existed before, and the resulting exchange of ideas would have a considerable impact when leisure climbing resumed after the war.

The second great change was the development of lighter, better equipment. Nylon rope, angle pitons, and lightweight carabiners all came out of the war effort. Nylon, being waterproof and ultra-light, also had a profound effect on climbing clothing and tents, and wartime research produced major improvements in the oxygen-breathing apparatus so critical to high-altitude expedition climbing. When the war came to its end, climbers were poised to jump back into the recreational fray with all these technological advantages.

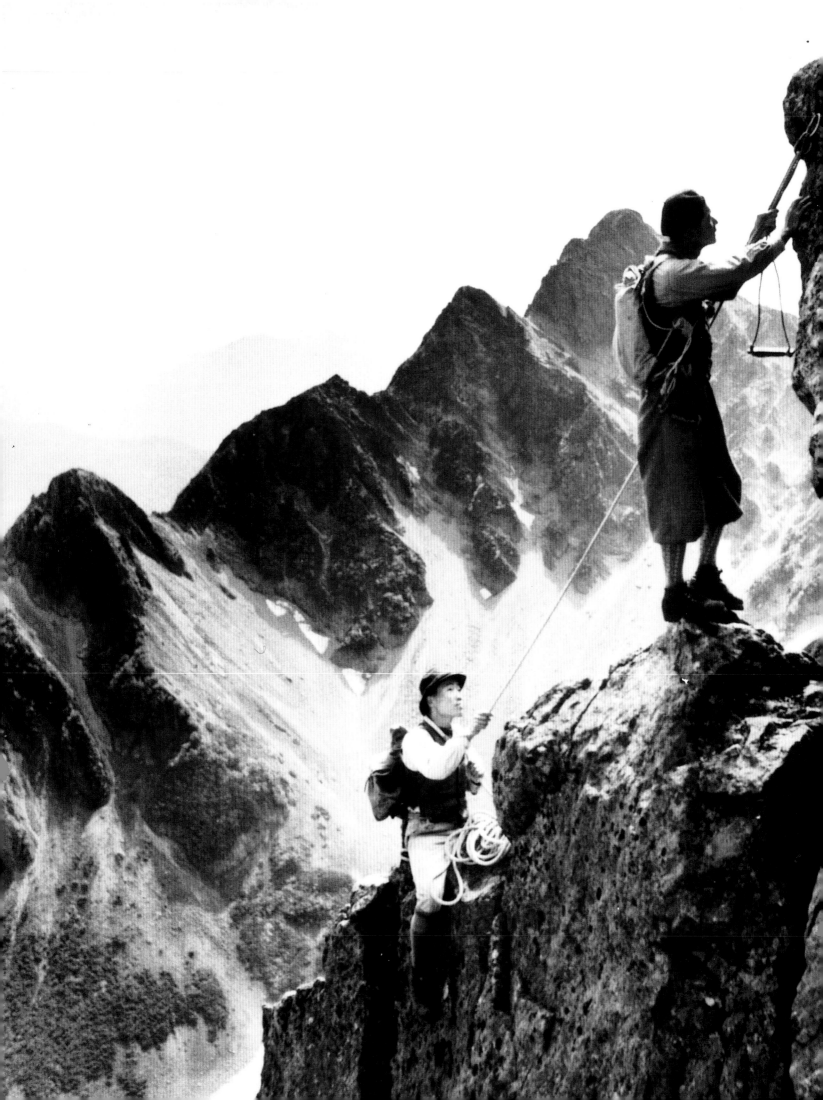

POST-WAR MOUNTAINEERING PHOTOGRAPHY

Climbing as a sport continued to grow in popularity following the war, with new clothing and equipment making possible numerous groundbreaking ascents.

INTO THE MODERN ERA

Immediately upon the conclusion of World War II, mountaineers resumed their activity. As the armies demobilized, thousands of fit young men were released from service. Many of them had been climbers before the war, while others were newly conditioned to the sensation of excitement – and fear – that could find an outlet in the challenges presented by the mountains.

The French entered enthusiastically into the post-war climbing scene. In 1945, Gaston Rébuffat and Edouard Frendo made the second ascent of the Walker Spur of the Grandes Jorasses; two years later, Louis Lachenal and Lionel Terray made the second ascent of the Eigerwand. Rébuffat, Lachenal, and Terray would all go on to play major roles in later French successes in expedition climbing, including the landmark ascent of Annapurna in 1950, under the leadership of Maurice Herzog (see page 102).

The British slowly regained their earlier leadership status, although it was a different type of climber who emerged from the war's social upheaval. In addition to the Alpine Club and the traditional clubs at Oxford and Cambridge, smaller regional clubs now became more active. As a result, some of Britain's finest post-war climbers came from working-class backgrounds, and from parts of the country quite apart from the mainstream of the earlier establishment.

It is little cause for wonder that the French and British (and, of course, the neutral Swiss) should have quickly returned to the fore, but the resumption of peacetime mountain activity must also have held a special meaning for climbers from the former Axis nations. Defeated and humbled, their countries overrun by the Allies, the East Alps provided a refuge of sorts for the German and Austrian survivors, while for the Italians there was a sense in every aspect

LEFT *Climbing an overhang in the Japanese Alps* (Takeharu Maeda, 1953).

of life that the war's end meant the termination of a grim and costly mistake. It is interesting – although understandable – that the Austro-German climbing force which had dominated the whole of the Alps just prior to the war was slow to emerge from its East Alp enclave, whereas the Italians came rather quickly back on to the climbing scene in the West Alps.

Nor was it solely the climbers of war-torn Europe who returned with great vigour to mountain sport. Climbers the world over were freed not only from the physical dangers and prohibitions of war, but also from the sheer pessimism of the times: people were ready to resume a full and enjoyable life. Notably, the post-war rise of Japanese mountaineering from relative obscurity to the forefront of the international expedition scene parallels – and in some ways symbolizes – that nation's emergence from the depths of wartime tragedy to the pinnacle of prosperity occupied by Japan today.

INCREASED EXPEDITION ACTIVITY

Throughout the post-war period, mountaineering grew steadily in popularity. Organizations such as Outward Bound (founded in Britain), together with a huge range of commercial climbing schools and associations, promoted the sport among an ever-broadening spectrum of the public. Climbing clubs also greatly increased their activities, and new mountain clothing and equipment helped to spur the rapid return to ambitious projects in the mountains.

Mountaineering in the Alps now focused on greater challenges, such as winter ascents of the great wall problems of the pre-war era. There was a continuing trend towards climbing harder and faster, and, as the Alps became more crowded, serious climbing expeditions spilled over to the more remote ranges.

Also evident was a return to the intense pursuit of first ascents that had characterized the "Golden Age" of mountaineering (see pages 29–30) – but this time transplanted to exotic regions, as more aggressive activity was focused on the Andes and the Himalayas. Less expensive and logistically simpler than climbing in the Himalayas, the Andes in particular witnessed a tremendous variety of small, independent expedition activity from the 1950s onwards. To the south of the Andes, Patagonia also became a magnet for climbers looking for new challenges on vertical granite. At the far end of the Western Hemisphere, Alaskan mountains began to open up as a popular venue for expedition activity. Last but not least, New Zealand proved an ideal training ground for climbers who would later participate in important expeditions throughout the world.

There was little interaction between Soviet and Western climbers just after World War II. Although Soviet climbing was promoted by the state sports machine, technical standards lagged far behind those of the West, as did access to advanced equipment (disadvantages that appear to have had greater effects on the standard of rock-climbing than on mountaineering). However, the lengthy tradition that the Soviets had previously developed for highly physical, extended mountain traverses proved useful training for successful expeditions during the Cold War era, primarily in the Pamirs.

As for mountaineering in the Alps, the Italian climber Walter Bonatti and Frenchman René Desmaison (both b. 1930) were the acknowledged champions of the 1950s and 1960s. Bonatti burst on to the mountain scene with many projects of unprecedented difficulty and daring, including a solo ascent of the south-west pillar of the Petit Dru in 1955 and the first winter ascent of the Walker Spur of the Grandes Jorasses in 1963. In 1965, at the age of 35, he bowed out of the mountaineering limelight with a spectacular winter solo climb of a new, direct route on the north face of the Matterhorn. Desmaison was primarily known for his daring winter ascents and solo climbs. Meanwhile, Austrian climber Hermann Buhl established a reputation for courage and toughness in his native East Alps, before making an everlasting mark on Himalayan climbing with a series of tremendous feats, starting with an epic 1953 solo ascent (see page 104) of Nanga Parbat, at 8,114 m (26,620 ft).

The British also made their presence known in the Alps, with the arrival of a group of dedicated young climbers who would go on to set some of the highest standards in world mountaineering over the next two decades. While the British were still the leaders in large-scale Himalayan expeditions of the period, with a reputation cemented by their landmark success of 1953 on Mount Everest (see pages 102–4), their aggressive renewal of high-level achievement in the West Alps was equally noteworthy.

The 1950s and 1960s may stand out as a rather difficult transitional era in the photographic representation of mountain sport. This period was perhaps still a little too close to display the nostalgic exoticism of the distant past but not, as yet, a time of brilliant colour and dramatic photographic style.

The climbing projects themselves were certainly dramatic enough, with mountaineers such as Bonatti and Desmaison producing one audacious Alpine first after another, and with increasingly ambitious challenges taking place in the arena of international expedition climbing. However, the photographic coverage of these highly exciting events largely lacked the eye for drama, the thoroughness, and the technical polish that would really distinguish mountain photography in the following decades. Until the mid-1970s, it seems, climbers were primarily interested in getting up mountains rather than in recording their exploits. Still, there were a number of serious and skilled climber-photographers at work, including the Briton C D Milner (examples of his work are shown on pages 94 and 95) and, continuing the long tradition of masterful Italian climbing photographers, Fosco Maraini and Mario Fantin.

One photographer working in the post-war period who certainly was producing dramatic results was the American, Bradford Washburn (b. 1910). Chiefly recognized for his spectacular large-format aerial mountain landscapes (as well as for his important

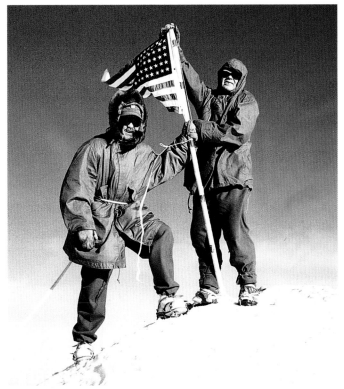

FAR LEFT *The East Ridge of the Doldenhorn, Bernese Oberland* (Bradford Washburn, 1960). Washburn took this stunning photograph just after several days of heavy snowfall, through which the climbers are wading (the footsteps of two other parties that climbed this ridge before the storm are also visible behind the group). It is an exaltation of light and form – an image unsurpassed in mountain representation – yet it also addresses with great eloquence the reasons why people climb.

LEFT *Bill Hackett and Jim Gale on the first ascent of the West Buttress Route, Mount McKinley, Alaska* (Bradford Washburn, 1951).

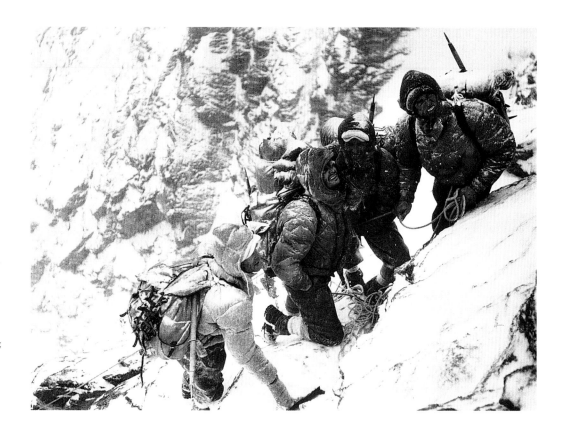

work in the field of topographic visualization), Washburn's aerial view of distant climbers on the summit ridge of the Doldenhorn in the Bernese Oberland (see pages 96–7) is universally acknowledged as one of the greatest landscape photographs of all time.

Washburn has had a long and very diverse involvement with mountaineering, tracing back to the period just after World War I. In the late 1920s he was climbing at a high standard in the West Alps; he also participated in several important inter-war expeditions in the Yukon and Alaska, and his many outstanding photographs of Mount McKinley served as the impetus towards opening up new routes on the peak. Nor was it solely as a photographer that Washburn pioneered in Alaska. In 1951, he led the team that opened up a new route on the West Buttress (see photograph on page 97), which today is the most popular option on the mountain.

Despite the increased attractions of mountaineering in the farther, higher, and more exotic ranges, the Alps continued to play their role as a source of inspiration and a focal point for mountaineers. There were certainly still great challenges to be found here, as climbers devised new ways to give climbs a more difficult standard than they had previously held. Guido Monzino's fine image of four alpinists on an autumn traverse in the West Alps (see above) speaks volumes about the pain, joy, and challenges of mixed, alpine-style climbing. The climb looks cold, uncomfortable, difficult, frightening – and yet at the same time quite wonderful.

Antoinette Frissell's more conventional image of a perfect day in the mountains, in the vicinity of Zermatt (see opposite), can be more readily appreciated as a justification for why people choose to climb – then as now. Frissell was a skilful professional photographer and an avid alpinist. She enjoyed an extremely successful 40-year career as a commercial fashion photographer, and was one of the earliest women to find regular work as a sports photo-journalist.

In general, the impact of photographic advances since the end of World War II has been rather small. Cameras and (in particular) films have progressed but, up until the recent introduction of digital, non-film technology, improvements over the compact 35-mm cameras and films of the 1950s have been only slight. Motor drives and improved long telephoto lenses have assisted professional climbing photographers in expanding their capacity for dramatic imagery, but these advances have actually had little impact on the picture-making of amateur photographers.

The new generation of light, durable, fully automatic "point-and-shoot" snapshot cameras has made climbing photography both more convenient and more affordable. These cameras are also somewhat more conducive to candid picture-making *en route*, as they require considerably less concern either for operation or for their own safety than did earlier models with many moving parts. However, a state-of-the-art Leica or Contax of a 1935 vintage is not significantly different from the cameras carried by most climbers today.

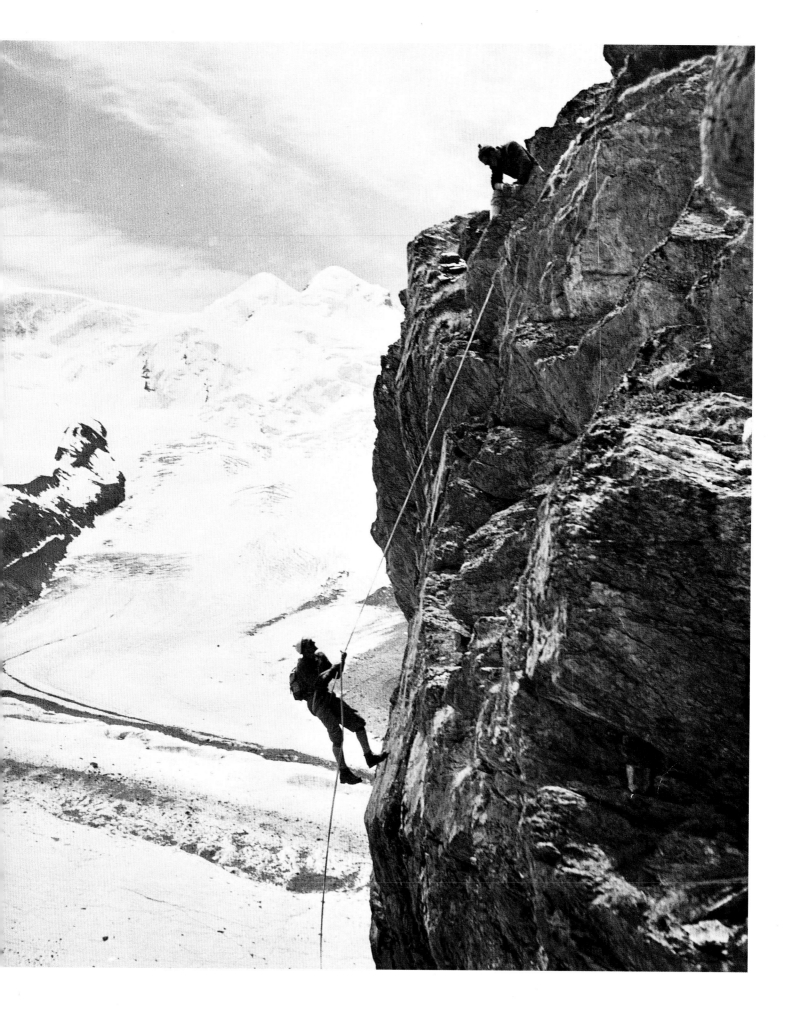

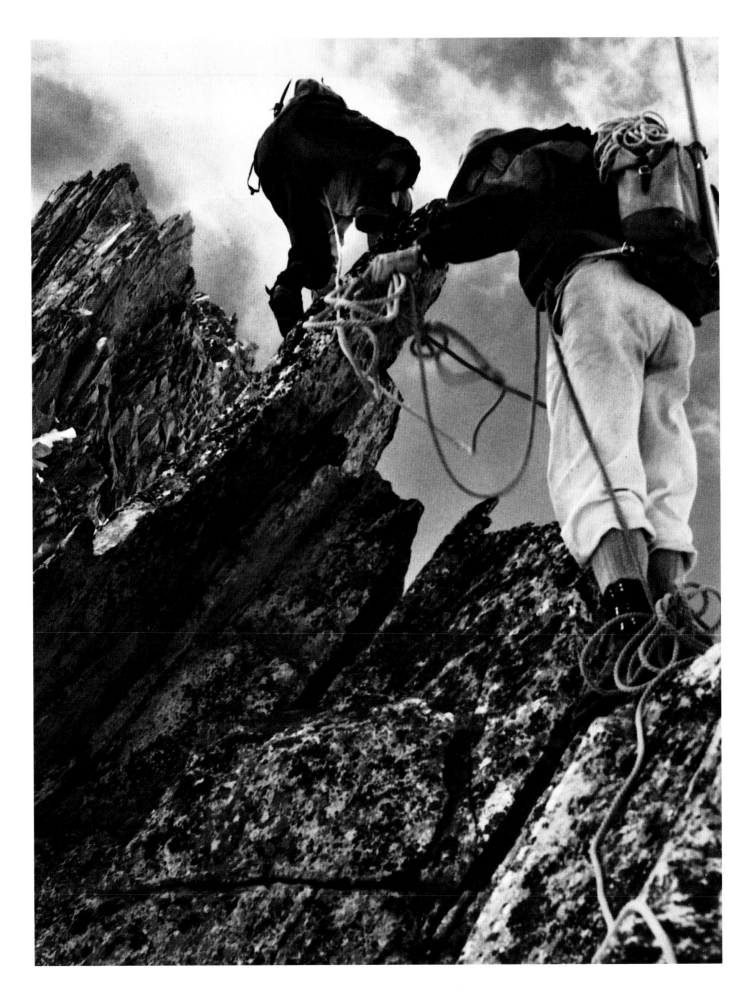

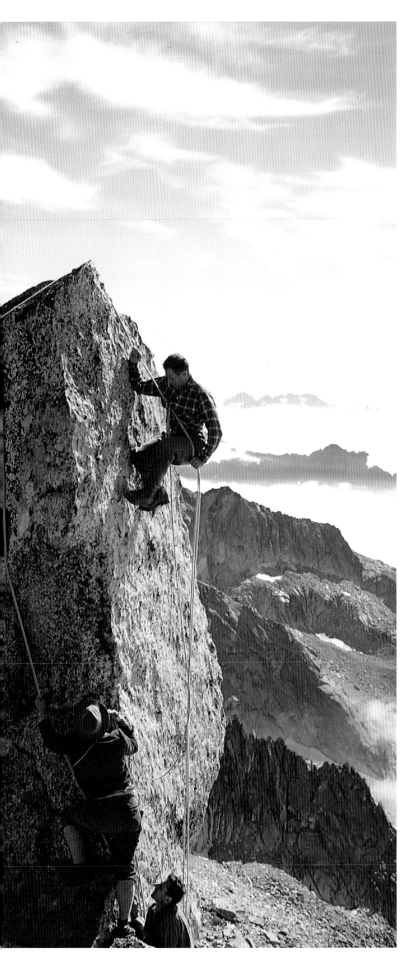

THE CHANGING LOOK OF CLIMBING

Colour films for amateur photographers have undergone steady improvements over the years but, since the 1936 introduction of Kodachrome (see page 75), there has been remarkably little change in the quality realizable by serious colour photographers. With the exception of the climbers' dress (and the dangerous-looking rope), Dr Aldo Godenzi's 1953 Kodachrome taken on the Punta Sertori (see left) might have been taken last summer.

What has changed dramatically is the *look* of both rock-climbing and mountaineering. There has been a thorough transformation in the representation of mountain sport, both in terms of what climbers do and what they wear. Styles of climbing, as well as of equipment and fashion, evolved relatively slowly over the decades from the early 1900s to the early 1950s, making it sometimes difficult to date precisely a climbing image of the inter-war period based on the appearance of the climbers. However, changes in clothing and equipment have become increasingly pronounced since World War II. There has also been a trend towards more dramatic projects, undertaken in more exotic locations.

Another aspect of climbing photography that changed significantly after the war was the sheer number of images being made. This was due to three main factors: increased participation in the sport, increased publicity of and by the climbing élite, and a much greater camera-consciousness. More climbing images appeared, both in the rapidly expanding climbing media and in the mainstream media, creating increased demand for good photographer-climbers. People also tended to take more of their own photographic souvenirs.

In other words, the more imagery that was consumed, the more visually sophisticated the audience became, and this in turn had an impact on the sorts of photographs produced by amateurs often in an attempt to emulate what they were seeing in the media.

FAR LEFT *Climbers on the Grossen Diamantstock* (Dr Aldo Godenzi, Switzerland, 1953). The capacity of the 35-mm camera for working in close is evident in this image of a classic Alpine ridge climb. The result is a real sense of participation, as if the viewer were next on the rope.

LEFT *Climbers roping down from the Punta Sertori* (Dr Aldo Godenzi, Switerland, 1953).

GLOBAL ACTIVITY

During the 1950s and '60s the Canadian Rockies continued to be a popular destination for casual holiday climbers, the majority of whom came from the United States, Europe, and Japan. Indeed, until the mid-1960s most of the climbing in western Canada consisted either of "milk-runs" up tourist routes or of traditional peak-bagging of remote unclimbed summits (one exception was the ambitious 1961 ascent of the north face of Edith Cavell, undertaken by Americans Yvon Chouinard, Fred Beckey, and Dan Doody). Only when the remaining unclimbed summits fell would serious mountaineers turn their full attention to more demanding routes.

The advances that had been made in outdoor materials and equipment during the war meant that mountaineers were now well equipped for the rigours of high-altitude climbing. The hitherto closed kingdom of Nepal was also opened to foreigners for the first time, greatly influencing the scope for expedition climbing in the Himalayas. The first post-war Himalayan expedition was mounted in 1947 by the Swiss, alone among the mountaineering nations in having abstained from the conflict. The redoubtable climber-photographer André Roch (see also page 75) led a Swiss team to the fairly accessible Garhwal Range, where the group climbed Kedarnath at 6,940 m (22,830 ft) and Satopanth at 7,075 m (23,270 ft).

Over the next 20 years, almost 60 major Himalayan summits would see first ascents. In addition to the sheer number of expeditions, the range of participation also broadened dramatically – this was no longer an Anglo-Austro-German-Italian-Swiss affair. Indeed, during the 1960s and 1970s Japanese climbers would be more likely to be found in the Himalayas than would any other nationality; while in the 1980s the presence of Eastern Europeans, Americans, and Koreans swelled the numbers still further.

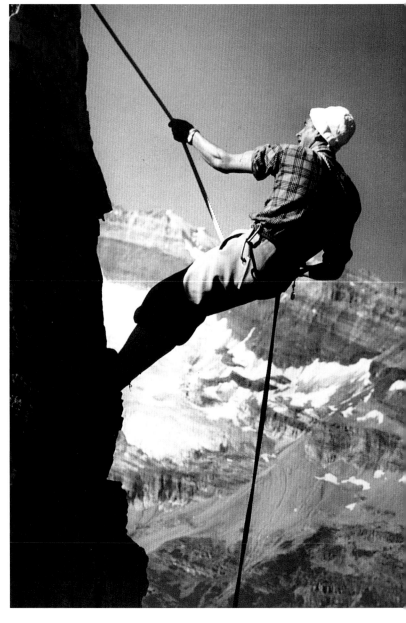

The first great post-war accomplishment in the Himalayas was the brilliant 1950 French success on Annapurna, under the leadership of Maurice Herzog. It was the first peak of over 8,000 m (26,200 ft) to be climbed and, although greater heights had been achieved on Everest and K2 before the war, it was reaching the summits that inevitably captured the public imagination. Only one of Herzog's team had been to the Himalayas before, and the expedition maps were wildly inaccurate, yet the French approached the giants of the range as if they had been part of the Mont Blanc massif.

However, Everest remained the chief plum and, when the British rule of India ended in 1948, the bid for the first ascent was opened up to all comers. The French and Swiss had already demonstrated

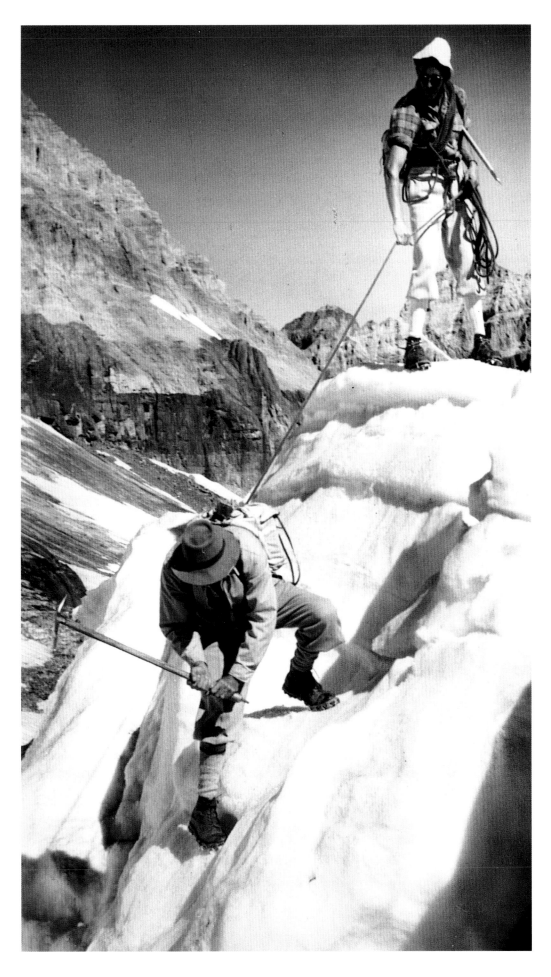

OPPOSITE, ABOVE *Mexican club climbers on the summit of Mount Victoria* (Eduardo Sanvicente, Canadian Rockies, 1954). During the descent, three of these women tragically fell to their deaths.

OPPOSITE, BELOW; AND LEFT Two images from the Canadian Rockies (Georgia Engelhard, *c.*1955). An American mountaineer, photographer and writer, Engelhard made repeated visits to the Rocky Mountains in the 1950s and 1960s, accomplishing 32 first ascents here and in the Purcell Range. She photographed extensively on all her climbing expeditions, both in Canada and in the West Alps.

their abilities. If the British were to commemorate the crowning of their new Queen in the summer of 1953 with a conquest of the world's highest summit, they would have to do it quickly. Two brave attempts by the Swiss failed in 1952, and the British were waiting in the wings. Just before noon on 29 May 1953, Edmund Hillary and Sherpa Tenzing Norgay left the first footprints on top of the world.

HIGH SUCCESS

Just five weeks after the British success on Everest, an Austro-German expedition finally slayed its old dragon when the Austrian Hermann Buhl summited Nanga Parbat (the only member of the team to do so). After 58 years of failed attempts, together with the loss of over 30 lives, the mountain had finally yielded to a truly remarkable mountaineer. The climb was largely overshadowed in the public eye by the conquest of Everest, yet it remains one of the sport's outstanding moments of human endurance and triumph.

American mountaineers must have viewed the British and Austro-German successes as good omens for their own attempt on their old foe, K2. In August of the same year a strong team of eight climbers was poised above 7,620 m (25,000 ft), ready to stock a final camp at a higher level before sending teams up to the 8,610-m (28,250-ft) summit. Unfortunately, 10 days of storm and the critical illness of one climber ended a promising attempt; the retreat from K2 was an epic of pain and sorrow that involved the death of one climber and serious injury to two others. The next year, in better conditions, Achille Compagnoni and Lino Lacedilli, members of an Italian team, took the first summit photographs from K2 (see above right).

In 1961 Edmund Hillary led the "Himalayan Scientific Expedition", which spent an entire winter in a hut at 5,790 m (19,000 ft). An American called Barry Bishop, who worked for *National Geographic* magazine, was a glaciologist on the expedition. In mid-February he and three others left the rest of the group for a recreational period on the nearby and unclimbed Ama Dablam, standing at 6,856 m (22,494 ft). Although the peak is lower in altitude than others of the Himalayan giants, this first ascent involved climbing of a higher technical level than was usual at that time in the Himalayas.

Bishop's experience as a high-altitude climber and his ability to take photographs in climbing situations made him the ideal choice for a 1963 Everest expedition, when the Americans advanced the standard of Himalayan climbing with the first traverse of Everest. This was an early Himalayan version of the old pattern of more arduous routes being opened on previously climbed summits. The

well-organized 1963 expedition was also remarkable for the amount of time spent on the mountain: Bishop and Lute Jerstad, another member of the team, stayed on the summit for 45 minutes, taking photographs and shooting motion-picture film.

By 1964, all 14 of the coveted 8,000-m (26,200-ft) peaks had been conquered. Small parties had climbed hard technical routes on Ama Dablam and Mustagh Tower (the latter involving difficult rock and ice); a more challenging route had also been forced on Everest. The modern era of Himalayan mountaineering had begun.

By the close of the 1960s, Himalayan climbing had also become a truly international affair. In the spirit of Eastern-bloc co-operation, the Soviets helped to launch China's mountaineering effort on a successful joint expedition in 1956 to Mustagh Tower. In a Cold War era fraught with rampant propagandizing and distrust, Chinese claims of climbing successes in the 1950s and 1960s were often viewed – rightly or wrongly – with great suspicion by the Western climbing establishment. It is perhaps for this reason that the Chinese may have understood better than anyone the summit photograph's function not just as the "team photo", but as evidence.

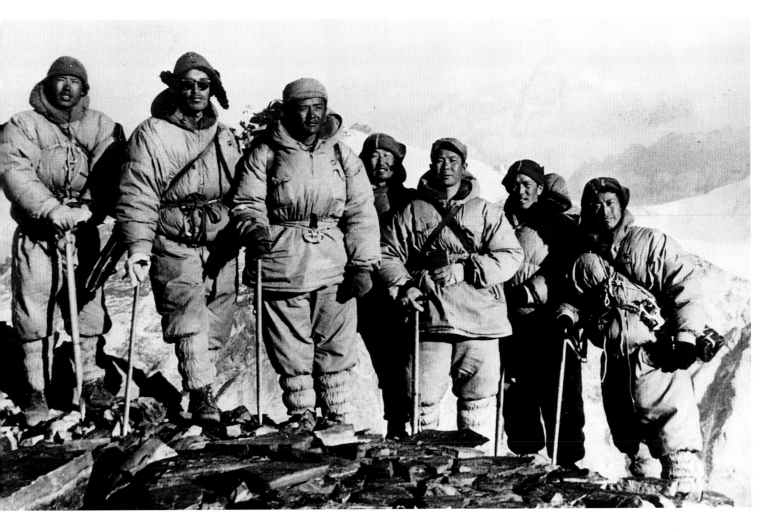

OPPOSITE, ABOVE *The summit of K2* (Achille Compagnoni, 1954). This success by an Italian team represented another in a series of remarkable Himalayan firsts during the 1950s.

ABOVE *Members of the Scientific Academy of Peking on the summit of Mount Everest* (anonymous, 1969).

LEFT *Lute Jerstad on the final trek to the summit of Mount Everest* (Barry Bishop, 1963).

ROCK-CLIMBING IN CALIFORNIA

Although climbing for sport progressed rapidly in North America following the war, it had resumed in a rather sluggish and insular way. Throughout the 1950s there was very little communication between individual climbing centres, with the consequence that they developed along distinctly regional lines.

The new wave of post-war American climbers converged on their hills and crags armed with the best army-surplus equipment and clothing that they could muster, including military boots or tennis shoes, baggy, multi-pocketed fatigue trousers, and either the ubiquitous white T-shirt or flannel work shirts. This attire contrasted sharply with that of the nattily attired European climbers, with their established sense of mountain fashion.

California's Yosemite Valley had already been recognized as a climbing centre before World War II (see pages 82–3), although little progress had been made on its imposing vertical walls. However, when the war ended, climbers were eager to get to grips with the challenge. It was all easily accessible, and most of it was unclimbed.

In 1946 John Salathé and Ax Nelson made a breakthrough two-day ascent of the south-west face of the Half Dome, establishing a tradition of bivouacking on Yosemite wall climbs. The next year, the same pair spent four days on the first true ascent of the Lost Arrow, Yosemite's last unclimbed spire (the previous year, a party had reached the top by lassooing the summit and ascending the rope).

Salathé and Nelson were helping to invent Yosemite climbing as they went along. The Lost Arrow climb employed equipment and techniques that were later absorbed into the standard *modus operandi* of big-wall projects: hard steel pitons for driving into rock (in place of the soft iron used in Europe); the faster single-rope technique (rather than clipping two ropes into alternating pitons, a method previously used by American and European aid-climbers); ascending the fixed rope by the second climber, using self-tightening prusik knots, rather than actually climbing the pitch; and using haul bags to bring up bivouac equipment and supplies. A new day had dawned in the Valley, and the era of big-wall climbing was about to begin.

As a teenager, the climber Royal Robbins (b. 1935) had set a new North American standard for free-climbing in 1952 when he led a breakthrough route on Tahquitz Rock in southern California. In 1953, Robbins and his Californian friends arrived in Yosemite. They infused the Valley with an unprecedented sense of performance, and the competition that developed for climbing hard new routes projected Yosemite into the very forefront of world rock-climbing.

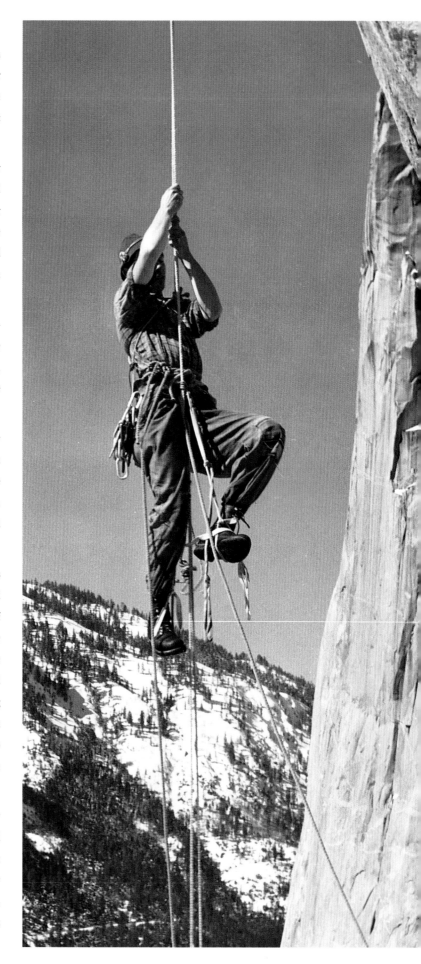

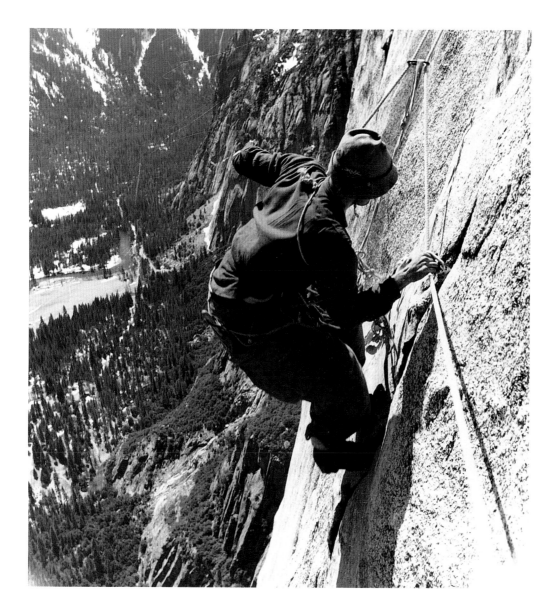

OPPOSITE *Bob Swift prusiking on the Tree Route of El Capitan* (Allen Steck, 1952). At 915 m (3,000 ft), El Capitan is the highest cliff in the Yosemite Valley.

LEFT, ABOVE *Allen Steck leaving the Pedestal on the Yosemite Point Buttress* (Bob Swift, 1952).

LEFT, BELOW Warren Harding (shown on the left) and Chuck Pratt, resting on the Valley floor after completing the first ascent of the east face of Washington Column in the Yosemite Valley (Steve Roper, 1959).

In 1958, Warren Harding engineered a route up a spur called the Nose on El Capitan. This was then the most spectacular and difficult aid route in the world – Harding's success had taken 18 months of effort, 45 days of climbing, 675 pitons, and 125 bolts – and the Nose became a hallmark climb. The Yosemite Valley also abounded in shorter climbs, where participants tested the limits of free-climbing. This push both on difficult aid routes and in free-climbing has largely distinguished the Yosemite aesthetic, in what for almost half a century has been the greatest big-wall training ground in the world.

CLIMBING IN THE PACIFIC NORTHWEST

During the 1950s the North Cascades in Washington State remained for the most part a wilderness backwater which, although greatly enjoyed by a growing number of Seattle club climbers, was not interacting a great deal with other regions. Northwest climbing was typically conservative and relaxed, lacking the competitive push of

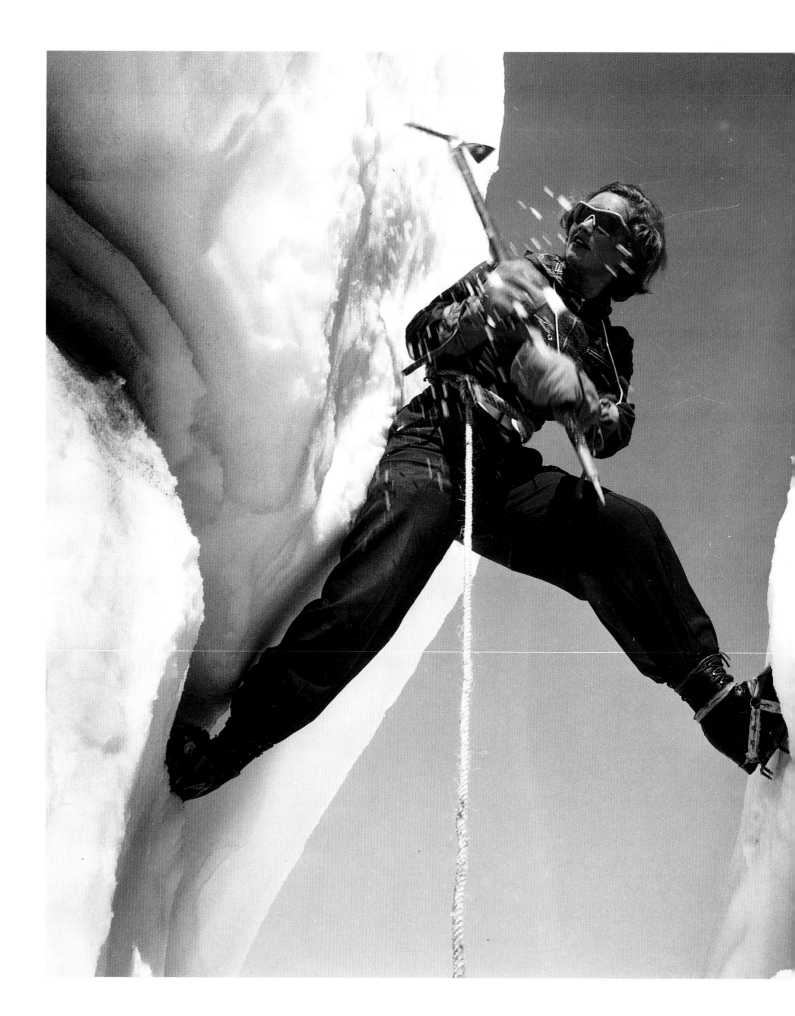

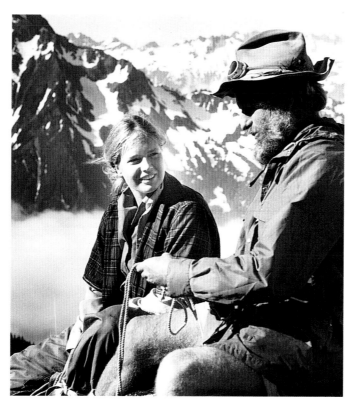

Yosemite, the Shawangunks in New York State, or the Tetons in Wyoming. Parties continued to make the easy snow slogs up Mount Rainier in the Cascades, ignoring the existing more arduous climbs as well as the potential for hard new routes on the northern slopes.

Yet in the midst of this relaxed milieu a core of highly ambitious Seattle-based climbers did advance standards and pioneer new routes. Paramount among the Northwest climbers as Fred Beckey (b. 1923), whose astonishing – and still continuing – career has spanned five decades and probably includes more first ascents and new routes than that of any living climber in the world. What is even more remarkable is that Beckey and his friends, most of whom were students and professionals, were mainly weekend climbers.

Towards the end of the 1950s, tales of a rock-climbing revolution taking place in the Yosemite Valley began to filter out to other climbing centres. Northwestern climbers made the trip south to see for themselves, and were inspired to develop new cragging areas at home – especially on the granite cliffs around Leavenworth, and on a prominent granite spire called Index, at 1,822 m (5,979 ft). This fresh impetus of competitive rock-climbing had a very progressive effect on the overall climbing atmosphere in the Northwest.

The photography of twin brothers Bob and Ira Spring (b. 1918; examples are shown left and above) has helped to define mountain recreation in the Pacific Northwest for half a century. Avid outdoor recreationalists and photographers since boyhood (the twins were

given their first camera in 1930), through their work the Springs open up a remarkably candid view of the club and family mountaineering adventures that have been the real backbone of Northwest climbing from its very beginnings.

The images reveal a world of rough-and-tumble pleasure in an environment that is mostly white and often wet. They are filled with a nostalgic warmth that calls to mind a time when climbers were perhaps a little less driven by competition, and when camaraderie meant more than sheer performance, yet there remains a distinct sense of mountaineering verve and the desire to achieve new goals. These are carefully planned, tightly composed images made by photographers who are highly skilled not merely in a technical sense, but who understand what it is to be a mountaineer.

STYLE AND SUBSTANCE

There has always been a Tairraz at the fore of professional climbing photography. Following in the important tradition of his father, grandfather, and great-grandfather (see pages 10–11), the work of Pierre Tairraz displays the same sensitivity to light and form typical of all the Tairraz photographers. He has used the entire range of photographic tools and all major film formats, in both colour and black and white, yet the work still bears the mark of his pedigree.

The photographs taken by Pierre Tairraz (two examples are shown opposite) are grandly rendered images, describing a heroic activity within the breathtaking West Alp landscape. They are technically superb and are, in some ways, much more painterly than is the work of most other climber-photographers whose intent has centred on recording climbs. The work of each of the Tairraz photographers gives the feeling that the specifics of a climb are less important than the idealized representation of dramatic action in dramatic settings. These are hardly casual souvenirs, and were made for public consumption; yet they help to define the perfected version of the ideals behind the urge to climb.

An entirely different form of mountaineering photograph, Richard Goedeke's highly decontextualized image of aid climbing on the Dent du Géant (see right) almost appears to be a mistake, as though the photographer had mis-aimed his camera. The picture is about the aid-climbing experience of the day, about standing in etriers in heavy mountain boots, on a vertical rock wall in the mountains. It all seems to be there, jammed into this single frame. Of course, much more than this is concentrated within this image for its maker, who remarked: "It was our first summer in the Mont Blanc area.

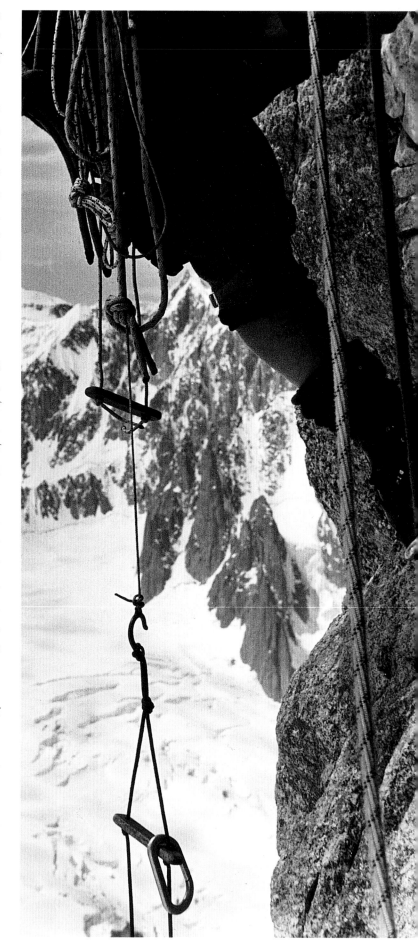

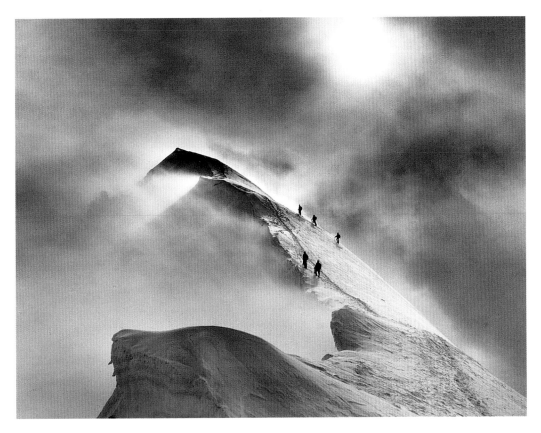

OPPOSITE *On the south face of the Dent du Géant, Mont Blanc* (Dr Richard Goedeke, 1966). This very daring and forward-looking composition manages to encapsulate the sense of action within the grand West Alp landscape in a completely different and more immediate way than the traditional and more "open" style could do.

LEFT *The summit of the Grande Casse* (Pierre Tairraz, 1974). The last in the four-man dynasty of Tairraz photographers, Pierre continues the family tradition of grand mountain landscapes and the heroic portrayal of mountaineering.

BELOW *The north face of the Barre des Ecrins* (Pierre Tairraz, 1970). This 4100-m (13,450-ft) peak, which is the culminating point of the Oisans range in the French Alps, had been scaled back in 1864 by Edward Whymper (see pages 26–30).

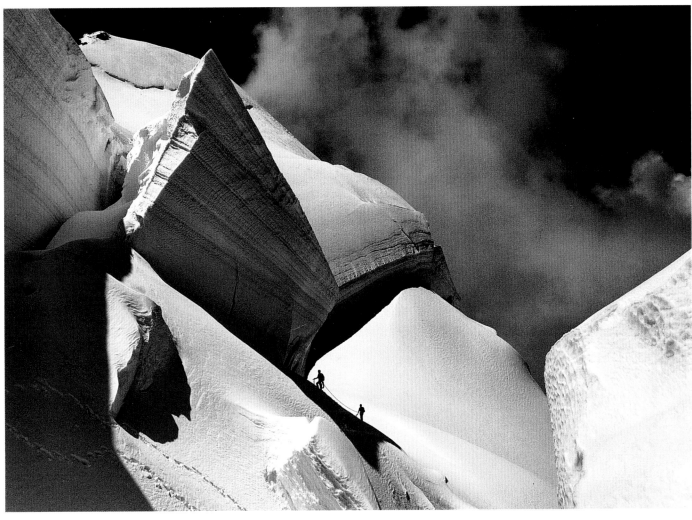

RIGHT *Royal Robbins dozing on the Salathé Wall of El Capitan* (Tom Frost, the Yosemite Valley, 1961). This visually sophisticated image represents the desire to make strong photographic compositions, while engaged in very serious, difficult, and cutting-edge climbs.

OPPOSITE *Royal Robbins prusiking the lower part of the Salathé Wall* (Tom Frost, 1961).

BELOW *John Harlin on the summit of the Aiguille du Fou, the last major unclimbed face in the Chamonix area of the Alps* (Tom Frost, 1963). This photograph works at various levels: it was made to commemorate a first ascent, but it also evokes the grand landscape while providing a touch of visual humour.

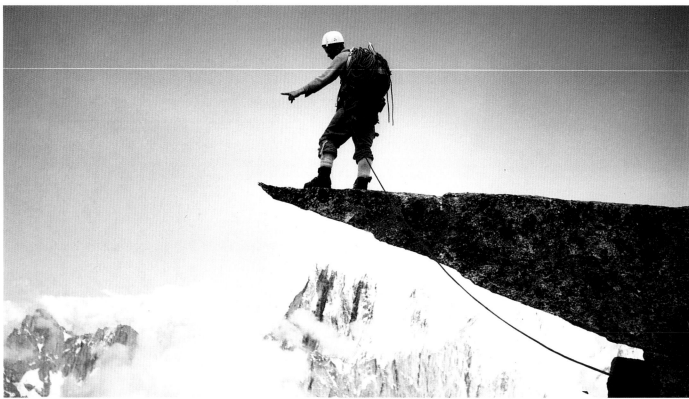

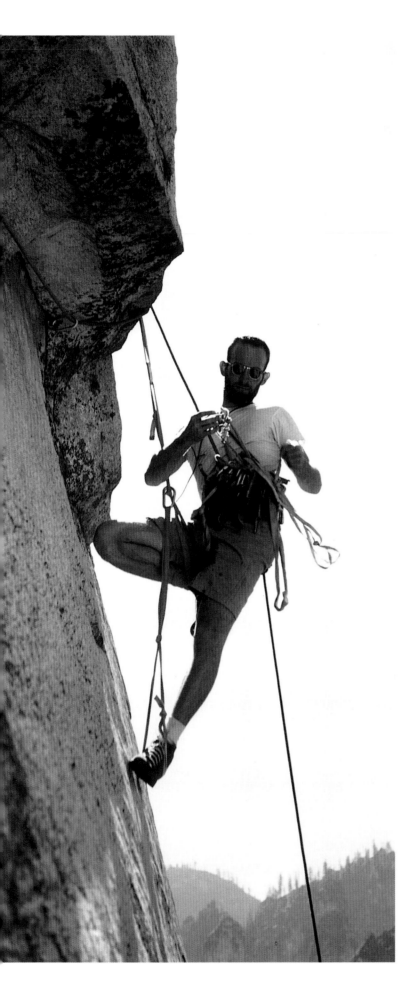

We had become experienced extreme Dolomite climbers in the years before, and now were not satisfied with the normal routes. Our main problem was the altitude, so we made abundant use of our etriers. It was a fine day, so calm that a butterfly came to visit us. And looking back at it after another 30 years of climbing and mountaineering, I still consider it one of my finest memories."

THE PIONEERING SPIRIT

By the mid-1960s, most of the modern trends in climbing were firmly established. The highest peaks of the Himalayas had been scaled, as had the sheerest walls of Yosemite, and in a sense climbing faced the same dilemma of 100 years earlier: what to do next? The modern answer was essentially what it had been before: to find more challenging problems and set higher standards on already climbed peaks and established routes. The difference this time was that the answer was much faster in coming; there was, in fact, no real period of debate over the direction that the sport would take.

In many ways, the period from 1960–80 marked a real resurgence of the pioneering spirit in climbing. Important new approaches to alpinism, rock-climbing and expedition climbing were evolving ever more quickly, and the public was made increasingly more aware through media coverage, books and climbing journals of what was happening at the cutting edge of the sport.

Nowhere was this more apparent than in the Yosemite Valley, where new approaches to rock-climbing on big walls continued to develop. Yosemite had evolved as a form of "laboratory" for the latest rock-climbing techniques, and the innovation of equipment and technique reached such a proportion that the Yosemite climbing scene progressed according to its own competitive impetus. Standards soared, independent of what was happening in Britain and the Alps. The Yosemite approach was brash, aggressive and rather unconcerned with tradition, and American proponents of big-wall climbing took to the sport with enormous zeal, intent on pushing the limits just a little further than anyone had thought possible.

In 1961 Royal Robbins (see also page 107) teamed up with Tom Frost and Chuck Pratt for the first ascent of the Salathé Wall of El Capitan (see opposite, above; and left). Perhaps the best rock-climbers in the world at that time, the three set a new standard – one of many established at Yosemite – for hard free-climbing on a big wall that others could only get up using direct aid. Frost was a self-taught photographer, and his position at the centre of possibly the liveliest period of Yosemite climbing ensured that he would have great

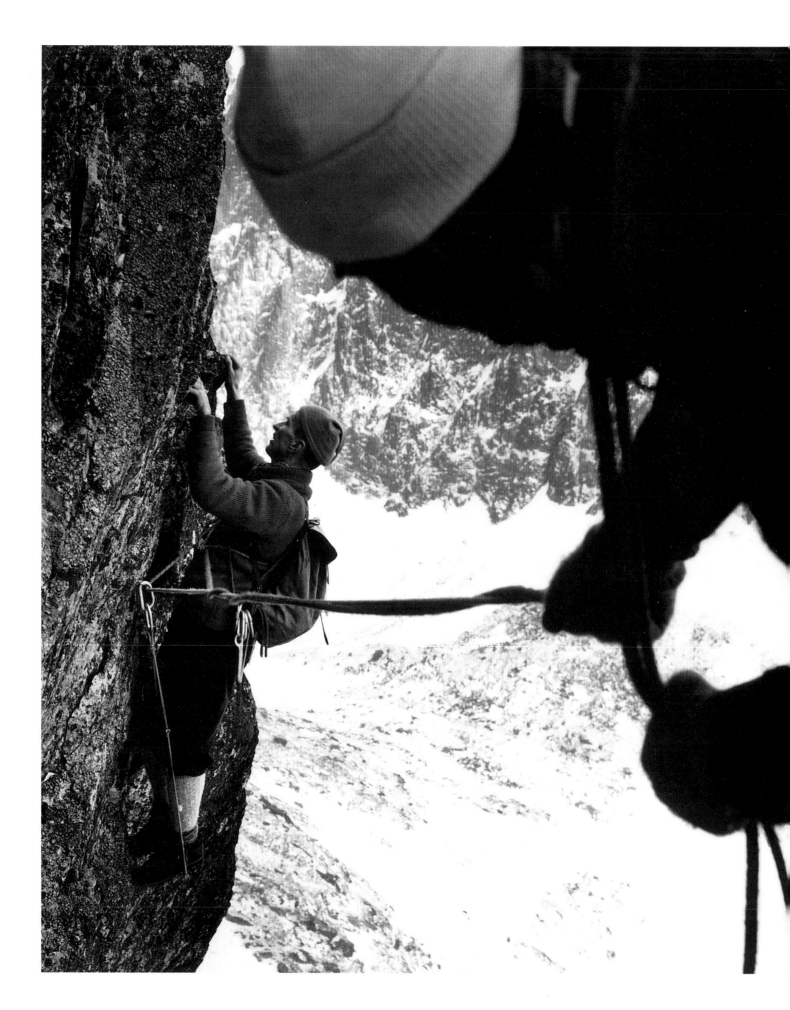

events – and important figures – in front of his cameras. Like most of the best climbing photographers of any era, he demonstrated a special talent for producing action pictures in the most dramatic climbing situations, as well as for capturing his companions in candid portraiture. Frost and his fellow climbers were engaged in some of the most important breakthrough climbs in the entire history of the sport, and it was fortunate that a photographer of his calibre was able to record them.

YOSEMITE INFLUENCES IN EUROPE

Ultimately, the daring approaches to rock-climbing being practised in California would have an impact on Alpine mountaineering. Just as, in the 1920s, the technical innovations of the East Alps and the philosophical approaches of the Munich School (see pages 76–82) had infused the climbing world with new standards of performance and fresh ambition, so too would the Yosemite methods influence notions of what was possible on rock walls in the mountains.

From the early 1960s, a new breed of American climber began to appear in the West Alp climbing centres. As relative outsiders to the traditional Alpine scene, these climbers were generally well received by the Europeans who, although maintaining their longstanding national competitiveness against one another, could embrace more openly any influence from the far side of the Atlantic. The Americans certainly had something to contribute: trained on big granite walls, and armed with new hardware unseen in Europe, they made an impression in the Chamonix area with bold, technically advanced routes on the west face of the Dru and south face of the Fou, and with a direct route on the west face of the Petit Dru (at the time, among the hardest aid routes in Europe).

It is interesting to note the difference between the Yosemite rock-climbing style and the traditional alpine approach represented in Vilem Heckel's 1967 photograph of aid-climbing in his native Czechoslovakia (see opposite). The climber plods up patiently and securely, pounding in pitons, his mountain boots stuck into

OPPOSITE *Czechoslovakia* (Vilem Heckel, 1967). Not content merely with recording experience, Heckel was an artist with a distinct sense of personal visual style. His use of crowded foreground figures gives an intense feeling of personal involvement in the climbing.

LEFT *Pakistan* (Vilem Heckel, 1967). The texture and detail are paramount in this close-up image; it is another typical example of Heckel's avant-garde approach to his art.

étriers and his pack on his back, whereas by this date Yosemite-influenced climbers would use these safer but slower aid techniques only on the most difficult pitches. Instead, they would free-climb quickly at a much higher standard, wearing soft rock shoes and without a pack, before hauling up their gear. This more efficient approach gradually also predominated on hard Alpine rock routes.

Heckel's climbing style may have been traditional, but his pictures lay at the other extreme. He was a photographer ahead of his time, possessing a flair for bold, avant-garde compositions, and using that flair while engaged in extremely serious climbing. His compositions are complex, yet the style remains strictly in the service of the subject. Heckel was a strong rock-climber and an accomplished mountaineer – a true all-round climber. Tragically, he died in 1970 in an avalanche on Huascaran, in the Peruvian Andes, leaving a body of work that is remarkable for the breadth of his mountain experience and for the character of his photographic vision.

HIGH PERFORMANCE IN THE ALPS

Through the 1960s and early '70s, legions of eager climbers were busy enjoying themselves on peaks great and small. Despite the increased attraction and accessibility of mountaineering farther afield, the Alps remained a focal point for climbers. The ever-continuing advances and increasing standards were apparent in many instances: in 1961, for instance, a German team climbed the north face of the Eiger for the first time in winter; by 1975, every one of the great Alpine faces had been climbed in winter.

This was also the great period of reconceptualizing all the classic aid routes in the Alps, which had previously only been climbed using pitons and rope as aids in progression, but were now tackled entirely "free", using just the rock for progression. As climbers developed greater technical and athletic skills, and equipment evolved to meet new demands, the standards of performance soared.

These radical advances in athleticism, technique, and materials were partly a function of increasing competitiveness and a higher degree of specialization in the sport. In particular, the emphasis on difficult free-climbing spurred the development of important new tools to facilitate protection on rock. In the mid-1970s, American climber Ray Jardine (shown in action opposite, in a photograph by Robert Godfrey) introduced fast-placing, spring-loaded camming devices called "Friends", which transformed approaches to free-climbing difficult rock routes. Jardine was an active member of the Colorado climbing community, as was Godfrey, a British expatriate

Pavtirian –

Roland Edwards.

Koveland Pass. '89

Joe on Vector.

Gofd.

Innominate Crack, Gable. '65

Cecile.

Roland on Kipling Grove '61

Brown on Vector.

Roland on Grimmer.

Aiguille Noire de Peuterey – S' Ridge

Fred Smith – Aralla '64

Malcolm – S' Ridge Aiguille Noire.

Gore Range – 1969

Barry "Gaston" Williams

Malcolm, Chamonix

1973.

The Donovans Bar Party. '69.

LEFT Composite of personal snapshots
(Robert Godfrey, *c.* 1965–75). These
handmade panels mix images from
various aspects of the climbing life
of Godfrey's close circle of friends,
forming an intimate souvenir.

BELOW *Ray Jardine aid-climbing
"Wisdom" at El Dorado Springs*
(Robert Godfrey, *c.* 1970).

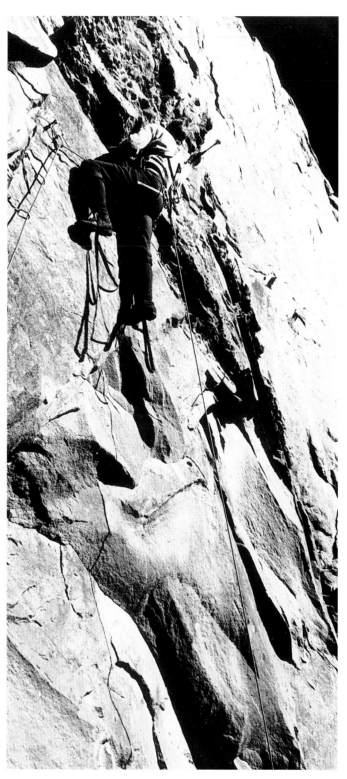

RIGHT *Rusty Baillie on "Cenotaph Corner" on the Dinas Cromlech crag* (John Cleare, Snowdonia National Park, north Wales, 1965). This very modern image reveals an awareness of perspective in a vertical composition. Cleare chose to shoot straight on and at a distance, emphasizing the strong vertical lines of the climb. This image was not caught casually; the perspective was carefully planned to produce a photograph that demonstrates the contemporary state of climbing art.

FAR RIGHT *Ian Howell, carrying bamboo wands* (route markers) *on the summit ridge of Himalchuli in the Himalayas* (John Cleare, 1978). This picture resembles the classic alpine images of the Tairraz family, with its strong emphasis on the formal qualities of light and structure.

BELOW *Rusty Baillie on "Cemetery Gates", Llanberis Pass* (John Cleare, Snowdonia National Park, 1965). There is no pretence to beauty or grand landscape in this tightly composed image: it is purely about climbing steep rock. The equipment and clothing reveal the photograph's date, yet it is absolutely modern in structure, and timeless in its desire to reveal what it is to be a rock-climber.

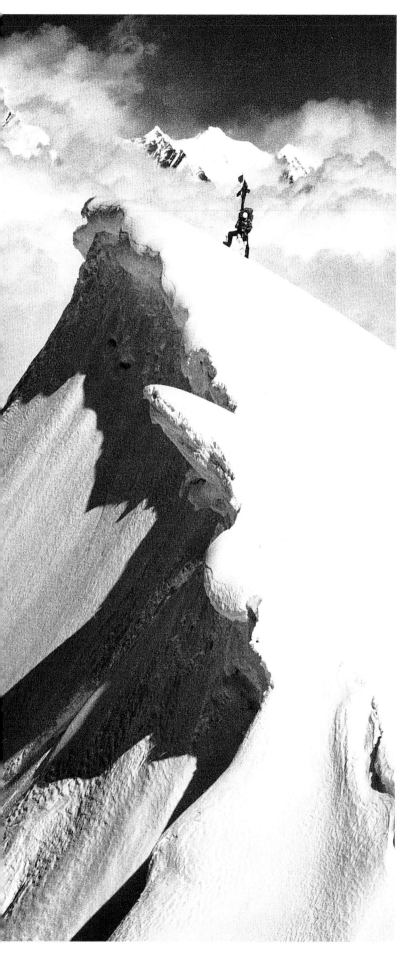

who left behind a rich record of the camaraderie of the 1970s' American climbing scene. Godfrey was a writer, photographer, film-maker, and teacher, whose interest lay not only in climbing activity, but in the society of climbers.

THE COMMERCIAL GROWTH OF CLIMBING

Just as photography had been readily embraced by the masses when camera technology became more user-friendly, so too had mountaineering become more accessible to the growing middle class in the post-war years. This in turn created another important development: as mountain sports grew in popularity through the 1950s and 1960s, many new independent (non-club) magazines and books specifically dedicated to the subject of mountains and climbing emerged. These provided outlets for an ever-increasing quantity of professional photography, as well as of writing, and "mountain" (or "adventure") journalism became a recognized field. The result was that, where once there had been just a handful of professional mountaineering journalists – such as Frank Smythe (see pages 87–8) – at work, by the end of the 1960s there were dozens.

There also developed a much stronger mercantile component to climbing itself. By the mid-1970s, for instance, there were no longer three or four companies making two or three models of packs, parkas, and sleeping-bags in two shades of khaki plus red, but a multitude of new companies, all competing for a share of the steadily growing purse. A major strategy for market competition is, of course, advertising; and selling the mountaineering image to the public provided yet more good opportunities for professional photography in the mountains. Climbing – like many other forms of recreational activity – was becoming big business.

It was easy for the outdoor media – together with the recreation industries – to romanticize mountaineering. The sport is, after all, already highly romantic by nature, and certainly lends itself to dramatic and colourful represention. Climbing is a very photogenic activity, and continues to become more so every year.

Among those who have managed to build a career around the representation of the climbing arena is John Cleare. A British mountain journalist, Cleare has a strong background in both editorial and commercial photography. His work (three pictures are shown here) represents over 30 years of photo-documentation of climbing around the world. It also spans the important period of transition from a predominantly black-and-white era to the current period when photography is almost exclusively in colour.

While the nature of Cleare's projects reveals his orientation as a climber, the structure of his images also reveals his formal background in photography and the impulse to "make" images rather than merely to capture scenes. In this respect he was a forerunner of today's professional climbing photographers who set out to create images. For instance, at a time when British climbers favoured drab, ex-military clothing, Cleare clad his photographic subjects in white sweaters (knitted by his mother) in order to set them apart from the rock. A strong climber himself, Cleare also pioneered techniques of the photographer positioning him- or herself alongside the subject.

MORE COLOUR, MORE DRAMA

As more first-rate imagery found its way into the public eye, members of the climbing public became increasingly sophisticated in attempts at recording their own personal adventures. Although many amateur mountaineers continued to take the same type of "just-for-the-record" snapshots that they had produced for the past 40 years (albeit now mainly using colour film), others took their stylistic cues from the state-of-the-art work to which they were exposed in the mountain media. From the 1970s onwards, climbing without a camera became increasingly rare.

At the opposite end of the spectrum, the British mountaineer Chris Bonington (b. 1934) is as remote from the amateur climbing public as one could imagine. Arguably the most accomplished mountaineer of his generation, he has been at the forefront of both alpine and expedition climbing for nearly four decades, and ranks as one of the greatest figures in the history of the sport. His earliest successes were achieved as part of the resurgence of British influence in the West Alps during the late 1950s and 1960s; further success in Patagonia established his reputation as an expedition leader of rare calibre, and led directly to his groundbreaking Himalayan ventures. Bonington's 1970 expedition to the south face of Annapurna was a classic example of the search for greater challenges on already climbed peaks, while his expedition to the south-west face of Everest in 1975 put up the most difficult route on the world's highest peak.

For all his great expedition triumphs, what is perhaps most remarkable about Chris Bonington's career is that it is still ongoing. At an age when others might well be retiring from active climbing (and with substantial laurels to rest upon), Bonington shows no signs of leaving the sport. If he is not involved with a new mountain project, he is likely to be found on the lecture circuit, sharing his vast knowledge with a new generation of adventure-seekers.

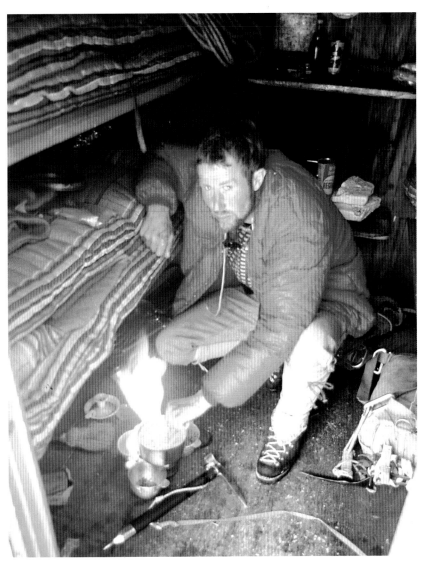

FAR LEFT *Ian Clough making a difficult traverse of the south face of Annapurna, Nepal* (Chris Bonington, 1970). Clough was part of the élite inner circle of British climbers active in the 1960s; tragically, he was killed on the descent from Annapurna when an ice-wall collapsed.

LEFT *Tending the cooking stove in the Eccles hut, Pillars of Brouillard* (Chris Bonington, Mont Blanc, 1965).

BELOW *Contemplating the lack of (climbing) progress during an expedition to Patagonia* (Don Whillans, 1963).

Bonington's photography is about great experiences. His pictures define a tremendous range of his most ambitious mountaineering projects, carried out with some of the greatest figures in the recent history of the sport. Yet for Bonington himself these are not merely records of a successful career, nor simply a collection of great value in the history of climbing. They are the visual manifestations of significant moments and fellow climbers from his life in the mountains, both of which are memorialized in the images.

BACK IN THE VALLEY

In the Yosemite Valley, the climbing mood in the 1970s continued the ambitions and tremendous accomplishments of the Yosemite pioneers of the late 1950s and '60s. A community of climbers developed, together with an elaborate network of partnering climbs and sharing information. This sense of community was strengthened by the remarkable loosening of bonds and broadening of horizons that grew out of the contemporary "hippie" culture.

The free-spirited atmosphere that characterized Yosemite during this vibrant period is captured in the two images shown here by Bill Westbay, relating to the breakthrough one-day ascent of the Nose of El Capitan made by Westbay with Jim Bridwell and John Long in 1975. The concept of making this hallmark Yosemite wall climb in a single day (strong parties had previously climbed it in four days) was staggering, and Bridwell considered that an event of such daring and imagination should be memorialized in psychedelic costume.

The vintage 1968, Jimi Hendrix-inspired garb chosen was, in fact, not so different from the way many Yosemite climbers dressed during that free-living era. It was a time when cutting-edge climbs were often named either for the hallucinogen of choice, or for the climbers' favourite acid-rock ballads. The outrageous, retro-hippie dress seems perfectly appropriate, while the posed team photograph (see above right) acts both as a memorial to a great achievement, and as a statement about a certain sort of zeitgeist seldom seen since.

It is easy to imagine that this was all merely clowning and costumed bravado, but it must be remembered that the climb undertaken was of the highest difficulty and intensity for the time. That intensity comes across in Westbay's image of Bridwell embracing Long at a pivotal moment on the climb (see right). It was just before noon and the three had concluded they were close to realizing their goal of completing the climb in a day, at which point they made the commitment of jettisoning their extra gear and spare clothing. The image manages to be light-hearted and yet very serious. It is

OPPOSITE, ABOVE *Bill Westbay, Jim Bridwell, and John Long, after climbing the Nose of El Capitan in a single day* (Bill Westbay, Yosemite Valley, 1975).

OPPOSITE, BELOW *Jim Bridwell and John Long on the Nose of El Capitan* (Bill Westbay, 1975).

LEFT *Reinhold Messner after the first ascent of Everest without oxygen* (Leo Dickinson, 1978); Messner completed this tremendous feat with his regular climbing partner, Peter Habeler.

BELOW *Bivouacking on the north face of the Matterhorn* (Leo Dickinson, 1975).

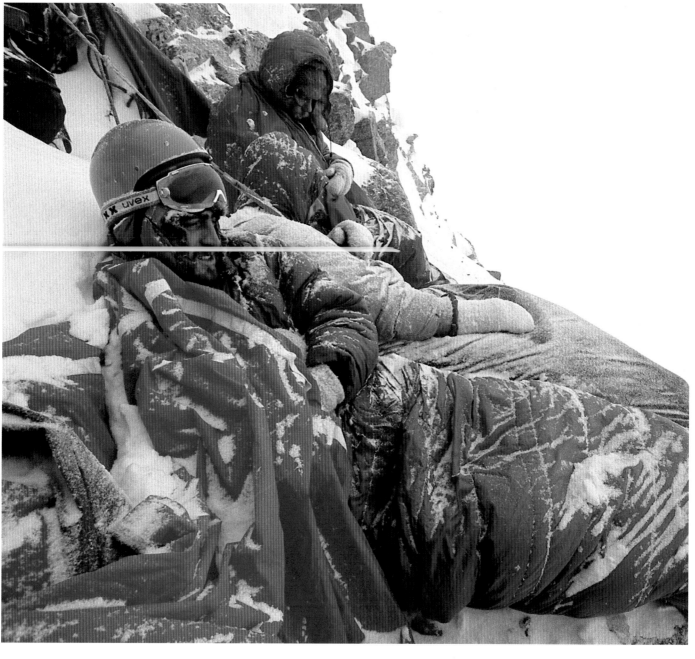

simple, direct, and rich in feeling, conveying both a camaraderie that comes only from complete trust and mutual respect, as well as the sheer thrill of knowing that history is being made.

Leo Dickinson is part of a tradition of adventure photographers who have gained greater public recognition through film-making than through their still photography. Indeed, Dickinson is perhaps the foremost adventure film-maker of his generation, justly famous and highly regarded for the many feats that he has recorded. Yet in his still photography and climbing films, it is clear that he is a true climber, portraying the often unglamorous reality of hard climbing.

Dickinson knew to make his rather grim record of a bleak bivouac on the north face of the Matterhorn (see page 123, below), because he understood its significance. This image represents aspects essential to being a mountaineer; it is in some ways the *sine que non* of alpinism. Dickinson knew that he must make this record, and anticipated its appreciation by other climbers. His image of an exhausted Reinhold Messner, on the latter's return from Everest (see page 123, above), strikes a chord to which many people will relate – even without experiencing this kind of physical stress. In many ways, it also presents a more accurate record of the high-altitude experience than the classic summit image of smiling climbers.

THE GRAND STYLE

The work of German photographer Jürgen Winkler is part of the tradition of the grand-scale mountain landscape. Yet during the course of 35 years of serious climbing and dedicated photography, he has managed to produce his finest work in 35 mm. Throughout the 1960s Winkler climbed as a personal pursuit, and was a photographer by profession. During this period he engaged in a fruitful association with the renowned writer and editor Walter Pause, with whom he collaborated on his first book of mountain photography in 1970. From that time until the present day, Winkler has climbed and guided all over the world (especially in the Himalayas).

Winkler's images (see opposite and below) possess an exquisite quality that seems almost an impossible achievement using a 35-mm format. Known also for his spectacular colour photography from the Himalayas and Karakoram (he worked on his landmark 1989 opus, called *Himalaya*, for 15 years), it is nevertheless the black-and-white work that seems so striking in an age when colour inevitably saturates the media.

Jürgen Winkler represents the true synthesis of climber and artist. Whereas most of the professional climbing photographers of the post-war era have achieved success through the technically skilled

RIGHT *Storm on the Gran Paradiso* (Jürgen Winkler, 1965). Unlike most of the climber-photographers in this chapter, Winkler had been a serious photographer prior to his involvement with climbing. Taking pictures from the age of 11, he had professional training from his late teens onwards.

OPPOSITE *Nevado Condoriri, Bolivia* (Jürgen Winkler, 1976). Images such as this are in some respects reminiscent of those of Ansel Adams and other large-format landscape photographers.

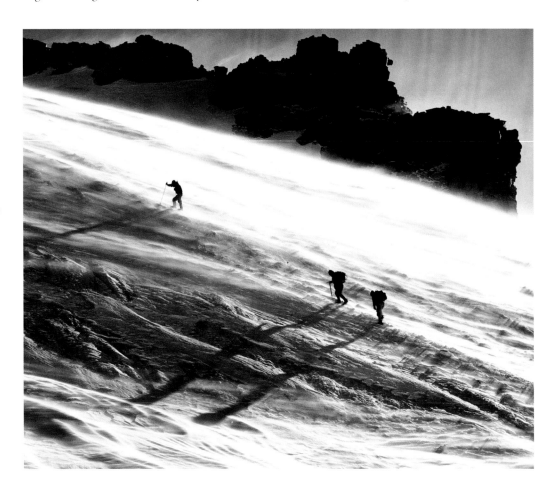

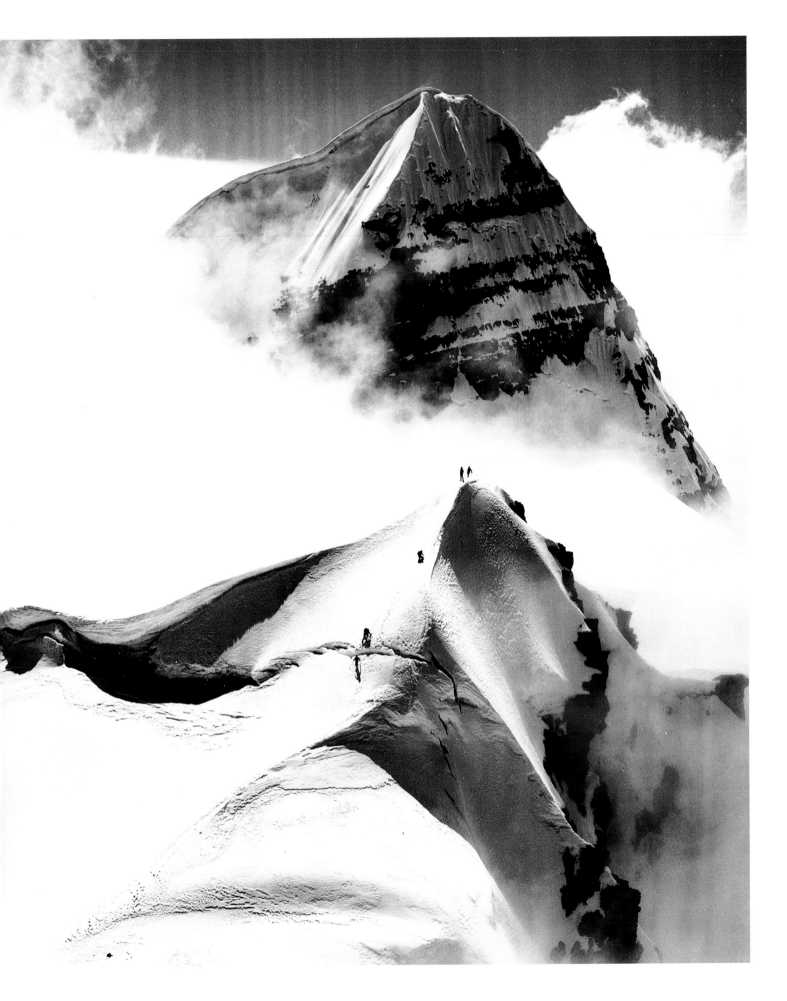

journalistic recording of extraordinary scenes, Winkler has a distinct vision tied to a sensitivity towards nature and light. He is most certainly a climber (indeed, he is still a professional guide), but his photography has more to do with aesthetics than with sport.

CONTINUING CHALLENGES

Canadian climber Pat Morrow began his successful ascent of the highest peaks of every continent (for which he received the Order of Canada in 1987) with the 1982 Canadian Everest expedition. The two images shown here, made on that climb, represent alternative facets of the expedition experience: on one hand, the exhilaration of a crystal-clear summit morning; on the other, the tragic death of a team member. The first photograph was an act of celebration for Morrow, commemorating the literal high point of his climbing career; the funeral photograph was a matter of responsibility.

The impulse propelling climbing's cutting edge, now that almost every mountain has been climbed, is that of new challenges. The 1963 traverse of Everest (see page 104) was one such challenge, as was the single-day ascent of the Nose of El Capitan (see page 122). In 1975 Reinhold Messner and Peter Habeler created a stir by climbing the 8,000 m (26,200 ft) Himalayan giant, Hidden Peak, with no support. They made the first Everest ascent without oxygen (1978), before Messner ended his Everest feats with a solo ascent (1980). Meanwhile, in 1976, Britons Joe Tasker and Peter Boardman climbed Changabang's west face, purely for its beauty and difficulty.

ABOVE *Funeral of a climber killed by ice-fall on Mount Everest* (Patrick Morrow, 1982).

RIGHT *Summit day on Everest* (Patrick Morrow, 1982). This was the south col route; Makalu is visible behind.

Where would it end? In Yosemite, the Salathé Wall was free-climbed by Todd Skinner and Paul Piana in 1988; the Nose was free-climbed by Lynn Hill in 1993. The Frenchman Christophe Profit's one-day (helicopter-assisted) trilogy in 1985 on the great north faces of the Eiger, Matterhorn, and Grandes Jorasses was a milestone; two years later he re-climbed them, in winter, in 42 hours of continual effort.

Each example suggests strongly that the search for greater challenges has hardly run dry. While most amateur climbers are happy to get into the hills or on to the crags for exercise and a little excitement, there have always been individuals unable to participate at the pace of the *status quo*, and with the combination of skill, imagination, daring, and ambition to push back the boundaries just a little further.

THE REALIZATION OF ADVENTURE IMAGERY

Most of the photographs in this chapter were made by professional climber-photographers. The point is sometimes raised that they are largely successful because they work with such photogenic subjects, and that any photographer could create these images, given the same opportunity of being there. From a purely technical standpoint – the simple act of exposing film in a camera – this is probably true.

Certainly the "being there" matters. Given the technical ability, putting great things in front of a camera will almost always yield strong photographs – but getting there is not so easy.

When looking at Pat Morrow's images from the continents' high points, or at Jürgen Winkler's grand mountainscapes, the viewer may be struck by the piercing quality of mountain light, or by the contrast of bright clothing against a backdrop of rock and ice; what is rarely seen is the sweat and years of hard work behind the "being there". And being there is only part of the process. That apparently simple act of exposing film in a modern camera becomes entirely different while dangling in space, shivering with cold, or worrying about the countless potential disasters in these picturesque situations.

Like Victorio Sella (see pages 54 and 56–7), the American Galen Rowell, whose work is shown here, came to the forefront of mountaineering photography with a rich combination of picture-making and climbing skills. Rowell has been the most successful mountain photographer of the past 25 years; he certainly raised the standard of photographic excellence, and has a continued presence. It is because of this influence that he represents the right point at which to move on to an assessment of climbing photography today.

OPPOSITE BELOW *Celebrating the return to green grass* (Galen Rowell, Karakoram, 1975). Rowell's name is associated with stunning images of an almost painterly nature, with great sensitivity paid to the quality of light.

LEFT *Ron Kauk, free-soloing beside the Yosemite Falls* (Galen Rowell, the Yosemite Valley, California, 1987). Rowell is equally well known for breathtaking images, such as this example, of high-angle rock-climbing.

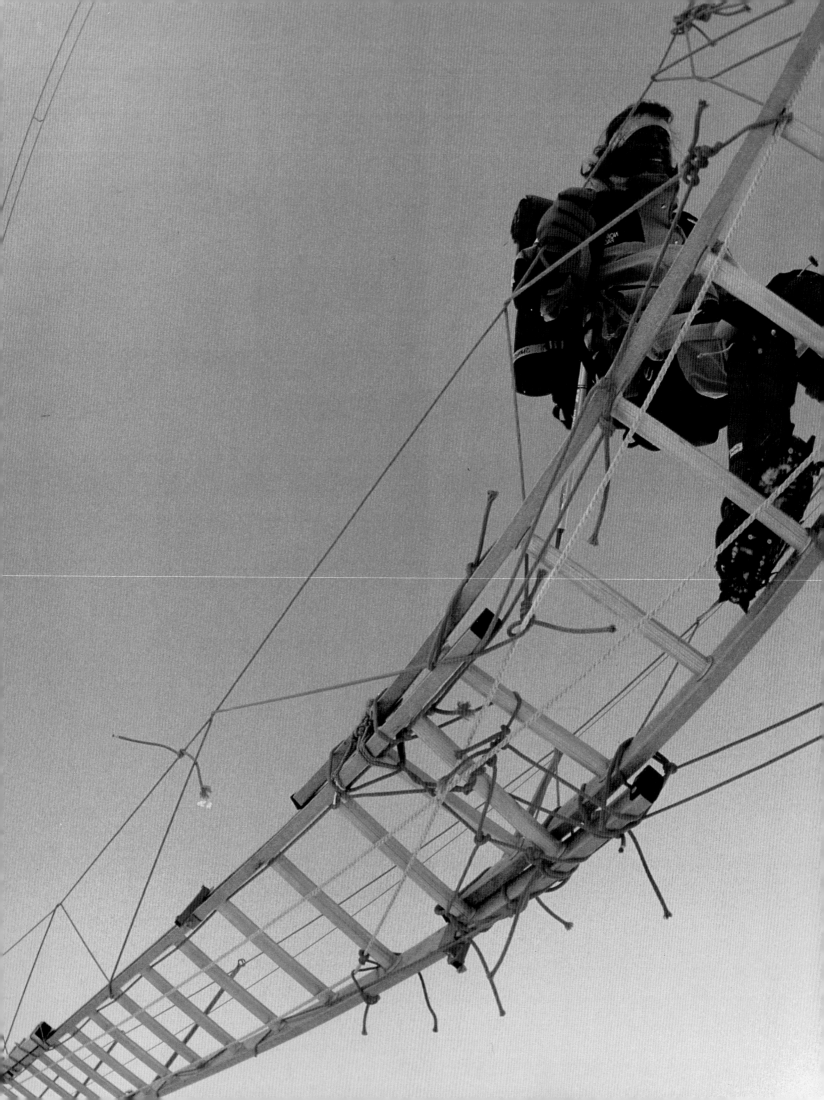

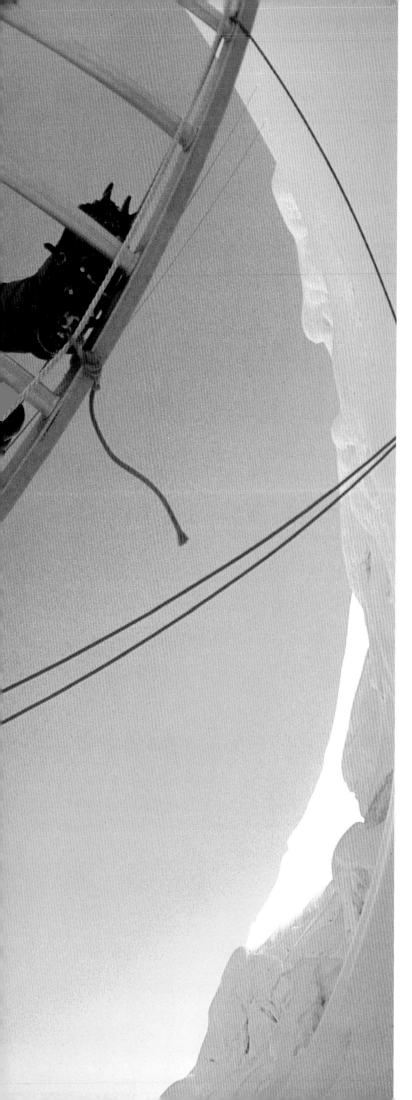

CLIMBING PHOTOGRAPHY TODAY

Photographers at the close of the 1990s are standing on the brink of the great transformation that new digital technology will undoubtedly bring.

PICTURE-MAKING IN THE 1990S

For the legions of climbers currently making souvenir records of their enjoyment in the mountains, little has changed from the 1980s. The influence of new technology has so far been minor, but the next decade will bring radical changes to the way pictures are made and perceived: they may be "doctored", customized, even created from "parts", producing an expectation of "perfect" images and perhaps removing photography's status of document/evidence.

The ranks of professional adventure photographers have swelled greatly in recent years, thanks in part to the growing public attraction to adventure sports. The increase in professionalism has made this field more competitive, with photographers pushing each other to produce ever more innovative work. This trend has been especially evident in gymnastic rock-climbing, with sport-climbing cliffs used as outdoor "studios" for organized shooting. Today's state-of-the-art rock-climbing photography has been transformed into an art form of drama and colour far beyond what the Abraham brothers (see pages 60–61) could have envisaged in the early years of this century.

This is less true of serious alpine-style and expedition climbing. Here the projects are so demanding that the photographers must essentially work as they have done for the past 100 years, catching shots when they can. In this field, improvements in film and equipment, and the brighter colours of climbers' clothing, are what chiefly distinguish the work of today from that of 30 years ago.

The American Chris Noble is one of the world's foremost professional outdoor-adventure photographers. Much of his work is shot commercially, as product advertisement; he also does a great

LEFT *Marjie Noble crossing a bridge on the Khumbu Icefall* (Chris Noble). The ice-fall is one of the major obstacles *en route* to the summit of Everest.

deal of less lucrative but personally rewarding editorial work for prominent outdoor-adventure publications. He enjoys a career of which most aspiring professionals dream – flying to exotic locations to record exciting events – but the road has been paved with hard work and fierce competition. Noble is successful because he has proved an ability consistently to make strong images in demanding situations. What the viewer sees are the smiling faces of athletic gymnasts on sunlit cliffs; what remains invisible is the photographer lugging equipment, or taking risks to capture the perfect picture.

SPORT-CLIMBING

There has always been a relationship between public interest in mountain sports and the visual images produced of these activities. This has become increasingly true in today's era of mass participation in outdoor sports and mass consumption of outdoor journalism. The colour and great drama of climbing and (especially) of rock-climbing, and their increased coverage in the media, has brought what were once esoteric pursuits into the recreational mainstream.

Like freestyle skiing in the early 1970s, sport-climbing has proved easy to sell to the public as a glamour sport, so that it has branched out distinctly from traditional mountaineering. While an image of an alpinist might occasionally have been used in (non-mountain) product advertising in Europe during the 1930s, today it is the lithe, bare-sleeved, brightly clad sport-climber who has taken centre stage. Such images are regularly seen in mainstream product marketing – a sure sign that the public has taken notice of mountain sport.

Beth Wald, from Colorado, is a busy professional photographer who has found her niche in outdoor sports. Her work is primarily editorial, although she also does a small amount of sports-related commercial shooting. Although she does cover other adventure sports, she is most comfortable working in the arena of climbing. Like all professional outdoor-recreation photographers, Wald will employ all the necessary strategies to produce superb images, but her work always conveys the feeling that she is a climber first and foremost, and that her concern lies more with the documentation of the activities she loves than with the production of brilliant visuals.

There may exist a relationship between Beth Wald's journalistic interest in profiling prominent climbing figures (she is also a writer) and the strong sense of personality visible in her work. Her images show an intimacy between subject and photographer, often seeming almost to be technically perfected versions of the pictures that any climber would take of his or her own friends, out climbing.

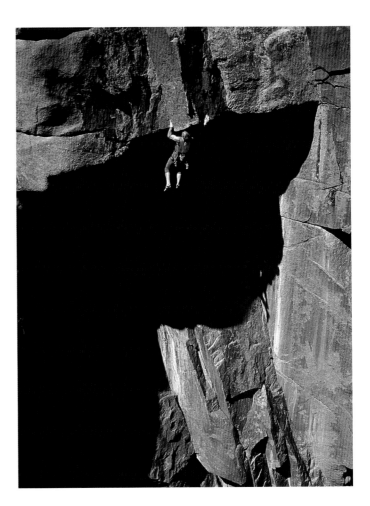

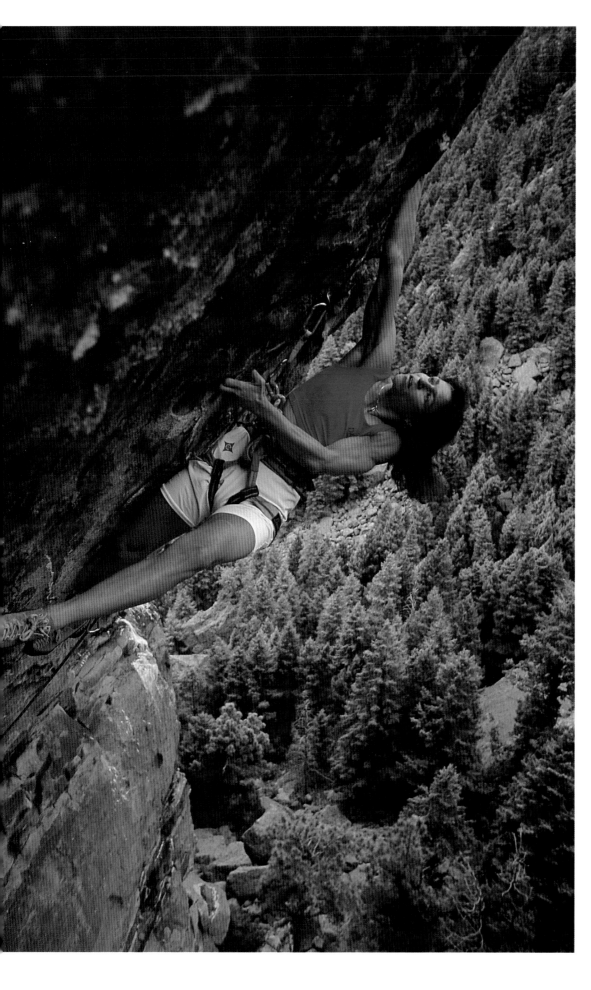

OPPOSITE, ABOVE *Todd Skinner on "Fiddler on the Roof"* (Chris Noble, Fremont Canyon, Wyoming).

OPPOSITE, BELOW *Will Oxx brewing coffee at a vertical bivouac high up on the Shield, El Capitan* (Beth Wald, the Yosemite Valley, California).

LEFT *Bobbi Bensman on "Chains of Love"* (Beth Wald, Colorado). Even in a photograph as carefully styled as this striking example, Wald manages to reveal a wonderful intimacy between herself and her subject.

The photographs made "in the process" of climbing seem to be much more in the souvenir spirit than the carefully organized conceptual photographs often orchestrated by today's professionals. Pushed by fierce competition to make ever more dramatic images, serious climbing photographers often put the photography ahead of the climbing, moving into the mode of dictating what and how their subjects climb for the sake of the image itself. There is nothing entirely new in this, of course – even the Abraham brothers organized their photographs at the turn of the century – but today it is becoming more and more the accepted way of making images.

NEW CONCERNS, NEW CONFLICTS

In crossing the conceptual border between recording and creating, a photographer becomes less concerned with preserving moments than with generating them. In one sense, he or she therefore operates more as a creative visual artist, whose aim is to realize a pre-formed plan, than as a reporter. The image comes into that person's head one day – perhaps while out climbing – and the photographer in them will not be satisfied until that image is realized.

The images of Californian-based photographer Kevin Powell are beautifully styled. He concentrates almost exclusively on rock-climbing, usually working with friends on whom he can count to help him realize his scenes. Powell also has a deep and longstanding interest in landscape art, which can be clearly seen in his work.

These photographs give the feeling of an image having being made, rather than of an activity being recorded. In this sense Powell's style is more painterly and artistic than purely documentary. He has also given himself greater freedom to create strictly according to his own criteria, since he chooses not to depend on photography for his livelihood. His work does appear in many of the most prominent outdoor publications, but only because a handful of editors have recognized the quality of his highly personal vision of climbing art.

The combination of mass participation and the much higher degree of specialization has caused many old-line climbers to wonder whether the sport's deep traditions of esoteric fraternity may be lost. Even within the rock-climbing category, subsets have formed, with "traditional" climbers insisting on placing protection as they ascend, while "sport" climbers clip the rope into pre-placed protective bolts. There are such major schisms today that many "mountaineers" will not even acknowledge the rock experts as fellow climbers. (Only at the start of the 20th century, with the old-liners railing against aid-climbing and even simple protection, was there so much

acrimonious debate, but today it is much more divisive.) Yet the sport will endure. Climbing may be more diverse and divisive now than ever before, yet the perceived differences between factions may be less significant than some believe, as sport-climbers transfer their skills to the mountains and mountaineers unwind on the crags.

Climbing is perhaps the most purely metaphorical of all sports. The climber transcends the everyday, aspiring to Olympian detachment from worldly concerns below. This has remained true for 200 years, and it is still the common ground shared by mountaineers and sport-climbers. Each group may form coteries, but there are encouraging signs that the fragmentation of the 1980s and 1990s may have been just one more growing pain in a continually evolving sport.

Whatever directions mountaineering and rock-climbing take in the future, climbers will still seek out the projects that appeal to them, regardless of what others may be doing. There will always be great things to do on mountains; indeed, the true greatness of mountain sport lies in its remarkable variety and flexibility.

CLIMBING AND IMAGES IN SYNTHESIS

Earlier this century, photographers often had to choose between taking pictures and participating in serious climbs. Photographers such as Frank Smythe (see pages 86–7) were the forerunners of a whole cadre of professionals today who undertake serious climbing projects and make pictures along the way. Switzerland's Robert Bösch is just such a photographer, having begun as a professional climber who took pictures, then working the photography into a successful career. Bösch has evolved into one of the most multi-faceted climber-photographers working today. Equally at home on a sport cliff or on a serious Himalayan expedition, his work defines what is state-of-the-art in modern climbing-action photography.

Bösch's dramatic image of Swiss climber Robert Jasper (see above right), on what is perhaps the most difficult mixed (rock and ice) climb in the world, captures all the intensity of the cutting edge of extreme climbing. In the photograph of Heinz Müller (see opposite) he manages to create a striking image of modern sport-climbing, while echoing the landscape style of previous generations of mountaineering photographers. These two images are direct descendants of the work of Jules Beck and the Abraham brothers (see pages 40–3 and 60–1) in the way they use cutting-edge drama to portray mountain sport, but the image that most stirs the photographer himself is the seemingly unspectacular picture of a retreat in foul weather on Everest's west ridge (see right). It seems

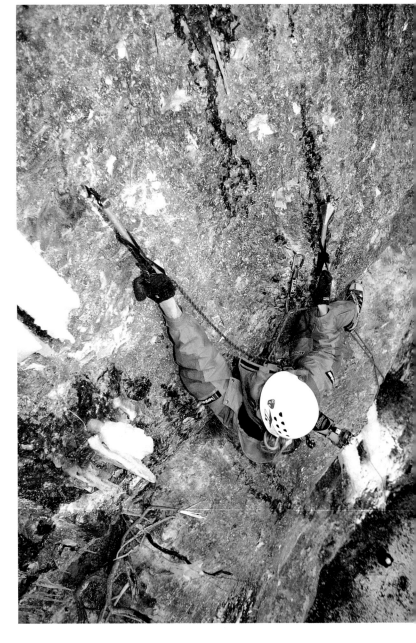

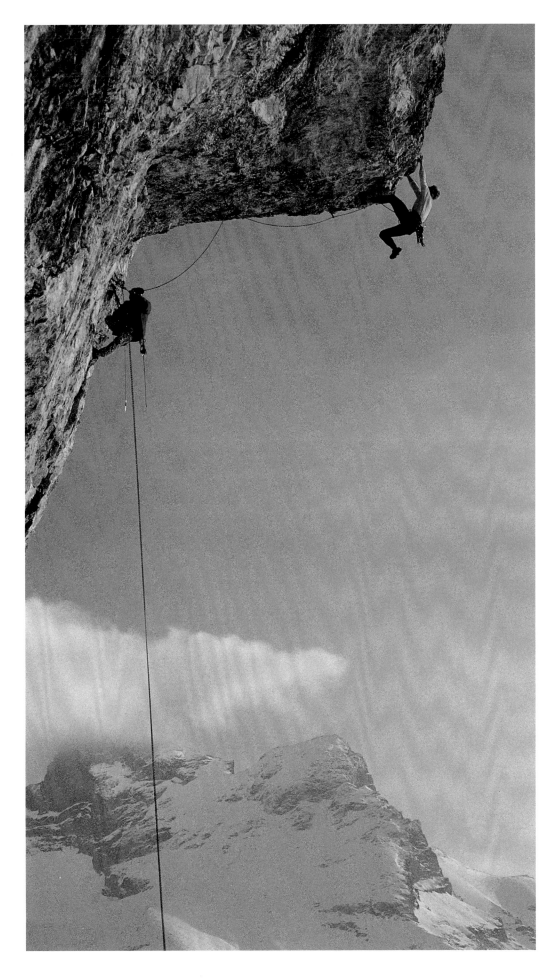

OPPOSITE, ABOVE *Robert Jasper,
on his creation "Trait de Lune"*
(Robert Bösch).

OPPOSITE, BELOW *Bad weather on the
west ridge of Everest* (Robert Bösch).

LEFT *Heinz Müller working on his
project, "Extasy"* (Robert Bösch).
Looking very much like a modern
Tairraz image – encapsulating the
heroic activity within a magnificent
landscape – this photograph is
simultaneously about the athleticism
of sport climbing and the grandeur
of the high mountain playground.

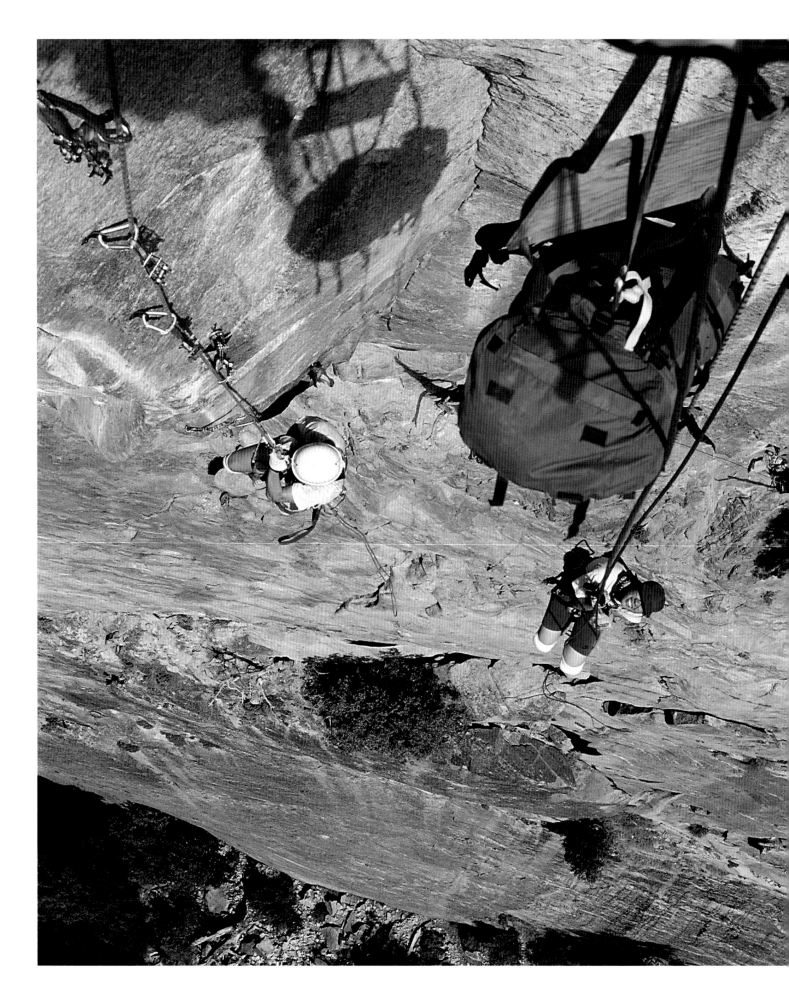

unglamorous, and the action understated beside the drama of Bösch's sport-climbing compositions. Yet this is drama of a different sort. As Bösch describes it: "I like the structure of the image. Just grey and white, fragile and powerful ... It is a small fragment of the world's largest mountain, which brings out, however, essential details of such an expedition: the discomforts and harshness, the difficulties and dangers." There is an honest brutality about the image: a climber's reminiscence that reaches the heart of the big-mountain experience.

A PERSONAL RECORD

If the other photographers in this short discussion of modern work are the descendants of the Becks, the Abrahams, and the Smythes of the climbing world, Quang-Tuan Luong is the spiritual descendant of the William Donkins and Dr Aldo Godenzis (see pages 38–9 and 100–101): dedicated climbers and serious photographers who have pursued both activities purely out of love. Luong is, indeed, an amateur in the very best sense of the word. Little distinguishes his work from that of today's professionals – certainly the quality is second to none. As an alpinist, a big-wall climber, and an expert in all formats of photography, neither his climbing projects nor his images are what one could possibly term pedestrian; but Luong, a French-Vietnamese computer scientist, holds his climbing and photographic activities quite apart from his career objectives.

Of his striking image of the Aiguille du Midi (see below), Luong writes: "We planned to climb the Grand Capucin the next day, so caught the last cable car to the Aiguille du Midi. Less than an hour before we were in the busy streets of Chamonix. Now we were in another world, as we walked down the knife-edged, exposed arête. When we reached the shoulder, I looked back, and was stunned by what looked like an apparition. I had just time to make a few pictures with my tiny Minox before the display disappeared. I wanted to share that special moment with my friends."

Of his picture of aid-climbing in the Yosemite Valley (see opposite), he says: "The West Face of the Leaning Tower is very overhanging, and the first pitch is already impressive because you start from a ledge on the face. Ky-Van ... was all smiles. I barely knew her, but by the end of the climb I was under her charm ... This picture preserves the memory of a very special climb with a very special person."

It is one thing to admire the foremost photographers recording feats of the current climbing stars but, throughout all the technical and stylistic advances, ordinary climbers continue to take souvenir snaps as personal documents of pleasure and accomplishment. Mountaineering photographs are very important records. To the non-climber, they reveal a great deal about the history of a highly dramatic sport; for the climber, they serve as perpetual reminders of moments of beauty and adventure – as souvenirs from high places.

OPPOSITE *Ky-Van and Oyvind on the west face of the Leaning Tower the Yosemite Valley, California* (Quang-Tuan Luong).

LEFT *The Aiguille du Midi* (Quang-Tuan Luong). In this image, Luong has captured a "Brocken spectre" (an atmospheric condition of shadows thrown upon clouds behind an object) to produce a striking result.

TIMELINE FOR SIGNIFICANT EVENTS IN MOUNTAINEERING AND PHOTOGRAPHY

Ⓜ = Mountaineering
Ⓟ = Photography

5th century BC Ⓟ Philosophers in Greece describe the optical principles of the *camera obscura*.

5th–4th centuries BC Ⓟ Chinese and Greek philosophers describe the basic principles of optics.

AD 633 Ⓜ The first recorded ascent of a high mountain – Japan's Mount Fuji – by the monk En no Shokaku.

10th century Ⓟ Hassan ibn Hassan describes the *camera obscura*.

1336 Ⓜ The poet Petrarch climbs Mont Ventoux in southern France.

1492 Ⓜ The knight, Antoine de Ville, and his companions make a technical ascent of Mont Aiguille, using ropes and other climbing aids.

1553 Ⓟ Giovanni Battista Porta publishes details of the construction and use of the *camera obscura*.

1648 Ⓜ Florin Perrier (Blaise Pascal's brother-in-law) ascends the Puy du Dome for barometric pressure experiments, which leads to the invention of the barometer.

1664–6 Ⓟ Isaac Newton discovers that white light is composed of different colours.

1725–7 Ⓟ Johann Heinrich Schulze experiments with "photo-sensitive" materials, darkening mixtures of chalk and silver nitrate with light.

1738 Ⓜ Two French travellers climb Corazon, in Ecuador, marking the first recorded ascent in the Andes by mountain tourists (although local Incas are known to have visited mountain tops for several centuries).

1779 Ⓜ Belsazar Hacquet climbs Triglav, highest point in the Julian Alps.

1786 Ⓜ Jacques Balmat and Michel Paccard, of Chamonix, make the first ascent of Mont Blanc (the date is generally acknowledged as the "birth" of the sport of mountaineering).

1799–1800 Ⓜ The first high peaks of the East Alps – Kleinglockner and Grossglockner – are climbed.

1802 Ⓟ Thomas Wedgwood produces silhouettes with silver nitrate on leather and paper, but is unable to make the images permanent.

1803 Ⓜ The German naturalist Alexander von Humboldt sets an altitude record of 5,800 m (19,030 ft) on Mount Chimborazo in Ecuador, noting the effects of altitude sickness.

1819 Ⓟ John Herschel discovers the photographic fixative, hyposulphite of soda, allowing an image produced on light-sensitive material to be made permanent.

1820 Ⓜ Ed James and companions make the first recorded ascent of a mountain in the Canadian Rockies, Colorado's Pike's Peak.

1826 Ⓟ Joseph Nicéphore Niépce uses bitumen of Judea to reproduce engravings on metal, and names them heliographs.
Ⓟ Aloys Senefelder devises a new process in colour lithography.

1827 Ⓟ Niépce successfully creates the first heliographs directly from a natural scene; these are arguably the first images "photographically" produced from nature.

1829 Ⓟ Niépce and Louis Jacques Mandé Daguerre form a 10-year partnership to develop photography.
Ⓜ The probable first ascent is made of Russia's Mount Elbrus, at 5,642 m (18,510 ft) the highest point in Europe.

1833 Ⓟ William Henry Fox Talbot begins a series of experiments with photogenic drawings.

1837 Ⓟ Daguerre produces the first Daguerreotype.

1839 Ⓟ The Daguerreotype is announced at the Academy of Sciences in Paris and "given" to the public by French Government (this date is often given as the "birth" of photography).
Ⓟ Fox Talbot announces the results of his ongoing experiments in recording images on paper.
Ⓟ Hippolyte Bayard exhibits his direct-positive images.

1840 Ⓟ Alexander Wolcott is issued with the first American patent in photography, and opens the world's first studio for portrait photography.

1841 Ⓟ Voigtlander reduces Daguerre's clumsy box to portable size, freeing the camera from the studio.
Ⓟ Fox Talbot is issued with a patent for the calotype process.

1842 Ⓟ Fox Talbot publishes the first major periodical, *Pencil of Nature*, on technical photography.

1846 Ⓟ Carl Zeiss opens his optical works at Jena.

1847 Ⓟ Luis Désiré Blanquard-Evrard improves on Fox Talbot's calotype process and establishes a photographic printing business.
Ⓟ A cousin of Nicéphore Niépce, Claude Niépce de Saint-Victor, suggests use of an emulsion of albumen and silver halides on a glass plate.

1848 Ⓟ Niépce de Saint-Victor uses albumen on glass plates for negatives.

1849 Ⓟ David Brewster patents the stereoscopic viewer.

1850 Ⓟ Albumen printing paper is introduced by L.D. Blanquard-Evrard; it remains in use until World War I.

1851 Ⓟ Frederick Scott Archer perfects the wet-collodion process for glass-plate negatives, the predominant process for the next 25 years.
Ⓟ Fox Talbot makes the first instantaneous photographs using electric-spark illumination.

1852 Ⓟ The Bausch and Lomb Optical Co. is established in the USA.

1853 Ⓟ The Royal Photographic Society is established in London.

1854 Ⓟ Ambrotype, a positive collodion image, is patented in USA.
Ⓜ The date given as the start of mountaineering's "Golden Age". Over the next 11 years, all of the highest Alpine peaks except the Meije would be climbed (see also **1877**).

1855 Ⓟ The ferrotype process (tintypes) is introduced to the USA.
Ⓜ The highest point of Monte Rosa, the Dufourspitze, is reached by a British-Swiss party.

1857 Ⓜ The first of the national mountaineering societies, the Alpine Club, is founded in London.

1861 Ⓟ Oliver Wendell Holmes invents the popular stereoscope viewer.
Ⓟ Felix Tournachon (a.k.a. Nadar) uses battery-powered artificial lighting.
Ⓜ The Swiss Weisshorn is ascended by John Tyndall, with guides Bennen and Wenger.

1865 Ⓜ Edward Whymper and party make the first ascent of the Matterhorn, with a tragic accident on the descent claiming four lives. This marks the end of the "Golden Age" of Alpine mountaineering.

1867 Ⓟ The first pre-coated, dry-plate glass negatives (convenient, but with poor light sensitivity) are used.

1869 Ⓟ Louis Ducos du Hauron's *Les Couleurs en Photographie* describes the principles of colour photography.

1871 Ⓟ Richard Leach Maddox invents the gelatin dry-plate silver bromide process, with its increased sensitivity and greater convenience.

1872 Ⓟ John W. Hyatt begins to manufacture celluloid.

1873 Ⓟ The platinum printing process is invented.

1877 Ⓜ The last of the high peaks of the Alps, the Meije, is climbed by Boileau de Castenau, with guides Pierre Gaspard, Sr and Jr.

1879 Ⓟ The first commercial manufacture of dry-plate negatives.

1880 Ⓟ The Eastman Dry Plate Company is founded.
Ⓟ Stephen Horgan's *A Scene in Shantytown* is printed in "halftone" in the *New York Daily Graphic*.
Ⓜ Edward Whymper climbs Mount Chimborazo in Ecuador.

1881 Ⓟ Frederick Ives invents the three-colour halftone process for colour printing.

1887 Ⓟ The Revd Hannibal Goodwin coats celluloid "film" with the now universal gelatin-bromide dry emulsion, to produce a flexible, prepared photographic material.

1888 Ⓟ Eastman markets the Kodak camera with the slogan: "You press the button, we do the rest."

1889 Ⓟ The first development of motion-picture roll film.

1890 Ⓟ Charles Driffield and Ferdinand Hurter publish their work on emulsion sensitivity and exposure measurement.

1892 Ⓟ Frederick Ives's first complete system for natural colour photography.

1895 Ⓟ The Lumière brothers show a moving-picture projector.

1898 Ⓜ Matthias Zurbriggen reaches the summit of Aconcagua, the highest point in the Andes.

1900 Ⓟ The first mass-marketed camera, the Kodak Brownie, on sale.

1906 Ⓜ Luigi Amedeo, the Duke of the Abruzzi, leads a successful expedition to the Ruwenzori Range in Uganda, reaching 17 summits.

1907 Ⓟ The Lumière Brother market the autochrome colour process.
Ⓜ Thomas Longstaff, with guides Alexis and Henri Brocherel, and the porter Kabir, reach the summit of Trisul in the Garhwal Himalaya – the first ascent of a 7,000-m (22,965-ft) peak.

1908 Ⓟ Gabriel Lippmann wins the Nobel Prize for his method of reproducing colour by photography.

1909 Ⓜ The Duke of the Abruzzi leads an ambitious expedition to the Karakoram. The team fails to ascend K2, but establishes an altitude record on Chogolisa, and completes mapping and photographic work upon which most subsequent expeditions depend.

1910 (M) A group of Alaska "sourdoughs" (gold prospectors) ascends the lower of the two summits of Mount McKinley.

1911 (M) Pitons are first used on a major Alpine rock-climb, the north face of the Lalidererwand.
(M) Paul Preuss solos a first ascent of the east face of Campanile Basso (the route would only be repeated by a roped team in 1928).

1913 (P) The Eastman Kodak Company establishes the first industrial photographic-research laboratory.

1914 (P) Oskar Barnack, of the Ernst Leitz Company, develops the first 35-mm still camera.

1916 (P) Agfa releases a colour plate film.

1920–21 (P) Ernst Belin introduces the wireless transmission of photographs. This carries obvious implications for the journalism industry, but also provides the groundwork for the digital revolution of the 1980s and 1990s.

1922 (M) The 8,000-m (26,200-ft) level is surpassed, by four members of an unsuccessful British expedition on Mount Everest.

1924 (P) The Ermanox, from the Ernemann Company, is the first practical "miniature" camera produced with features conducive to reportage.
(M) George Mallory and Andrew Irvine disappear above 8,500 m (27,880 ft) on Mount Everest, sparking great controversy over whether they might have reached the summit.

1925 (P) The Ernst Leitz Company markets the 35-mm Leica camera, setting the precedent for 35-mm roll film in journalistic reportage.
(M) Emil Solleder and Gustav Lettenbauer use "modern" aid techniques (pitons, carabiners, and double rope) to make a first ascent of the 1,000-m (3,280-ft) north-west face of the Punta Civetta.

1927 (P) General Electric introduces the modern flashbulb.

1930 (M) Karl Brendel and Hermann Schaller ascend the south ridge of the Aiguille Noir de Peuterey in the West Alps.

1931 (M) Holdsworth, Shipton, Smythe, and Sherpa Lewa climb Kamet, in the Garhwal Himalaya.
(M) Franz and Toni Schmid bicycle to Zermatt from Munich and climb the north face of the Matterhorn.

1932 (P) The photo-electric-cell light meter is developed.

1933 (M) Emilio Comici and the Dimai brothers use 80 pitons on a pure-aid ascent of the north face of the Cima Grande di Lavaredo.

1935 (P) Eastman Kodak markets Kodachrome (cinema-positive) film.
(M) Peters and Meier ascend the north face of the Grandes Jorasses.

1936 (P) Kodachrome is released as still film.
(M) Nöel Odell and Harold Tilman climb Nanda Devi, at 7,817 m (25,646 ft) the highest summit reached.

1938 (M) The deadly north face of the Eiger is finally climbed by Harrer, Heckmaier, Kasparek, and Vorg.

1940 (P) Ansco, Agfa, and Sakura colour films are introduced.

1941 (P) Eastman Kodak introduces Kodacolor negative film.

1948 (P) Edwin Land markets the Polaroid camera.
(P) The first 35-mm Nikon camera is introduced.

1949 (P) Contax markets the first single-lens reflex camera.

1950 (M) A French expedition climbs Annapurna, in the first ascent of an 8,000-m (26,200-ft) peak.
(M) John Salathé and Allen Steck use 150 pitons and nine expansion bolts for the first ascent of a Yosemite "big wall", the north face of Sentinel Rock.

1952 (M) Guido Magnone and Lionel Terray ascend Patagonia's Mount Fitzroy, arguably the most difficult summit in the world at the time.

1953 (M) The first ascent of Mount Everest is made by Edmund Hillary and Sherpa Tenzing Norgay, of John Hunt's British expedition.
(M) The first ascent of Nanga Parbat is made by Hermann Buhl, an Austrian member of a German expedition.

1954 (P) Eastman Kodak introduces high speed Tri-X film.
(M) The huge south face of Argentina's Mount Aconcagua is climbed by a French team.

1955 (M) Walter Bonatti makes an epic five-day solo of the Southwest Pillar of the Petit Dru.

1957 (M) Hamish MacInnes, Nicol, and Patey make the first ascent of the classic Scottish ice climb, Zero Gulley.

1958 (M) Warren Harding finally succeeds on the Nose of El Capitan, Yosemite, after 45 days of climbing (spread over eighteen months), involving 675 pitons, 125 expansion bolts, and numerous companions.

1961 (P) Eastman Kodak introduces faster Kodachrome II colour film.
(M) Almberger, Hiebeler, Kinshofer and Mannhardt climb the north face of the Eiger in winter.
(M) Claudio Barbier solos the five north-face routes of the Tre Cime di Lavaredo, in the Dolomites, all in a single day.

1963 (P) Polaroid introduces instant colour film.
(P) Eastman Kodak introduces the Instamatic camera.
(M) Michel Darbellay solos the north face of the Eiger.
(M) Yosemite big-wall technique comes to the West Alps, when Stewart Fulton, Tom Frost, John Harlin, and Gary Hemming make the first ascent of the south face of the Fou.

1965 (M) Walter Bonatti celebrates the 100th anniversary of the first ascent of the Matterhorn (and announces his retirement from the mountaineering limelight) with a solo, winter ascent of a new direct route on the north face of the Matterhorn.

1970 (M) Christian Bonington's successful Annapurna south-face expedition establishes a new standard for technical climbs in the Himalayas.

1974 (M) The first undisputed ascent is made of Patagonia's Cerro Torre, by an Italian expedition led by Casimiro Ferrari.

1975 (M) Peter Habeler and Reinhold Messner make a pioneering "alpine-style" ascent (lightweight, as a twosome, with no porter support) of a major Himalayan mountain, Hidden Peak.

1978 (P) Konica introduces the first point-and-shoot, auto-focus camera.
(M) Peter Habeler and Reinhold Messner ascend Everest without the use of oxygen.

1980–85 (P) Scitex, Hell, and Crossfield introduce computer systems for image management.

1980 (M) A Polish expedition climbs Mount Everest in winter.
(M) Reinhold Messner climbs Mount Everest solo.

1982 (P) SONY exhibits a digital still camera.

1984 (P) Canon demonstrates the first electronic still camera; Japanese newspapers cover the opening of the Olympics in Los Angeles with Canon RC-701 still video cameras and an analogue transmitter.

1985 (P) Pixar introduces a digital-imaging processor.

1986 (P) Technical standards are established and agreed by all makers of still digital equipment.
(M) Reinhold Messner becomes the first mountaineer to have climbed all 14 of the world's 8,000-m (26,200-ft) peaks.

1987 (P) USA Today begins to cover special events with the Canon RC-760 digital camera.

1988 (P) SONY and Fuji announce new digital cameras.
(P) PhotoMac is the first image manipulation program available for the Macintosh computer.

1990 (P) Adobe Photoshop, a professional image-manipulation program, becomes available for Macintosh computers.
(P) Eastman Kodak announces Photo CD as a digital-image storage medium.

1993 (P) Adobe Photoshop is available for MS-DOS/Windows platforms.
(P) Nikon, Canon, Leaf Systems, and others announce new professional-quality digital cameras.
(M) The American climber Lynn Hill free-climbs the Nose of El Capitan in the Yosemite Valley.

1994 (P) Apple Computer, Sony, and Kodak announce new digital cameras.

SOURCES
The following resources were used to develop this Timeline:

George Eastman House
website: http://www.eastman.org

Frison-Roche, Roger
(with Jouty, Sylvain)
A History of Mountain Climbing
(Flammarion, Paris, 1996)

Jeffrey, Ian
Photography, A Concise History,
(Oxford University Press, Oxford, 1981)

Newhall, Beaumont
The History of Photography,
(The Museum of Modern Art, New York, 1982)

Rosenblum, Naomi
A World History of Photography,
(Abbeville Publishing Group, New York, 1984)

Unsworth, Walter
Hold the Heights: The Foundations of Mountaineering
(Hodder & Stoughton, London, 1994)

GLOSSARY

CLIMBING

Aid-climbing The use of artificial holds or other devices to ascend.

Alpenstock An ice-axe.

Arête A ridge (generally one of the main ridges of a mountain).

Belay To secure oneself to a projection with a rope; the projection itself.

Bergschrund The crack (crevasse) that forms where a glacier has pushed steeply up a mountainside.

Camming device A fast-placing, spring-loaded, cammed piece that is inserted into a crack and then released. The cam expands to wedge into the crack, thus providing the climber with protection.

Carabiner A metal snap-link that clips to the established protection, with the climber's rope running through it.

Cornice An overhanging ledge of snow or ice, shaped like the crest of a wave, that forms on a windswept ridge.

Couloir A steep chute or gully of rock, ice, or snow.

Crampon A spiked metal frame that fits on to the sole of a boot to provide a secure foothold on hard snow or ice.

Crevasse A crack (fissure) on a glacier, created by general movement, and often of great depth.

Direttissima The straightest line of ascent – often considered the most aesthetic line – on a mountain face.

Étrier A nylon or metal-and-nylon ladder that is clipped to the protection; the climber then stands in the etrier and uses it for upward progression on a holdless rock face.

Expansion bolt A bolt placed in a hole drilled in a holdless rock face, used for protection or progression.

Free-climbing A method of climbing that uses *only* the features of the rock for progression.

"Friend" The brand-name of a commonly used camming device.

Glissade To slide down a snow slope, in a sitting or standing position, using an ice-axe to control the speed and direction of the slide.

Ice-axe An ice- and snow-climbing tool, combining a narrow adze and long pick on the head, with a spike at the bottom end of the shaft.

Ice-fall A much-torn and crevassed portion of a glacier, caused by a change of angle or direction in the slope.

Ice-hammer A short-handled climbing tool, fitted with a hammer head and a pick.

Massif A group of mountains.

Pitch On a climb, a section of difficult ice or rock.

Piton A metal spike with a ring at the head, which may be driven into cracks in a rock face for protection, or used for progression in aid-climbing.

Prusik To use a self-tightening knot to ascend a fixed rope (usually done today with a toothed-handle device that grips the rope); the self-tightening knot itself.

Rapel To use a rope doubled around a projection in order to descend a steep pitch.

Sérac An ice tower standing in a broken section of glacier.

Spur A rib of rock (the term is sometimes used to describe an arête).

Traverse To cross a mountain slope laterally; to ascend and descend a mountain via different routes.

PHOTOGRAPHY

Daguerreotype (A photograph taken by) an early photographic process using an iodine-sensitized silver-coated plate developed by mercury vapour. The work of Frenchman Louis Daguerre, this was the first far-reaching and truly influential advance in photography.

Dry-plate process A photography procedure using glass plates pre-coated with a light-sensitive emulsion.

Halftone printing The process used for preparing a photograph to be reproduced on a printed page.

Heliograph An early term for a photograph. The name was given by Frenchman Joseph Nicéphore Niépce, who used bitumen of Judea to reproduce engravings on metal in 1826; he created the first heliographs directly from nature the following year.

Stereo camera A camera used to form two slightly off-register images, side by side, which appear three-dimensional when seen through a special stereo viewer.

Wet-plate process An early process that involved coating individual plates of glass with a light-sensitive liquid emulsion, just prior to their exposure. The wet plates were later replaced by the more convenient dry plates.

BIBLIOGRAPHY

Audisio, Aldo (ed.)
Le Montagne Della Fotografia (Museo Nazionale della Montagna, Turin, 1992)
Christoffel, Ulrich
La Montagne dans la Peinture (Editions de la Centrale des Publications du Club Alpin Suisse, Zollikon, Switzerland, 1963)
Clark, Ronald
A Picture History of Mountaineering (Macmillan, New York, 1956)
Clark, Ronald
The Splendid Hills: The Life and Photographs of Vittorio Sella (Phoenix House, London, 1948)
Desemond, Maurice
Tairraz, Pere et Fils: Photographes de Montagne (Contrejour, Paris, 1992)
Frison-Roche, Roger (with Jouty, Sylvain)
A History of Mountain Climbing (Flammarion, Paris, 1996)
Garimoldi, Giuseppe
Fotografia E Alpinismo: Storie Parallele (Priuli & Verlucca, Ivrea, 1995)
Hankinson, Alan
Camera on the Crags (Heinemann, London, 1975)
Jeffrey, Ian
Photography, A Concise History (Oxford University Press, Oxford, 1981)
Jones, Chris
Climbing in North America (University of California Press, Berkeley, 1976)

Keenlyside, Francis
Peaks and Pioneers: The Story of Mountaineering (Elek, London, 1975)
Lukan, Karl
The Alps and Alpinism (Coward-McCann, New York, 1968)
Mazel, David (ed.)
Mountaineering Women: Stories by Early Climbers (Texas A&M University Press, College Station, Texas, 1994)
Newhall, Beaumont
The History of Photography (The Museum of Modern Art, New York, 1982)
Roper, Steve
Camp 4: Recollections of a Yosemite Rockclimber (Mountaineers Books, Seattle, 1994)
Rosenblum, Naomi
A World History of Photography (Abbeville Publishing Group, New York, 1984)
Sonntag, Susan
On Photography (Farrar, Straus and Giroux, New York, 1978)
Steinitzer, Alfred
Der Alpinismus in Bildern (R. Piper & Co., Munich, 1913)
Sugimoto, Makoto
Mountain Pictures and Photographers (Kodansha, Tokyo, 1985)
Trachtenberg, Alan (ed.)
Classic Essays on Photography (Leete's Island Books, New Haven, 1980)
Unsworth, Walter *Hold the Heights: The Foundations of Mountaineering* (Hodder & Stoughton, London, 1994)

INDEX

ACKNOWLEDGEMENTS

I would like to thank the following individuals for their generous contributions of information, and for images from their personal collections: Christian Bonington, Robert Bösch, John Cleare, Leo Dickinson, Tom Frost, Dr Aldo Godenzi, Dr Richard Goedeke, Steven Kalinowski, Quong-Tuan Luong, Pat Morrow, Chris Noble, Kevin Powell, André Roch, Galen Rowell, Ira Spring, Makoto Sugimoto, Pierre Tairraz, Beth Wald, Derek Walker, Bradford Washburn, Billy Westbay, and Jürgen Winkler. Steve Roper and Allen Steck were extremely helpful with material relating to the post-World War II Yosemite scene.

For their suggestions, support, and research assistance, thanks to: Laurent Belluard (Grimper), Marco Ferrari (Alp), Giuseppe Garimoldi, Kent Haldan, Bill Jay, Michael Kennedy (Climbing magazine), Jean-Marc Porte (Montagnes), Audrey Salkeld, and Walter Wenzel.

The directors and staffs of the following archives and picture agencies were extremely helpful:
Swiss Alpine Club/Swiss Alpine Museum, Bern, Switzerland. The Museum of Communication, Bern, Switzerland. Museo Nazionale della Montagna, Turin, Italy. Sella Institute for Alpine Photography, Biella, Italy. Austrian National Library, Vienna, Austria. Austrian Touring Club, Vienna, Austria. Austrian Alpine Club, Innsbruck, Austria. American Alpine Club, Golden, Colorado. Alpine Club, London, England. The British Museum, London, England. Getty Images, London, England. A & C Black, Ltd., London, England. The Fell and Rock Climbing Club Library, Manchester, England. German Alpine Club/Alpinesmuseum, Munich, Germany. Photo archives, Bruckmann Verlag, Munich, Germany. Hamburger Kunsthalle, Hamburg, Germany. Denver Public Library, Western History Coll., Denver, Colorado. Colorado Historical Society, Denver, Colorado. George Eastman House, Rochester, New York. University of Colorado, Library Archives, Boulder, Colorado. Ransom Humanities Center (Gernsheim Coll.), Austin, Texas. Bancroft Library, University of California, Berkeley, California. The National Geographic Society, Washington, DC. Library of Congress, Washington, DC. Whyte Museum of the Canadian Rockies, Banff, Alberta. The Vatican Museum.

A special word of thanks goes out to: Aldo Audisio and Emanuela De Rege of the Museo Nazionale della Montagna, Robert Lawford of the Alpine Club, Herr and Frau Landes of the German Alpine Club, Markus Schwyn and Alfred von Gunten of the Swiss Alpine Club, Karl Kronig of the Museum of Communication, Jim Swanson and Lena Goon at the Whyte Museum; also to: Gary Crabbe, Frances Daltrey, Mary Alice Harper, Jo-ann Kee, Madeleine Koch, Eric Paddock, Lodovico Sella, Michelle Simpson, Cassandra Volpe, and George Watkins.

The editorial staff at Mitchell Beazley provided encouragement and enthusiasm, and were a complete joy to work with. I would especially like to thank Samantha Ward-Dutton, who shepherded Souvenirs from the very beginning, as well as Emma Boys, Paul Drayson, Jenny Faithfull, Claire Musters, Luise Roberts, and Jane Royston. In addition, Mary Metz and Donna DeShazo, of The Mountaineers Books, have been supportive from the start of this project, some four years ago.

The early archival research for this study was partly supported by a grant from the Ludwig Vögelstein Foundation. I am grateful both for the financial support and for the emotional lift this gave me in getting the project off the ground.

Finally, a big thank you to the dozens of climbers who corresponded with me, by letter and computer, providing valuable insight and opinion on matters relating to the souvenir recording of the climbing experience. May all your belay stances be sunny and secure.

PICTURE CREDITS

1 Austrian National Library; 2–3 Robert Bosch; 4–5 Vittorio Sella Institute of Alpine Photography/Vittorio Sella; 6–7 Fell and Rock Climbing Club, Abraham Collection; 8 Bruckmann Verlag; 8–9 Robert Bosch Collection; 10–11 all Joseph, George Sr, George Jr and Pierre Tairraz; 12 top University of Colorado at Boulder, Library Archives/Ernest Greenman; 12 bottom Andre Roch; 13 top Billy Westbay; 13 bottom Chris Bonington Picture Library/Derek Walker; 14–15 Vatican Library; 16 Museum of Communication, Berne/F.N. Konig; 17 top Austrian National Library/Leonard Beck; 17 bottom Austrian National Library/Leonard Beck; 18 top British Museum/George Baxter; 18 bottom British Museum/George Baxter; 19 Swiss Alpine Museum/Martin Distelli; 20 Austrian National Library; 21 Kunsthalle, Hamburg/Caspar David Friedrich; 22 top Austrian National Library/Franz Pracher; 22 bottom Museum of Communication, Berne/Eugène Guérard; 23 Museum of Communication, Berne/Eugène Guérard; 24–5 Alpine Club of Britain; 26–7 Hulton Getty/Gustave Dore; 28–9 all Swiss Alpine Museum/Ferdinand Hodler; 30–1 Austrian National Library/Karl Reinhardt; 31 top Swiss Alpine Museum/R.C. Woodville; 32 Alpine Museum of the Austrian Alpine Club/Ernst Platz; 33 Alpine Museum of the Austrian Alpine Club/E.T. Compton; 34–5 George Eastman House; 36 George Eastman House/Timothy O'Sullivan; 37 top Joseph Tairraz; 37 bottom Hulton Getty; 38 top Alpine Club of Britain/W.F. Donkin; 38 bottom Swiss Alpine Museum/Jules Beck; 39 Swiss Alpine Museum/W.F. Donkin; 40 Swiss Alpine Museum/Jules Beck; 41 Swiss Alpine Museum/Jules Beck; 42 top Swiss Alpine Museum/Hans Brun; 42 bottom Swiss Alpine Museum/Hans Brun; 43 Austrian National Library; 44 Museo Nazionale della Montagne/Studio Mecozzi; 45 top Swiss Alpine Museum/Charles Hotz; 45 bottom Swiss Alpine Museum/Chernaux brothers; 46–7 Swiss Alpine Museum/B. Johannes; 48–9 Bruckmann Verlag/Fritz Benesch; 49 Swiss Alpine Museum; 50 Joseph Tairraz; 51 top Swiss Alpine Museum; 51 bottom Swiss Alpine Museum; 52–3 Vittorio Sella Institute of Alpine Photography/A. Holmes; 54 Vittorio Sella Institute of Alpine Photography/Vittorio Sella; 55 Denver Public Library, Western History Department; 56 Vittorio Sella Institute of Alpine Photography/Vittorio Sella; 56–7 Vittorio Sella Institute of Alpine Photography/Vittorio Sella; 58–9 Whyte Museum of the Canadian Rockies/Vaux family; 60 top Whyte Museum of the Canadian Rockies/Vaux family; 60 bottom Colorado History Society; 61 top Fell and Rock Climbing Club, Abraham Collection/Abraham brothers; 61 bottom Fell and Rock Climbing Club, Abraham Collection/Ashley Abraham; 62 Swiss Alpine Museum; 63 top Whyte Museum of Canadian Rockies/A.T. Dalton; 63 bottom Austrian National Library/Gustav Gotzinger; 64 top Whyte Museum of Canadian Rockies, Harmon Collection/Bryon Harmon; 65 bottom Whyte Museum of Canadian Rockies, Harmon Collection/Bryon Harmon; 66 Museo Nazionale della Montagne/Gugliermina brothers; 67 top Museo Nazionale della Montagne/Mario Piacenza; 67 bottom Makoto Sugimoto Collection/Mitsumaru Fujimoto; 68 George Tairraz; 69 top Alpine Museum of the German Alpine Club; 69 bottom Austrian National Library; 70–1 all Alpine Musem of the German Alpine Club; 72 top George Tairraz; 72 bottom George Tairraz; 73 Andre Roch Collection; 74–5 all Colorado Historical Society; 76 Alpine Museum of the German Alpine Club; 77 Alpine Museum of the German Alpine Club; 78 Alpine Museum of the German Alpine Club; 79 top Museo Nazionale della Montagne; 79 bottom Makoto Sugimoto Collection/Shigehiro Nojima; 80 Austrian Touring Club/Rudolf Sommereder; 81 top Austrian Touring Club/Karl Baumgartner; 81 bottom Austrian Touring Club/Fred Mauersperger; 82–3 Bancroft Library, University of California at Berkeley/Richard Leonard; 83 Bancroft Library, University of California at Berkeley/Richard Leonard; 84 top Denver Public Library, Western History Department; 84 bottom Joe Bensen; 85 top Denver Public Library, Western History Department; 85 bottom German Alpine Club; 86 A&C Black, Ltd/Frank Smythe; 87 top Swiss Alpine Club/Emil Gos; 87 bottom A&C Black, Ltd/Frank Smythe; 88 Swiss Alpine Club/Oskar Hug; 89 Swiss Alpine Club/Emil de Waldkirch; 90 top Denver Public Library, Western History Department/John Woodward; 90 bottom Denver Public Library, Western History Department/C.M. Molenaar; 90–1 Bradford Washburn; 92–3 Makoto Sugimoto Collection/Takeharu Maeda; 94 Alpine Club of Britain/C.D. Milner; 95 top Alpine Club of Britain/C.D. Milner; 95 bottom Swiss Alpine Club/Otto Pfenniger; 96–7 Bradford Washburn; 97 Bradford Washburn; 98 Museo Nazionale della Montagne/Guido Monzino; 99 Library of Congress/Antoinette Frissell; 100 Dr Aldo Godenzi; 101 Dr Aldo Godenzi; 102 top Whyte Museum of the Canadian Rockies/Eduardo Sanvicente; 102 bottom Whyte Museum of the Canadian Rockies/Georgia Engelhard; 103 Whyte Museum of the Canadian Rockies/Georgia Engelhard; 104 Museo Nazionale della Montagne/Achille Compagnoni; 105 top Hulton-Getty; 105 bottom National Geographic Society/Barry Bishop; 106 Allen Steck; 107 top Bob Swift; 107 bottom Chris Bonington Picture Library/Steve Roper; 108–9 Bob and Ira Spring; 109 Bob and Ira Spring; 110 Dr Richard Goedeke; 111 top Pierre Tairraz; 111 bottom Pierre Tairraz; 112 top Tom Frost; 112 bottom Tom Frost; 113 Tom Frost; 114 Vilem Heckel; 115 Vilem Heckel; 116–7 all University of Colorado at Boulder, Godfrey Collection/Robert Godfrey; 118 top John Cleare; 118 bottom John Cleare; 118–9 John Cleare; 120 Chris Bonington Picture Library/Chris Bonington; 121 top Chris Bonington Picture Library/Chris Bonington; 121 bottom Chris Bonington Picture Library/Don Whillans; 122 top Billy Westbay; 122 bottom Billy Westbay; 123 top Leo Dickinson; 123 bottom Leo Dickinson; 124 Jürgen Winkler; 125 Jürgen Winkler; 126 Patrick Morrow; 126–7 Patrick Morrow; 128 Galen Rowell, Mountain Light/Galen Rowell; 129 Galen Rowell, Mountain Light/Galen Rowell; 130–1 Chris Noble; 132 top Chris Noble; 132 bottom Beth Wald; 133 Beth Wald; 134 Kevin Powell; 135 Kevin Powell; 136 top Robert Bösch; 136 bottom Robert Bösch; 137 Robert Bösch; 138 Quang-Tuan Luong; 139 Quang-Tuan Luong.